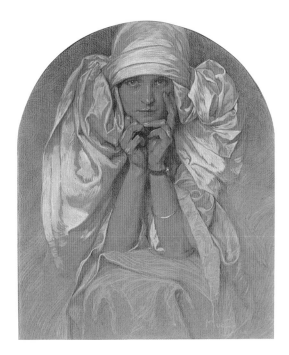

LESSONS *in*
CLASSICAL
DRAWING

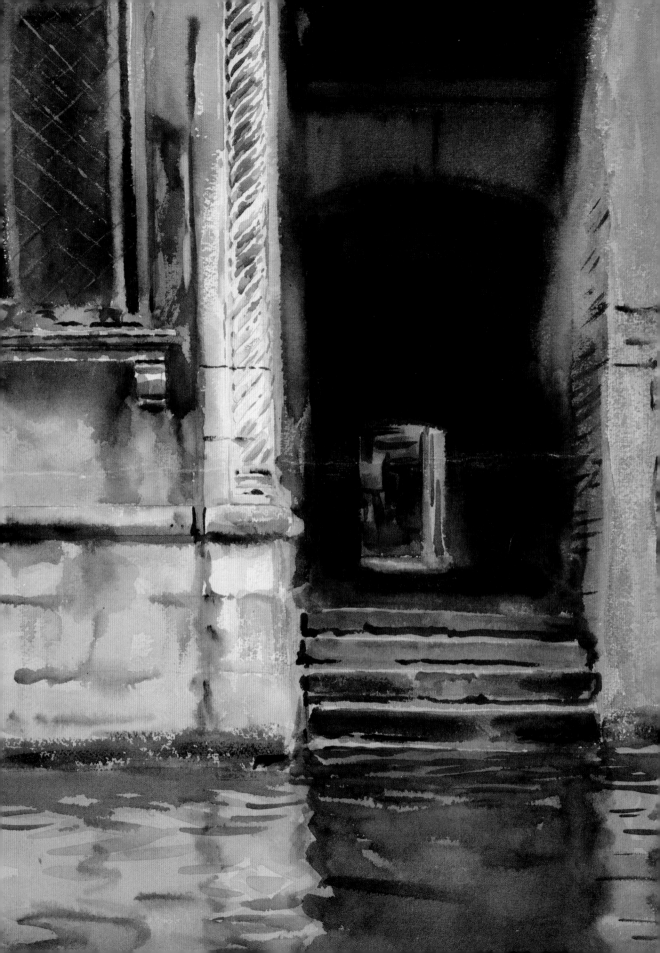

LESSONS *in* CLASSICAL DRAWING

ESSENTIAL TECHNIQUES FROM INSIDE THE ATELIER

For Barry
I wish you much
joy with your
art. Juliette

Juliette Aristides

WATSON-GUPTILL PUBLICATIONS / NEW YORK

HALF TITLE PAGE: **ALPHONSE MUCHA**, *Portrait of the Artist's Daughter, Jaroslava*, 1922, pastel and gouache on tan paper, 15 ¼ x 12 ⅝ inches (39 x 32.5 cm), private collection, courtesy of Art Renewal Center

TITLE PAGE: **JOHN SINGER SARGENT**, *Venetian Passageway*, circa 1905, watercolor, gouache, and graphite on white wove paper, 21 ³/₁₆ x 14 ½ inches (53.8 x 36.8 cm), collection of The Metropolitan Museum of Art (New York, NY), gift of Mrs. Francis Ormond, 1950

Photo Credit: Image copyright © The Metropolitan Museum of Art / Art Resource, New York, NY

FACING PAGE: **VICTORIA HERRERA**, *Seraphim Adorned by Garlands*, 2009, graphite on paper, 5 x 21 inches (12.7 x 53.3 cm)

CONTENTS PAGE: **BENNETT VADNAIS**, *Birch Tree*, 2008, graphite and white chalk on paper, 16 x 12 inches (40.6 x 30.5 cm)

COVER IMAGE: **ELIZABETH ZANZINGER**, *Sarah Resting*, 2008, charcoal on paper, 20 ½ x 18 inches (52.1 x 45.7 cm)

The illustrations throughout the book were created with brush and ink by Jennifer Baker. They appear on the following pages: 22, 29, 40, 42, 48, 50, 54, 55, 68, 72, 74, 78, 83, 100, 129, 130, and 161.

Published in the United States by Watson-Guptill Publications, an imprint of the Crown Publishing Group, a division of Random House, Inc., New York.

www.crownpublishing.com
www.watsonguptill.com

WATSON-GUPTILL is a registered trademark, and the WG and Horse designs are trademarks of Random House, Inc.

Library of Congress Cataloging-in-Publication Data

Aristides, Juliette.
 Lessons in classical drawing : essential techniques from inside the atelier / Juliette Aristides. — 1st ed.
 p. cm.
 Includes bibliographical references and index.
 ISBN 978-0-8230-0659-5
 1. Drawing—Technique. I. Title. II. Title: Essential techniques from inside the atelier.
 NC730.A685 2011
 741.2—dc22

 2010053087

Printed in China
Cover and interior design by Danielle Deschenes

10 9 8 7 6 5 4 3 2 1

First Edition

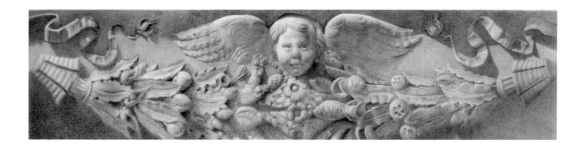

To all who love to draw

Many people contributed to the creation of this publication. This book would never have been started or finished without the help of D. Jordan Parietti. My thanks to two wonderful filmmakers, Don Porter and Bob Campbell, for your vision and sense of humor. Special thanks to Fred and Sherry Ross; Art Renewal Center is a powerful force supporting traditional art. Elizabeth Zanzinger, my sincere appreciation for your initial design and layout. Jennifer Baker, who did the illustrations for this book by hand with a small brush and a bottle of ink—you are one of a kind. Thanks to Sarah Jardine Howard for jump-starting this project with early editing, and to my editor, Alison Hagge, for your optimism and encouragement. Larine Chung, I am indebted to you for your research and support. Kim Bendheim and Susan Torrance, your support was invaluable, thank you. A special acknowledgment to Barbara Katus for sharing the wealth of drawings from the archives of the Pennsylvania Academy of the Fine Arts. Photography was done by Andrei Orlano; thank you for sharing your vision through the eye of a camera lens. Candace Raney, executive editor at Watson-Guptill, you have seen countless art books to fruition; thank you for believing in this one. Pamela Belyea, executive director at the Gage Academy of Art, has been a tireless advocate of the fine arts. I am especially grateful to my family: Frances Bendheim and Barry Bub, Dino, Natalia, Jason, and Simon Aristides, who have contributed with love and support for the creation of this project. My deepest appreciation goes to every artist who contributed to this book and DVD. Your art brings beauty and meaning into a world that needs you. Thank you one and all.

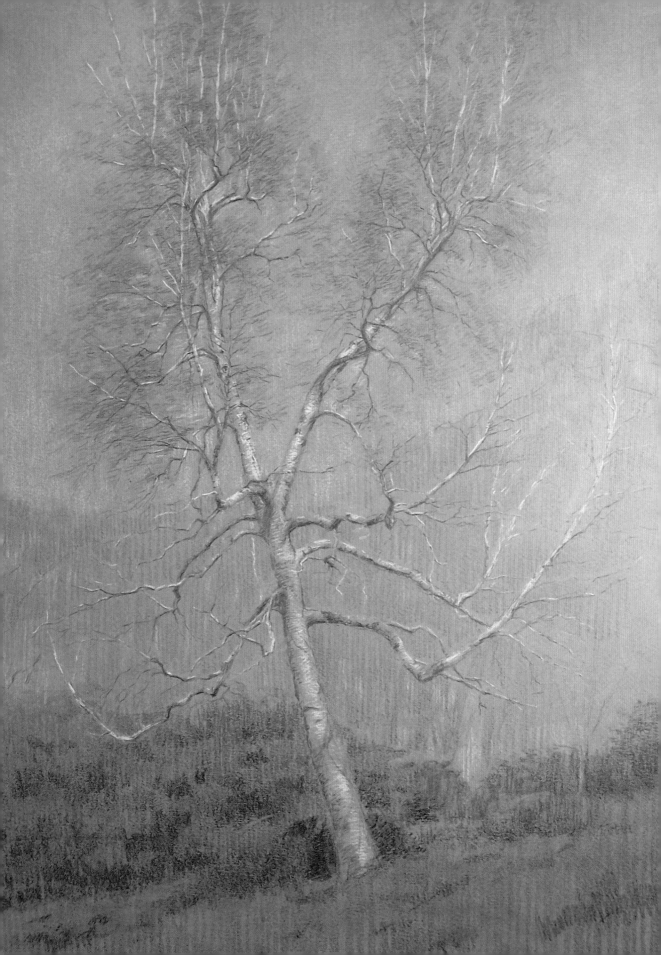

CONTENTS

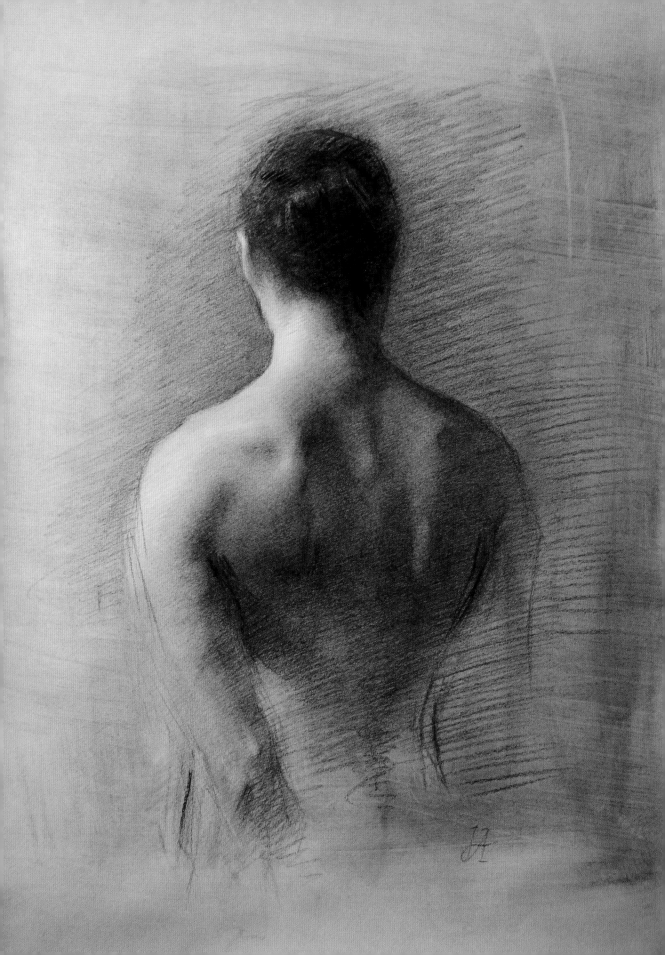

PROLOGUE

Why learn to draw? Simply stated: Because drawing is powerful. Drawing is the most basic passageway through which you can access the power of art to express profound universal ideas, feelings, beliefs, and truths.

Beethoven began by practicing scales. Shakespeare started by learning his ABCs. You, too, must begin with the basics. For the visual artist, an understanding of the elements of pattern, proportion, line, value, form, and volume offers keys that unlock the doors to the successful expression of concepts of nearly every type and kind. This core technical knowledge will be presented on the pages that follow. The plain truth is, one cannot learn the things one needs to become a good artist until one has learned to draw well. In fact, the biggest mistake many people make in modern times is proceeding to painting before they have put enough work into first learning to draw. Drawing is the key that will open the doors to everything else. There is no way around it.

Your work—whether drawing, painting, or sculpture—will stand only if it is constructed on a solid foundation. Without a solid grounding in the basics, effective communication through art is impossible. Thus, it is of the utmost importance for aspiring artists to build a firm foundation based on real knowledge provided by a carefully trained teacher. Only with mastery of one's medium is there any realistic possibility of artistic freedom, of creative expression, and of the attainment of excellence in the fine arts.

While the power of art can be magical, there is nothing magical in its creation. Great works of art are not divined or conjured with some incomprehensible mystical power. Rather, for centuries, artists have relied upon concrete methods and techniques for artistic execution. This book imparts that tradition.

Every would-be artist who reads this book or sees this DVD would be well advised to adopt the same dedication to learning with great discipline and devotion that has been the hallmark of master artists for centuries. If you become a well-trained artist, there should be no ideas that you can express in words that you cannot also express in a visual work of art.

Fred Ross
CHAIRMAN, ART RENEWAL CENTER

JULIETTE ARISTIDES, *Yma*, 2010, charcoal on toned paper, heightened with white chalk, 25 x 18 ½ inches (63.5 x 47 cm)

Marks on a page form a visual language that connects us to the fellowship of artists throughout the ages. Drawing provides a communion of emotions and ideas between the artist and the viewer.

INTRODUCTION

In all cases where excellence has ever been attained in art, love for it has been the first, continued, and abiding impulse.

—JOHN GADSBY CHAPMAN (from *The American Drawing Book*)

JORY GLAZENER, *City Gate in Vézelay,* 2005, bister ink on rag paper, 12 x 12 inches (30.5 x 30.5 cm)

The tiny figure in the portal provides an opportunity for our eye to move from the foreground to the background.

Somehow I managed to fail my high school art class. Part of the problem was that I wanted to learn to draw, but these classes tended to be craft oriented. So, while I emerged with plenty of experience with a hot glue gun, I did not learn to draw or become a more astute observer of the world.

Despite my lackluster performance in school, I forged ahead in my study of art. Drawing in my sketchbook became a haven for me, a refuge and place of fascination. Drawing was a tangible expression of my thoughts and a beacon to me during many dark hours. Still, regardless of my investment of time and my devotion, I was constantly bumping against the limitations of my skill. I was unable to push beyond the place where my natural ability failed me.

I was seventeen when I first heard about a man teaching the secrets of the old masters in the small town of Coplay, Pennsylvania. I did not know what it meant exactly, but I felt resonance—as if a long dormant gene was stirred and awakened.

My father and I decided to make the trek to visit Myron Barnstone. We arrived one evening and climbed up the two flights of stairs to his studio. Myron himself opened the door, meeting us with an authoritative force. His very presence scared me to death. With a cigarette dangling from his mouth and one eyebrow raised fiercely over his bifocals, he stared at me as if sizing up my capability. Then he looked at my dad and said, "You are going to spend $100,000 on Juliette's education, and she will be a waitress the rest of her life."

Nice try, Myron.

Studying at the Barnstone Studios was the hardest thing I had done up to that point. I was making up for lost time. Drawing, which had always felt so natural, all of a sudden felt cumbersome and awkward. My drawing got worse before it got better. Yet accompanying my frustration was the joy of total engagement. It was as if I had been given a new set of eyes. I was suddenly seeing connections, patterns, and relationships that I never dreamt existed.

I fell in love with the process of studying art and over the next decade worked with the best people I could find—at the

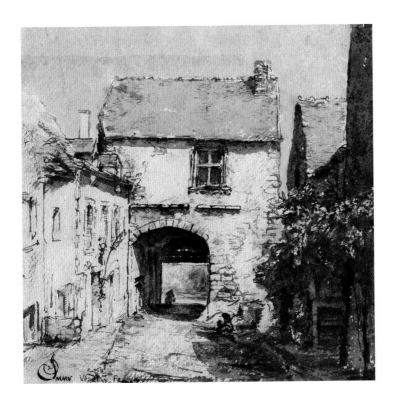

Pennsylvania Academy of the Fine Arts, National Academy of Design, and various ateliers. Throughout those years of practice I learned many things. I understood, firsthand, that studying art is a lifetime pursuit, endlessly challenging and rewarding. I also learned that drawing is as teachable as math, music, or writing. Anyone can draw. The secret of making great art lies in combining foundational skills with sensitivity of expression. The most important thing a student can do is get time-tested information and build on it consecutively, allowing plenty of time for practice.

In this book I will share with you the sequential steps that will enable you to learn to draw. I will break down the act of drawing into simple tasks. Through this process you will form a solid foundation upon which you can build skills in as many artistic directions as your taste and temperament desire. The accompanying DVD will eliminate some of the gaps in the learning process that come from working primarily from books. Together, this book and DVD will allow you to see for yourself that the techniques of the masters are not entirely cloaked in mystery. With adequate time and practice they will become your own.

The world needs more beauty. I encourage you to take the plunge and learn to draw—and I wish you much joy in the process.

Juliette Aristides

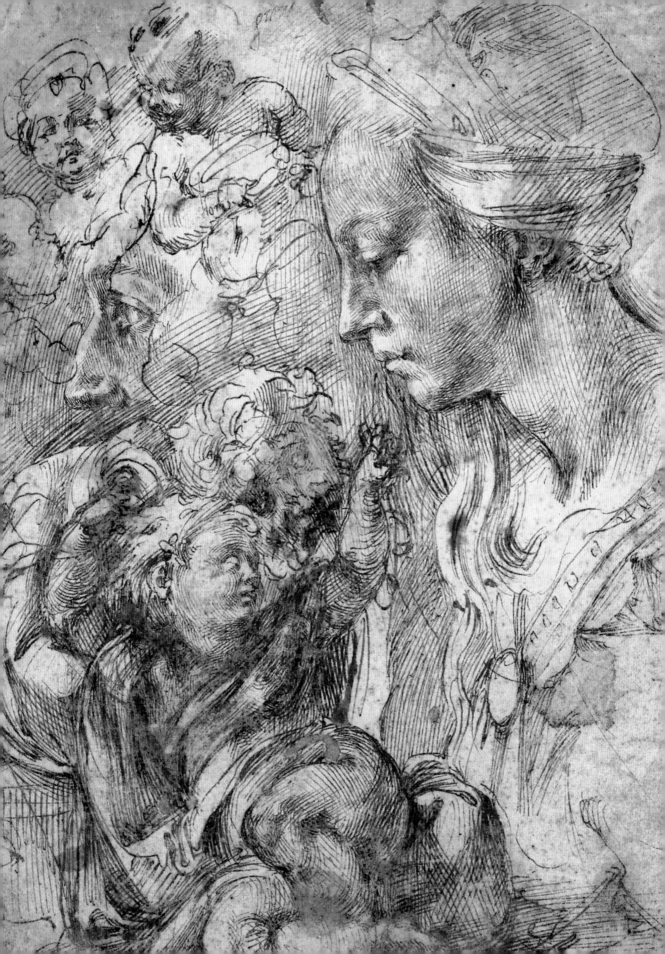

BEGINNING LINES:

THE WORLD THROUGH AN ARTIST'S EYE

When we look deeply into the patterns of an apple blossom, a seashell, or a swinging pendulum we discover a perfection, an incredible order, that awakens in us a sense of awe that we knew as children. Something reveals itself that is infinitely greater than we are and yet part of us; the limitless emerges from limits.

—GYÖRGY DOCZI (from *The Power of Limits*)

A few years ago, I took a very short trip from my home in Seattle to New York City. Because I had only two days, my first desire as I stepped off a red-eye flight was to get down to the business of seeing some art.

My father had driven up from Philadelphia to join me for the day. As we walked in the direction of the museum we planned to visit, he took his time, examining every window decoration, advertisement, and unusual outfit we passed, saying things like, "Art is everywhere if we look for it." Not only was I annoyed with his leisurely pace, but I disagreed with his philosophy. This fuzzy language has resulted in lowering the bar in art education to the point of extinction.

Although this is a longstanding point of contention between us, my desire to get to the museum persuaded me to remain silent. So, we idled along peacefully until the museum finally came into sight. Just as I quickened my pace, however, Dad turned to yet another window.

This time the distraction was a shop selling rocks, minerals, and fossils. I peered inside, expecting just another store. But I was immediately struck by an anomaly. Everything in the window was obviously mined from the ground except for one oddity—a near-perfect, shiny, metal cube. My curiosity drove me inside to ask why they would choose to include a man-made object among all the natural ones.

The owner walked nearer to me and in a heavy Greek accent answered, "Nothing in the shop is man-made. That is from a mine in Spain. We didn't even polish it." I was absolutely stunned.

"It's a miracle!" I said as he placed the rock into my hand.

"No," he replied. "You're a miracle. You hear, move, and talk. That? Well, it is just a rock."

MICHELANGELO BUONARROTI, *Studies of a Holy Family with the Infant Saint John*, circa 1505, pen and brown ink on paper, 11 ¼ x 8 ⅛ inches (28.7 x 20.9 cm), collection of the Kupferstichkabinett, Staatliche Museen (Berlin, Germany), courtesy of Art Renewal Center

Michelangelo sketched the Madonna and Child to further understand his subject and reconcile it with his artistic vision. Sometimes the outcome of this wresting process is far more complex and beautiful than if the drawing was found in the first pass.

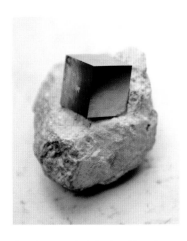

This photograph of the Spanish pyrite shows the near perfect cube I bought in New York. The walls are so smooth I can see my reflection as in a mirror.

Photograph by Andrei Kozlov

OPPOSITE: WINSLOW HOMER, *Fisher Girls on Shore, Tynemouth,* 1884, black chalk heightened by white on paper, 22 ½ x 17 ¼ inches (57.2 x 43.8 cm), collection of the Wadsworth Atheneum Museum of Art (Hartford, CT)

Photo Credit: Wadsworth Atheneum Museum of Art / Art Resource, New York, NY

Homer, an American master, found nature to be a constant source of inspiration for his art.

His words hit me with such force that I doubt I would have been more surprised if an ancient obelisk had emerged through the floorboards. The uncanny perfection of the metallic shape shattered my categories. I know there is order in nature, but to see it laid bare, in such an unexpected form, was remarkable. This tiny, near-perfect cube filled me with awe, a feeling I experience occasionally and only in front of the most breathtaking works of nature and art.

I spent the next hour in the shop. As my eyes acclimated to identifying the more obvious patterns, the owner gave me a magnifying glass to reveal the more subtle and hidden order that could be found. I ended up buying the Spanish pyrite from the window. I paid more for it than I would for a pair of fantastic shoes. I bought it with the hope that every time I looked at it I would be reminded of the awe-inspiring wonder of life. In short, I bought a simple mineral for the same reason I would buy a piece of art.

When we left the shop we headed straight to the museum. Yet nothing else I saw that day moved me half as much as the experience in the shop. I will not say the mineral is art, but I gained an appreciation for my dad's desire to find unexpected beauty.

Our best efforts are spent on timeless principles before specific techniques.

The following sections will help you see the significance of the underlying structure of a drawing. You will observe the powerful design that is all around us, learn to differentiate between essential and unnecessary lines, and distill a concise pattern onto which you can build your work of art. The more clearly you identify the underlying structure of your subject, the easier it will be to draw, and the more pleasure you will gain from recognizing it in other works of art.

Principle Before Practice

There are many ways to learn to draw. The technique is less significant than the principles underlying the method. Just beneath the surface of diverse masterpieces are remarkably constant truths. For example, every good drawing exhibits an understanding and control of tone, proportion, harmony, and composition. Although learning a quick technique can offer some short-term satisfaction, the best investment of your time in the long run will be to focus on timeless principles whenever possible, even if the process initially seems slow. These principles will provide you with a solid foundation to build upon anyway you wish. To really understand the complex act of drawing, I suggest breaking it into its composite parts. By the end of this book, you will recognize the elements of drawing and how to critique each stage of a work of art.

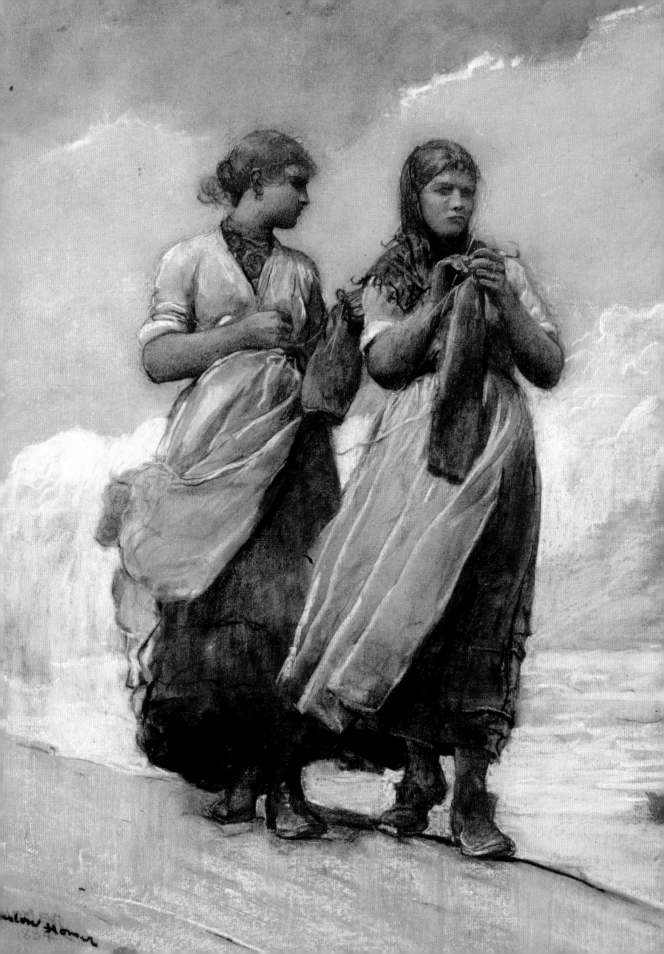

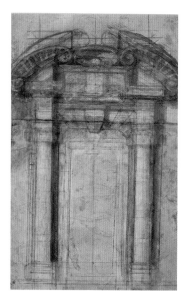

MICHELANGELO BUONARROTI, *Study for the Porta Pia*, circa 1561, chalk and ink on paper, 17 ½ x 11 inches (44.2 x 28.1 cm), collection of Casa Buonarroti (Florence, Italy), courtesy of Art Renewal Center

Note the vertical and horizontal construction lines that Michelangelo used to locate his image are still visible at the end of the drawing.

Look Before You Leap

Great drawings begin long before pencil touches paper. Your first practice should be careful observation. Studying your subject for a full minute or two before committing your pencil to paper enables you to form a visual opinion about your subject.

I have realized over the years that taking time to look before acting makes the drawing process more focused. It enables me to sort out what I find interesting or moving about my subject, and to better understand important elements of the underlying pattern or structure. Many times, I am surprised what I discover when I take time to look more carefully and let my assumptions be challenged—as in my experience with the Spanish pyrite. I expected to see beauty in one place and found it in another.

When beginning the drawing process, you may be uncertain about what you are looking for. Think of this as an exploratory process, one without any single right answer. By crystallizing your thoughts or emotions about your subject you can help keep your passion and enthusiasm throughout the process. This activity will also help you know when you have achieved your goal.

When I look at my subject I often ask myself, "What is beautiful about what I am seeing? Is the quality of the light special? Is there a repeating shape or angle?" Often, the answers to these questions start to emerge after a few moments of contemplation. Artistic vision does not always happen instinctively or easily. It takes enormous concentration and an act of the will.

Good habits directly affect the outcome of your drawings. Spend time looking before you start to draw.

Looking in a *physically* different way can also be helpful in breaking you of your preconceived visual notions. For example, one of the secrets of the masters was to squint. This practice shifts sight from an ordinary way of viewing the world to seeing it artistically. Half closing your eyes lessens the amount of light hitting your retina and simplifies the visual information. This practice sifts the more significant data from the smaller distractions. The most critical information lies in the biggest shapes, and those become clearer when squinting. No matter the method you use, it is absolutely essential to take the time to look before you draw.

Forming One Essential Vision

A great artist can turn even the most mundane subject into a revelation—not by recording every detail, but by making careful choices that create patterns that guide the eye of the viewer through the piece. Much of the lasting power of art comes not from the obvious content of the image but from the more subtle impact of harmoniously arranged lines, values, and colors. These form the bedrock of masterful artwork.

The ability to sort through information and identify significant relationships remains a hallmark of the well-trained artist. Because of its importance, I reserve the beginning part of a drawing almost exclusively for pattern seeking. Writers often draft a thesis statement before beginning a project, a few sentences that summarize

Simple figures such as this triangle are easy for the eye to grab hold of and remember.

ALBRECHT DÜRER, *Hare*, 1502, watercolor and gouache on paper, 9 ¾ x 8 ⅞ inches (25.1 x 22.6 cm), Albertina, Graphische Sammlung (Vienna, Austria), courtesy of Art Renewal Center

The envelope (or simplified outline) used by Dürer forms a strong, clean geometric shape. The term *envelope* refers only to a simplified contour of a subject. It is a few lines that form a packet containing the subject.

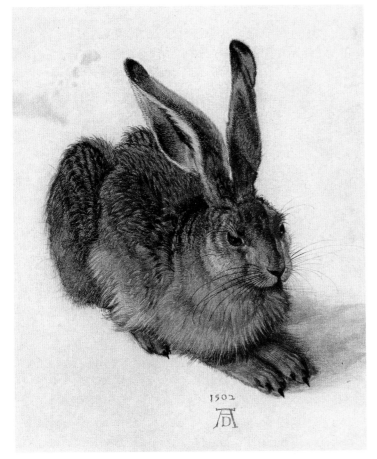

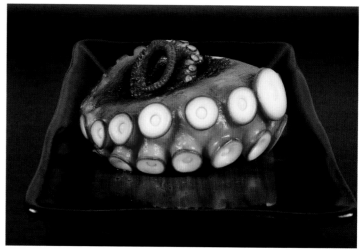

RIGHT: Circles imply perfect unity and are often used in art to reconcile diverse parts of a picture into a harmonious relationship. They are found everywhere in nature—from water droplets to planets to the tentacle on this octopus.

Photograph by Jeff Leisawitz

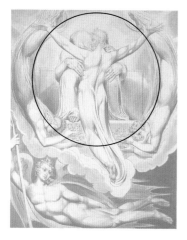

The central figures are flanked by upside-down figures that arch around them on both sides, forming a circle.

OPPOSITE: WILLIAM BLAKE, *Christ as the Redeemer of Man*, 1808, watercolor on paper, 19 ¼ x 15 ⅜ inches (50 x 38.9 cm), collection of the Museum of Fine Arts, Boston (Boston, MA), courtesy of Art Renewal Center

Blake has based his composition on the circle, whose geometry has been used to symbolize God because it has neither beginning nor end.

their entire work; this helps to keep them focused as they flesh out their ideas. In drawing, a similar logic prevails. If you find a distilled impression that captures the essence of your work and place this on your paper first, this foundation ensures that there will be a big supporting idea for your more nuanced observations. It is not the number of lines that you put down that makes a successful work, but the precision of those lines in accordance with your aims.

Reserve the beginning part of a drawing for unifying lines and shapes.

Beginning artists often work piecemeal, starting carefully at one area of the page and figuring it out as they move along. They have no plan or map to provide an overall structure to the piece. I live in the Northwest, and every year we hear about hikers walking into the woods, in their flip-flops and with a bottle of soda, only to be saved by a search-and-rescue team three days later. The outcome of a drawing created without a map is not so dire, yet a few structural lines in the beginning often mean the difference between a successful drawing and a disappointing one.

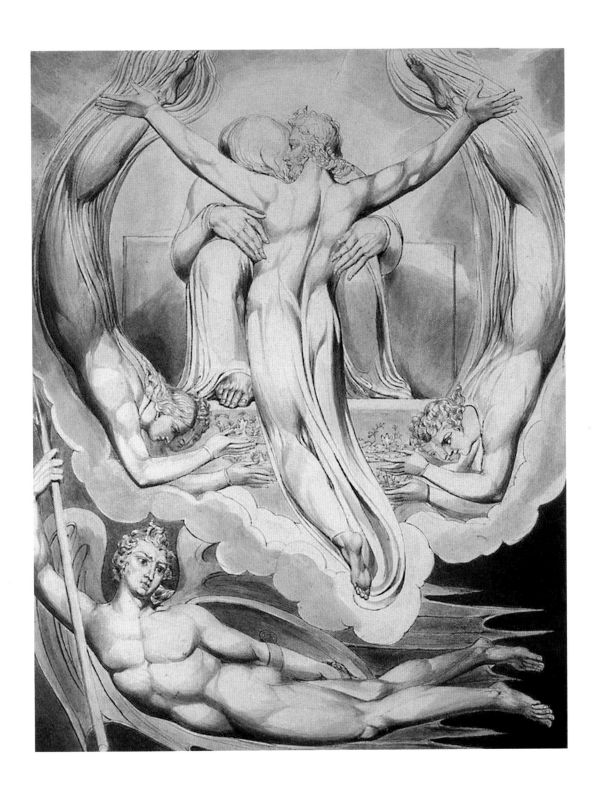

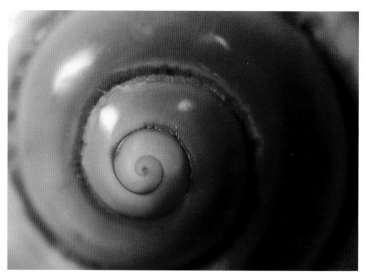

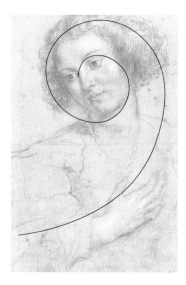

The spiral is implied in many romantic pieces of art, especially those interested in capturing emotion and movement.

OPPOSITE: PETER PAUL RUBENS, *Young Woman Looking Down* (study for the head of Saint Apollonia), 1628, black and red chalk heightened with white, 16 ⁵⁄₁₆ x 11 ¼ inches (41.4 x 28.7 cm), collection of the Galleria degli Uffizi (Florence, Italy), courtesy of Art Renewal Center

Rubens, the baroque master of motion and drama, is predominantly known for his monumental figure work. In this more intimate portrait he implies a spiral as our eyes are led through the hand toward her face.

Mark the parameters of the drawing on the page. (This can help you remember to work the whole drawing simultaneously.) Identify what you are working toward and make every line count. Focus on general, structural issues first. Keep your lines as broad and long as possible, setting the entire scaffolding first before focusing on nuances. Once you start the drawing, you are shaped by it as much as it is shaped by you.

Form one essential vision when you start your drawing that will still be evident upon completion.

When you place the first few marks of your block in, or gesture, you must state it simply and strongly enough that it remains intact through the completion of the work. This vision will help you avoid the artistic entropy that can set in when a piece is worked over an extended period. Over time, we tend to dull the gesture and clarity of our first glance as we find nuances and subtleties. Even a piece that starts off dynamic and full of life can end up stilted unless you continually refresh your first vision and make sure that your initial governing lines come through.

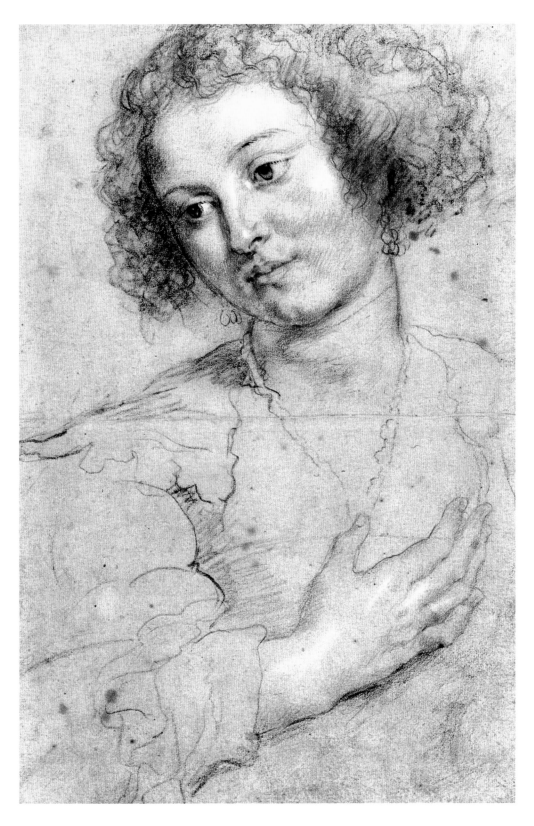

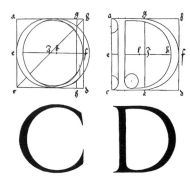

ALBRECHT DÜRER, from *A Course on the Art of Measurement*, published 1525, pen and ink on paper, size of original drawing unknown

The controlled use of the diagonal, vertical, horizontal, and arcs are applied with infinite variation to create anything we can imagine—from the letters *C* and *D* to a boat on the ocean and beyond.

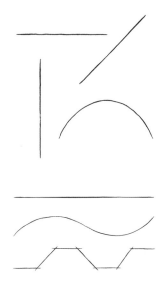

Vertical, horizontal, diagonal, and arced lines form the foundation for other more complex shapes.

The Language of Lines

Every child I meet feels comfortable drawing. When children are very young they scribble for the sheer delight of creating. As they get older, their mark making can be harnessed into consistent patterns. Many children draw a tree, for example, as an oval resting on a long rectangular trunk, or a car as a box resting on several circles. With the command of a few simple line directions— vertical, horizontal, diagonal, and arcs—they learn to write. These marks become letters of the alphabet, then words, and finally full sentences. Using these marks, they can leave a note on a table, and a person who comes in later will understand exactly what they mean. The magic of communication is born.

There is elegance and economy in the skillful application of a few line directions.

As it turns out, the same skills used to gain command of writing are also the building blocks of drawing: a mastery of fine motor skills, a sense of proportion, and a desire for communication. Children begin to write by mastering several simple angle directions, which in turn make (for speakers of the English language) twenty-six letters. These letters make, conservatively, a quarter of a million words in English alone, which in turn can fashion an infinite number of sentences. Historically, many great drawing teachers start with these same simple line directions, which can be reconfigured to form shapes, and those in turn form images. While the most sophisticated drawings go way beyond this principle, they all have to start somewhere.

After a student can form letters and write words it becomes essential to extend the range of communication through emphasis. Your writing would be very dry and confusing if you never used adjectives or punctuation. These tools help you accurately convey your meaning. In much the same way, as an artist you must vary, embellish, and punctuate your lines. To create meaningful drawings, you must learn when and how to deemphasize some information, when to exaggerate, and how to weave individual elements into a unified, meaningful whole.

Locating Important Lines

For better or worse, when looking at an object or group of objects, the human mind starts like I did in the rock shop by first identifying the obvious. So how does the artist determine which line is most important? What lines best capture the character of a particular object and enable them to be woven into relationships?

Start with a line that captures the majority of the action.

I determine which lines are most important by asking myself, "If I had only one line, where should it be placed to reflect the movement or action of the piece?" This line is often called the "line

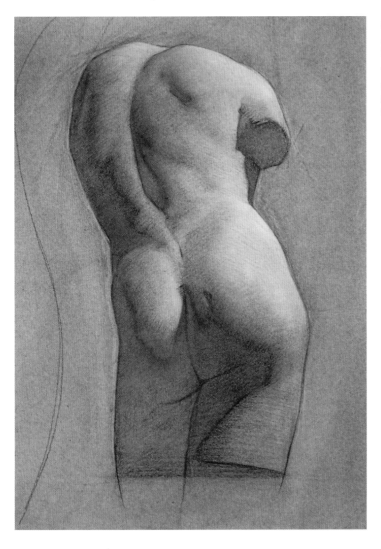

COLLEEN BARRY, cast drawing of *Eros*, 2009, charcoal on paper, 13 x 11 inches (33 x 27.9 cm)

The gesture line, or line of action, seen on the left side of the page, manages to capture the movement inherent in the finished piece.

ABOVE LEFT: This drawing sequence by atelier student Katherine Leeds starts with a single vertical line. This line shows the orientation of the sculpture and corresponds with the central weight line. Katherine used a plumb line to see where this line would fall.

ABOVE MIDDLE: Next, Katherine placed a few major line directions to show the movement of the figure. These lines of perception are felt, but they do not actually exist in the figure. In addition, she visually reinforced the initial central weight line along the base of the cast and the small of the figure's back.

ABOVE RIGHT: KATHERINE LEEDS, *Male Torso,* 2010, charcoal on paper, 16 x 12 inches (40.6 x 30.5 cm), courtesy of the Aristides Atelier

To complete the work, Katherine created a number of smaller angle changes. Notice how these correspond to the larger line directions in the previous image. Those initial governing lines dictate much of the gesture and feeling of this image.

of action." It is helpful to think of this first mark as a sentence or two that summarizes a whole book. The line of action establishes the theme of the work. Because the simplest angles and arcs often account for the majority of the action, beginning with a dominant line direction can create the clarity of a single voice, and in so doing will unify the piece.

The mark does not have to be perfectly placed, just a best guess. As you add additional lines that repeat this original angle and echo this first sentiment, the drawing becomes reinforced, strengthened, and cohesive. The additional lines add emphasis, focus, and rhythm. The clarity of a reinforced series of line directions becomes a forceful visual statement.

Give careful consideration to your first few marks—the rest of your drawing hangs on this structure.

Yet repetition alone runs the risk of monotony. Therefore, once you establish the main theme and build upon it, you must introduce countering angles or arcs, building the drawing up one line at a time. A crossing line often dramatically extends the range of expression. Introducing this new angle direction further describes the subject without diminishing the power of line of action.

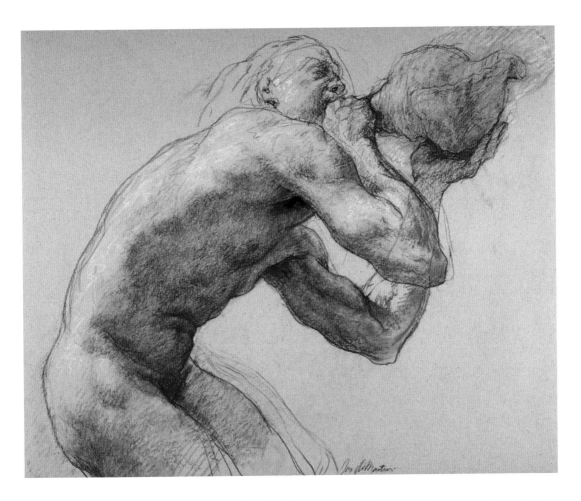

Harmony in a drawing requires the interplay of both sameness and difference; repeated themes with opposing variation account for the liveliness of a work.

As the artist Jacob Collins said, "A master sketch is always unified at every stage." Often beginners make the mistake of working on a single part so intently that they forget the rest of the piece. For example, they might place the head and chest of a figure while forgetting the hands and feet. Creating a coherent gesture and block in offsets this tendency. Working with the large movements of straights and curves ensures from the beginning that no part ever gets ahead of the whole.

JON DEMARTIN, *Triton*, 2002, red and white chalk on paper, 18 x 24 inches (45.7 x 61 cm)

DeMartin captures a figure in action with curved lines that appear to pulsate with energy.

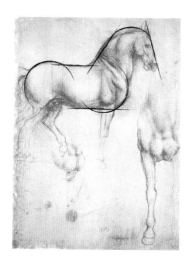

Da Vinci's curves are created with restraint. They push outward, implying the fullness of the muscle mass.

LEONARDO DA VINCI, *Study of Horses*, 1490, silverpoint on prepared paper, 9 ⅞ x 7 ⅜ inches (25 x 18.7 cm), collection of the Royal Library at Windsor Castle (London, United Kingdom), courtesy of Art Renewal Center

The alternating straight and curved lines along the contours of the back and the belly of the horse create a strong sense of rhythm.

OPPOSITE: CHRISTIAN SCHUSSELE, *Iron Works*, date unknown, graphite and black ink wash on green-gray wove paper, 6 ¼ x 12 ⅝ inches (15.2 x 32.8 cm), Pennsylvania Academy of the Fine Arts (Philadelphia, PA), The John S. Phillips Collection

This nineteenth-century artist's drawing is predominantly composed of lines. The straight line is emblematic of our manmade world, perfectly suited for representing workers at their press.

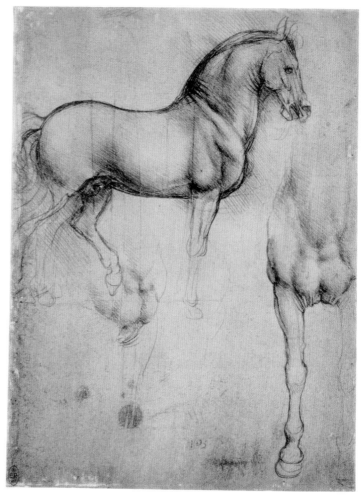

Different Kinds of Lines

There is no way to copy all the information we see with our eyes, even if that were our goal. In drawing, we are forced to distill. Lines are our best weapon in this effort. For while lines, in their

Use straight lines to link individual elements into a coherent visual whole.

simplest form, are just a series of points going in a particular direction, they also have the power to send the eye and mind along a particular path of movement. Straight and curved lines play different but equally important roles in conveying this visual information.

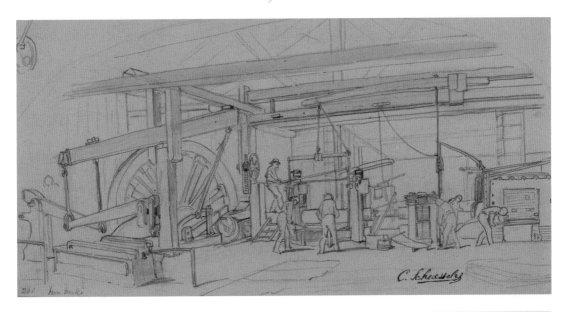

Straight Lines

Straight lines serve as the artist's shorthand and ensure that the larger issues are considered before more nuanced ones. Straight lines are measurable directional angles that efficiently convey a great deal of general information with a minimum amount of effort. A straight line has an unfinished quality; it reads as a first thought, a reminder that this is just an estimate to be finessed at a later time. But these beginning, unfinished lines can link individual elements into a coherent visual whole. Strength of composition comes from these interlocking shapes and angles.

Curved Lines

In contrast to straight lines, curved lines reflect the growth, unpredictability, and fluidity found in nature, and as such they are responsible for the animation of a work of art. Many uncontrolled curves give the appearance of exuberant emotionality, often conveying more

Curves mirror the growth and fluidity found in nature.

effervescence than precision. A curved line tends to feel complete even if it is not accurate, making it difficult to find and correct errors as the drawing progresses. While essential, curves are notoriously hard to judge accurately, so I tend to use them judiciously—especially at the beginning of a drawing.

ALBRECHT DÜRER, *Dürer's Wife, Agnes Frey,* circa 1494, pen on paper, 6 1/8 x 3 7/8 inches (15.6 x 9.8 cm), collection of Albertina, Graphische Sammlung (Vienna, Austria), courtesy of Art Renewal Center

For an artist who so loved the analytical process, it is wonderful to see this playful drawing of his wife. Not a straight line to be found.

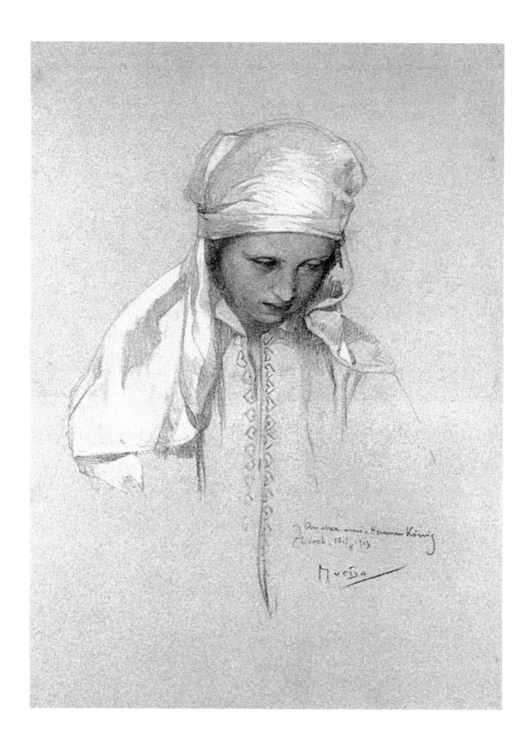

Be Flexible and Go Lightly

Before you begin drawing, it is important to remember that flexibility in the beginning stage of a drawing is key. The first few marks of an artist's drawing are often quite general, or broadly placed. However, that does not mean they are inaccurate.

Go lightly and slowly at first, extending the beginning stage as long as possible.

If you asked me how to get to Seattle from New York City, I would be correct in saying, "Go west." But if I tried to be more specific without yet knowing my facts and told you to "take a right and two lefts," I would be incorrect. You are better off giving a broad directional mark that you know will be truthful even if it is very unspecific. This way you can refine your information over time.

One of the most immediate things beginners can do to improve their work is to draw lightly. When a student gets too dark right away, it creates an emphatic statement, essentially saying, "I know I am right." This presumption is bad for the work. An artist who starts off too dark and specific in their work will find their drawing finished long before they intended and not know how to go back. Furthermore, it is often difficult to erase heavy beginning lines.

The longer the drawing remains open the greater the likelihood of obtaining accuracy.

Often, the more experience an artist has is reflected in how lightly and slowly he or she goes when beginning a drawing. The experienced artist knows that the longer the drawing is kept flexible or open, the more the accuracy can increase over time. This means make your lines light and thin. It is better to leave an area blank than to fill it in with a wild guess. When you draw lightly and purposefully with grace you will be pleased with the results. As you practice, your hand will become accustomed to finding good drawing decisions, and beginning lightly and accurately will become effortless and instinctual over time.

The pencil point just barely touches the surface of the page. The weight of the hand rests on the pinkie for balance; other artists use a mahl stick (a dowel with padding at the top) for the same purpose.

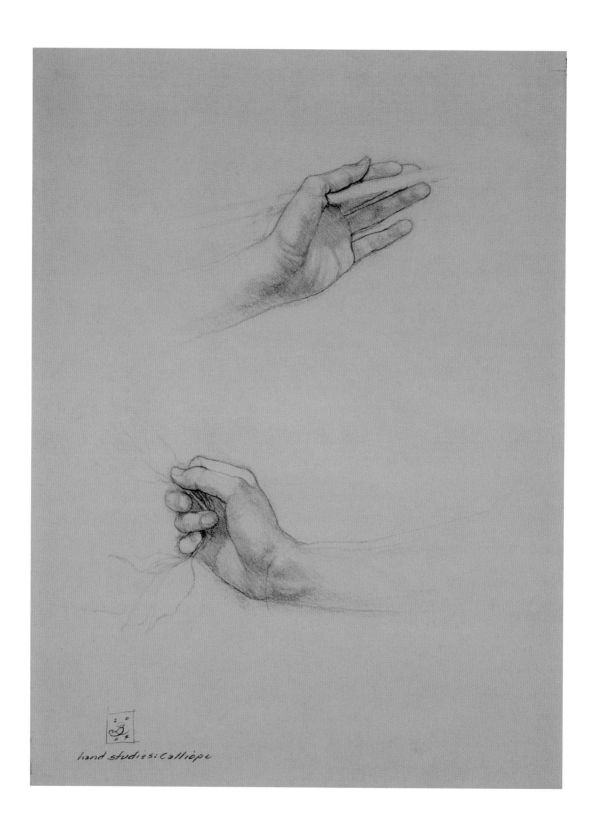

hand studies: Calliope

THE MATERIALS NEEDED FOR DRAWING are simple and inexpensive. Basically, you need something to draw with and something to draw on. Any art store will invariably contain a bewildering array of artist's materials. It is easy to buy too much or get overwhelmed and leave with nothing at all. Don't let materials stand in your way: All you need for any of the lessons in this book are a pencil and paper. The most important outcome of a drawing education remains having an understanding of the principles and being able to implement the ideas.

At a minimum, I recommend using a very sharp pencil (preferably an HB graphite pencil), white drawing paper (around 11 x 14 inches or 28 x 35.5 cm), and an eraser. From here you can start to experiment and see what drawing materials work best for you. It is best to avoid pencils that leave lines that are dark and thick, making them difficult to erase. Each lesson in this book begins with a suggested materials list. Feel free to adapt these as you see fit. Don't wait until you have the perfect materials to get started. Masterful drawing can be done with a ballpoint pen and a piece of paper at the kitchen table, if all else fails.

I discuss these materials—and many others—at length on my website, **www.aristidesatelier.com.** The website is updated to reflect the changing availability of certain art supplies. It also contains detailed discussions related to such things as sharpening charcoal, comparing different types of papers, and so forth. Additional information about drawing materials also appears in my previous book, *Classical Drawing Atelier: A Contemporary Guide to Traditional Studio Practice.*

Here we see the artist's toolbox, sharpened graphite pencils, a blade, and sandpaper.

OPPOSITE: BEN LONG, *Hand Studies for Calliope*, 2003, graphite on paper, 15 x 11 inches (38.1 x 27.9 cm), courtesy of the Ann Long Gallery, Charleston, South Carolina

This drawing shows how much warmth and personality can be captured with the searching lines of a pencil. It lures us while never raising its voice above a whisper.

LESSON 1 MASTER COPY SKETCH

THE OBJECTIVE OF THIS EXERCISE is to become familiar with governing lines and directions. The practice of copying masterworks has helped train some of the greatest artists who have ever lived. You want to begin to answer the following questions: What lines do I believe are essential for the unity of the piece? Which lines make the work more dynamic? Training your eye to see governing lines in finished drawings will help you begin to see them in life.

GATHERING YOUR MATERIALS

In preparation for your master copy sketch, assemble the following materials:

A master drawing*
Tracing paper
Artist's tape
Graphite pencil
Drawing board
Drawing paper
Pencil sharpener
Kneaded or hard eraser

*This image may be photocopied from a book or printed out from one of the many online sources, such as the Art Renewal Center's online museum (artrenewal.com).

SELECTING YOUR MASTER DRAWING

When I choose a drawing, I look for certain criteria. First, it needs to be a drawing I really love to look at. Second, I choose works that are masterpieces, so that I know I will get an education when studying them. Finally, I try and find works with a clear gesture or strong directional lines. The Michelangelo drawing that I use to illustrate this demo fits all three of my requirements. (The original appears on page 116.) If a drawing has survived the ages, usually something can be learned from it.

FINDING THE LINE DIRECTIONS

Attach the tracing paper to the photocopy or printout with removable artist's tape, making sure that both papers are steady. Using your pencil and drawing directly on the tracing paper, find the major gesture and line directions. An example of this process can be seen on pages 24–25.

SETTING UP YOUR DRAWING

Tape your photocopy or printout to one side of your firm drawing surface. Then tape your piece of drawing paper next to the drawing. Ideally, the drawing you create will be the same size as the original, so you can flick your eye quickly and easily between the two images, as well as check measurements against the original. You might also want to pad your paper, meaning tape several sheets down so the surface has a bit of cushion.

EXECUTING YOUR MASTER COPY SKETCH

Squint down and see if there is an overall gesture to the image. Sometimes it takes a minute or two of looking before a pattern starts to emerge. As you work, the drawing will tell you if you are correct or not because your best guesses will either be plausible or look a little off. Keep in mind that if your solution is not beautiful, it is unlikely to be true. When these things come together there is a simplicity and beauty even in a few lines.

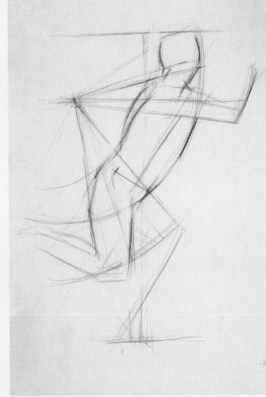

STAGE ONE: Mark lines at the top and bottom to dictate the scale of the drawing. Then articulate the action line of the image. In this image, a vertical weight line and several arcs serve this purpose.

STAGE TWO: Place a few governing lines to get an overall shape to the gesture. In this image, an ovoid shape for the rib cage and an additional arc to capture the tip of the body achieve this goal.

STAGE ONE: *Identifying the Action Line*

Take a best guess at a single angle direction to see if you can account for some of the movement of the work. It can go straight down the center or through forms from the top of the drawing to the bottom. Right now you are a detective just looking for clues, trying different theories to see which ones work. Sometimes it is not possible to find one single angle direction, in which case just use the minimum necessary to account for the facts.

STAGE TWO: *Locating Repeating Lines*

After you find one plausible line, see where that line is repeated. It can be repeated in small areas or big ones. See how many times you can find that one angle direction. Follow it on a trail as it starts somewhere, dissolves, and then reappears elsewhere. Not all lines will repeat. Some will radiate, as seen in the drawing above. I recommend bringing numerous master copy analyses no farther than this degree of finish, so you can practice many of them rather than perfecting one or two.

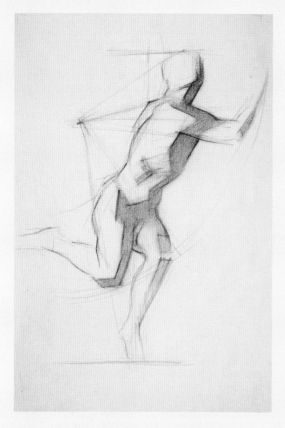

STAGE THREE: Formalize the lines into coherent shapes so that your drawing more closely resembles the original drawing.

STAGE FOUR: Tone the large planes of shadow to separate them from the light shapes. Accent some of the edges to give them greater importance.

STAGE THREE: *Establishing Coherent Shapes*

Begin to formalize individual lines into coherent shapes. A drawing can come together quite quickly at this stage if the initial lines are well placed. Once you have located the shapes it becomes easy to determine if the drawing is working or if the proportion or gesture is off in some way. The initial structural lines and gestures provide the strength and the bones of the work. Take your time in positioning the shadow shapes and formally stating the large planes of the body, and correct inaccuracies along the way.

OPPOSITE: JENNIFER BAKER, copy after Charles Bargue's *Jeune Fille Italienne*, 2009, sepia pastel on paper, 13 ½ x 10 inches (34.3 x 25.4 cm)

This is an example of a finished master copy drawing, part of the atelier first-year curriculum.

STAGE FOUR: *Articulating the Basic Gesture*

When you are comfortable finding these first few lines, practice developing the drawing a little further. Then start applying what you have learned when working from life. You can try it when working from the model in a life class and at home from still life setups. It is important to make the bridge from the theory found in master drawings to the application in your own work.

For further study, consult Charles Bargue and Jean-Leon Gérôme's *Drawing Course*. This in-depth course is based on the practice of master copying and includes a progression of plates to work from.

ABOVE: JULIETTE ARISTIDES, master copy sketch after Michelangelo Buonarroti's *Study for Battle of Casina*, 2011, Conté pencil on paper, 24 x 18 inches (61 x45.7 cm)

CHAPTER 2 HARMONIOUS RELATIONSHIPS:
A STUDY OF PROPORTION

It is very certain that no one was ever born with genius that could grasp instinctively, and all at once, the first principles of art. All have learned, and all must learn, to draw.

—JOHN GADSPY CHAPMAN (from *The American Drawing Book*)

In art, harmony refers to the proportional relationships between parts—the perfect balance between diverse elements. Most people have an innate sense of harmony without ever having formally studied the subject. We are intrinsically sensitive to well-balanced parts because we live in an ordered, natural environment where we recognize the symmetry in a person's face, for instance, or experience the rhythm of the seasons over the course of a year. We sense an order in the very build of our bodies, the way our fingers relate to our hand, the hand relates to the arm, and so forth. Often, we instinctively feel this rightness without consciously identifying it.

Harmony occurs when the different-size parts relate to each other and to the whole in a similar and balanced way. Because good proportion feels natural, we often notice it only when a problem arises. For example, my brother—who has never studied art and never willingly spent an afternoon in a museum—can easily give me a valid critique of my figure work, particularly when an unintentional distortion in the features makes something look unnatural.

It is one thing to see proportion clearly; it is another thing entirely to create great art. Even the most competent artists need much practice and training to achieve consistent proportion. Fortunately, you do not have to reinvent the wheel. Many artistic disciplines, from architecture to fashion drawing, are inseparably connected to the study of proportion, largely because it contributes to the success of any work of art. This study has been historically pursued two ways—by carefully observing nature or by following tenets laid out by expert practitioners.

CLAUDIA RILLING, *Self-portrait*, 2003, charcoal pencil on paper, 15 15/16 x 11 15/16 inches (40.6 x 30.4 cm), courtesy of the Barnstone Studios

The artist has run lines throughout the head so every angle relates to another part of the drawing. See how many repeating angles you can find.

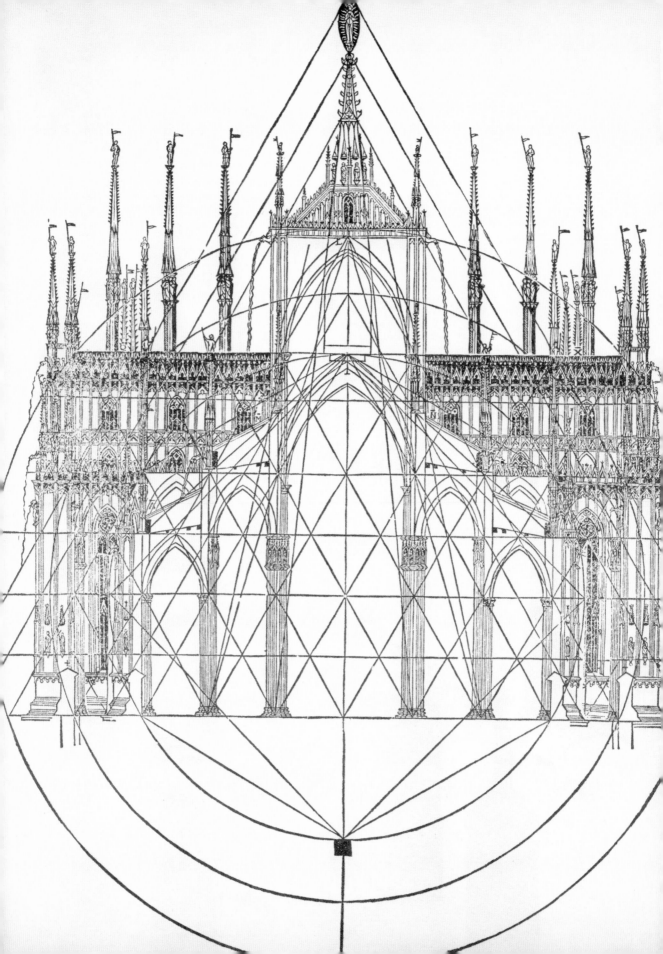

Learning from Nature

In the study of harmony, artists have looked for millennia to nature to build on a thread of knowledge. Ancient Greek architects related each element of their buildings to one another in much the same way the human body is designed. Each part has an individual integrity that nevertheless relates perfectly to the whole. Artists such as Albrecht Dürer, Filippo Brunelleschi, and Piero della Francesca studied the natural world so intensely that they pushed the boundaries of knowledge and advanced many fields. Through close study of the natural world, artists throughout history have discovered that nature conforms to certain rules and patterns that can be translated into methods useful for art, science, and design.

Nature remains the greatest teacher of all and is the first source of artistic knowledge.

Scholars have noted that Leonardo da Vinci used a similar proportional system in both his anatomical dissections and his architectural drawings. Pietro C. Marani, author of *Leonardo da Vinci: The Complete Paintings*, wrote, "Leonardo's definition of the human body in terms of proportional relationships gave him a mathematically measureable, secure foundation for the translation of the figure into artistic representation, based not only on observation, but on underlying laws of harmony and beauty."

The Renaissance tradition of blending studious observation of the visible world with an interest in the design systems of classical art remains alive and well. Many contemporary artists value the surprising beauty and efficient design found in nature and want to incorporate it into their own work. We can learn a great deal about the Western artistic tradition by using similar means.

LEFT: UNKNOWN PRIX DE ROME ARCHITECTURE STUDENT, *Chapiteau Antique, Rome*, 1903, pencil on paper, size unknown

The designs of nature have worked their way into the proportional systems of artists and are an invaluable source of imagery for architects and designers.

OPPOSITE: DEAN SNYDER, *Cathedral*, 1972, ink on paper, 11 x 8 ½ inches (27.9 x 21.6 cm)

The artist analyzes the façade of a cathedral using circles and triangles. This orderly substructure of geometry lends a unity and cohesiveness between parts and the whole.

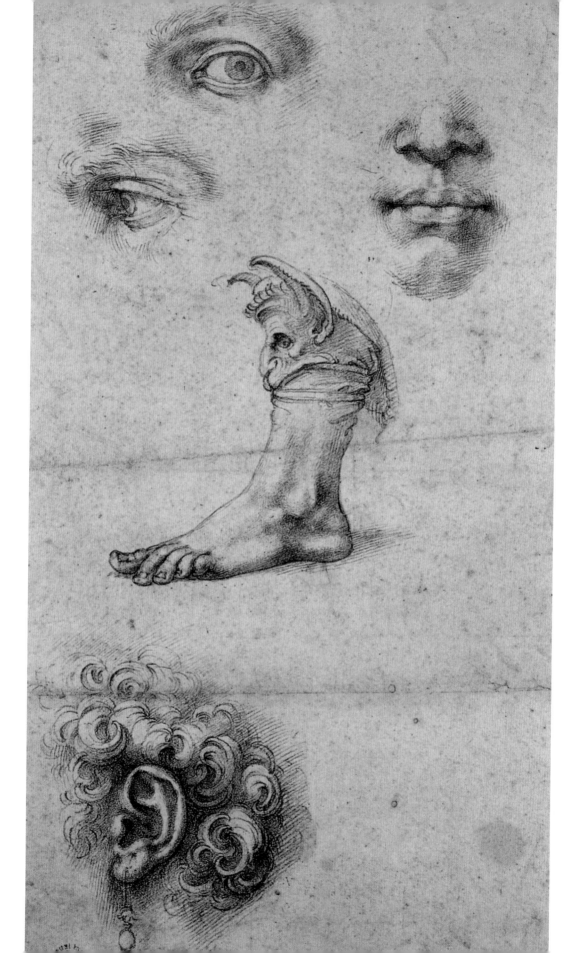

The Artist's Schema

In the past it was common to draw according to convention. Drawing templates of animals, plants, and figures flourished. Artists learned to copy an ideal image, and from that they could choose to amend it by direct observation from life.

Take the time to memorize a few simple proportional rules for figure and portrait.

From the early days of art history through Victorian times, budding art students practiced traditional canons of such things as eyes and ears, in various positions, until they were known by heart. (Place a single line above and below, add a circle, tone in some hatching, and presto . . . a convincing feature.) Today such a process is unthinkable for the fine artist. Gone are the days when schools trained fine art students to draw by memorization. Why this kind of drawing fell out of favor is a complex and varied topic, but needless to say there was a change of taste.

OPPOSITE: BENVENUTO CELLINI, *Five Studies*, date unknown, pencil on paper, size unknown

Historically, it was not uncommon to spend considerable time studying each individual element of a figure to fully understand it. This was certainly the case during the Renaissance, when Cellini came of age.

This drawing is a copy of an illustration from an early American children's drawing book. The eye is constructed around a triangle.

LEFT: ALBRECHT DÜRER, from *Vier Bücher von menschlicher Proportion*, published 1528, pen and ink on paper, size of original drawing unknown

Albrect Dürer, with a true Renaissance love of knowledge, did countless studies of ideal proportion, which he used as an underpinning for his masterful work.

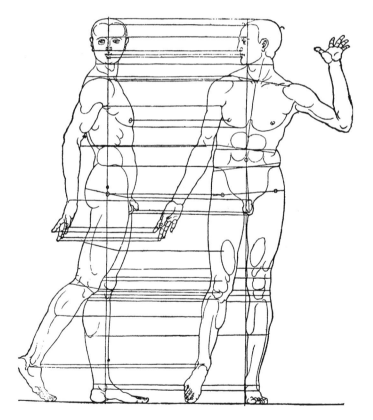

The figure is subdivided into seven and a half head lengths. Each of those points hits a memorable landmark. These measurements apply only to a figure viewed straight on, not at an angle.

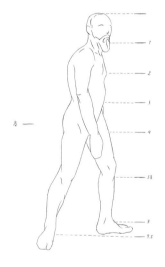

This rule of thumb creates useful points of comparison to relate with the actual model. Never force your drawing into these regular markers, yet you will be surprised by how consistently accurate they are.

Many of the greatest artists of the past and present have studied rules of proportion in depth. Some Renaissance and Baroque artists not only memorized the formulas handed down by their predecessors, but they also studied countless models from life to exact consistent rules that feel universal in application. Da Vinci, Dürer, Poussin, Rubens, and many others compiled sketchbooks on human proportion with the study of antique design systems. These notebooks are beautiful works in and of themselves, as seen on the facing page. They give us clues as to how these master artists were trained.

By learning these rules, you can quickly solve artistic problems, use convincing shorthand, and recognize how your subject departs from the expected. These schemas provide a strong substructure on which you can build an original drawing. In time, you will see how some of these schemas work in real life. Of course, there will be deviations, but the rules provide an outstanding starting point.

The downside of using formulas is obvious: If you rely upon them too heavily, your work can feel unobserved and formulaic. The upside, however, is that you will often be more accurate. Plus, when used carefully and thoughtfully, formulas can be a gateway to more careful observation from life. Artistic canons can perfectly bridge the world of the mind—the universals—and the world of the particular—the observed. To the left are some commonly accepted proportional formulas for the figure.

Remember that your schema should adjust to the model, rather than your model adapt to your ideal.

Standard divisions of the figure and portrait can be found in most drawing books. A common unit of measure for the figure is head lengths (or head widths). In most cases, it is one head length down to the nipples and two head lengths to the navel. The halfway point on the body is usually at the pubic bone. The full height of a body is generally seven and a half head lengths. The bone of the upper arm is typically one and a half head lengths. The bone of the thigh measures two head lengths, and the lower bone nearly one and a half head lengths.

Portrait drawing offers another opportunity to use structural landmarks to your advantage. Just as with the body, reliable relationships between the parts of the face will help you to accurately measure the whole. For instance, the halfway point of the head, the

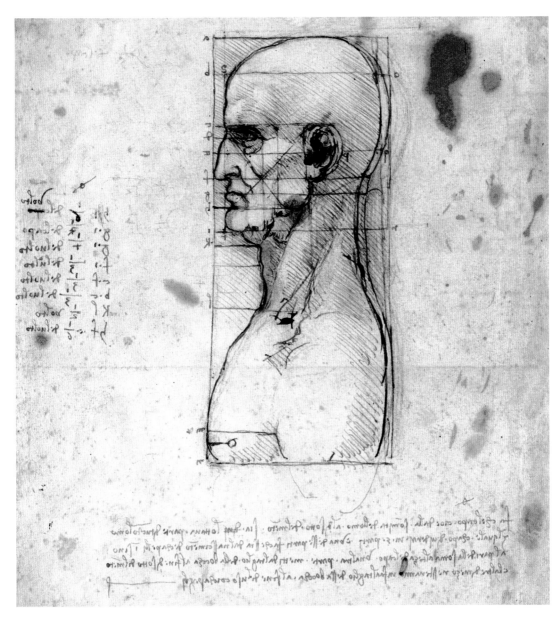

LEONARDO DA VINCI, *Male Head
in Profile with Proportions,* circa 1490,
pen and ink on paper, 11 x 8 ¾ inches
(27.9 x 22.2 cm), collection of Gallerie
dell'Accademia (Venice, Italy)

Da Vinci carefully constructed the head
inside a square and used it as a unit
of measurement. Within the square he
related each part of the head to another
by running his angles through. See how
many of these intersections you can find.

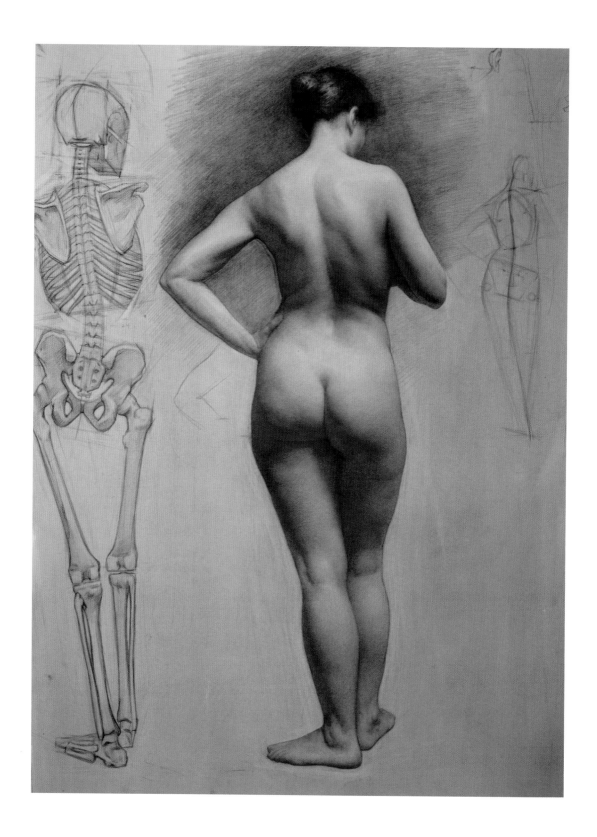

centerline, runs through the eyes. The mask of the face breaks down into thirds—from chin to just under the nose, from nose to brow line, and from the brow line to the hairline. The eyes tend to be one eye width apart. In a front-facing position, the entire width of the face across the temples is generally five eye widths, and the width of the base of the nose is an eye length. For these measurements to be useful you have to be eye level with the model; if the model is foreshortened, they do not hold.

Of course, these universal similarities do not preclude individuality. Ideal proportions provide only a benchmark to check against your subject. They help us see where our subject departs from the norm, because unless we know what to expect, we cannot recognize how something is different.

Finding Visual Landmarks

Landmarks are easily recognizable features used to help you navigate your position in an area or an object—whether you are driving or drawing. These clearly delineated areas help you identify where you are in relationship to where you are going. The markers can be universally agreed upon (such as eyes, hips, and shoulders in anatomy) or self-invented (such as a knot in the wood midway across a table).

Necessity demands that we distill the complex visual world into things that can be efficiently grasped. Because of our practical need to name the things we see, we tend to be object oriented. It is cumbersome for me to say, "Please bring me the blackish, shiny, hard object with the blue-violet reflection on the uppermost rim and the four legs that at this moment look like *X*s because of the perspective," when what I really mean is, "Please bring me a chair." Yet most visual landmarks are not objects, or even things with names that we know. They are markers that stand out because of a tonal change, a color change, a texture difference, or an edge.

Draw from an artist's anatomy book to become familiar with drawing shorthand for universal forms.

With that in mind, anything can become fair game for use as an important visual landmark. Furthermore, the process of looking for landmarks can be streamlined, especially if you know where to look. Artists study anatomy because it helps them conceptualize complex parts of the body in manageable ways and enables the easy identification of landmarks. (Several great books on the subject, such as Eliot Goldfinger's *Human Anatomy for Artists*, are listed in the bibliography.) Landmarks found in other subjects, such as landscapes or still lifes, can be anything visually noteworthy. Any part of your subject that stands out clearly is useful as a point to measure against.

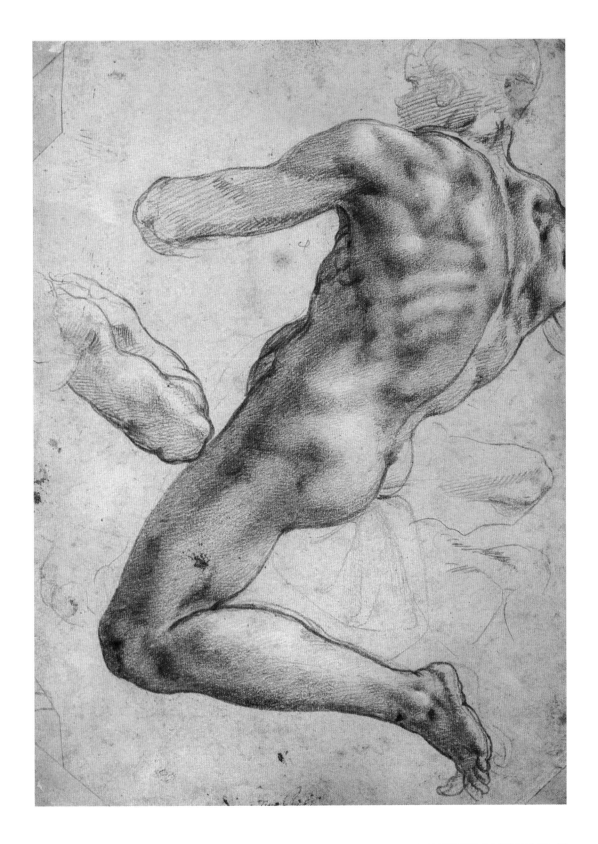

This paper, which is divided into quarters, can be held up and compared with the object or person you are drawing.

The artist is holding up the knitting needle, measuring and siting the size of the sculpture's head.

Learning to Measure

The systems of measuring discovered by master artists help us deconstruct what we see, study divisions of space, and sharpen our observational accuracy. Measuring is a way to double-check your first instincts. It exposes your emotions to the cold light of reason and enables you to extend your accuracy beyond what comes naturally.

Make a habit of accuracy, such as finding a few large measurements in your drawing right from the beginning.

The traditional methods of measuring—using a thin knitting needle or a plumb line or siting angles—are discussed below, but as an artist, I am continually brushing up against the vastness of the field. Several months ago I was in the archives of the Pennsylvania Academy of the Fine Arts with curator Barbara Katus. As we looked at the art we talked. Barbara mentioned a deceptively simple method for measuring accurately taught to her by her instructor. First, select a piece of paper big enough to cover your view of the object and fold it into quarters as illustrated. Then, hold the paper so that it aligns with your view with the subject, matching the top and bottom points by moving the paper either closer to you or further away. Take note of where it breaks into fourths. Mark your drawing paper accordingly with light lines that form the quarters you have observed and then simply compare between the two as you work. I had never heard of this easy and accurate way of measuring. This experience, however, reminded me that there are many helpful ways to measure and that, essentially, good measuring depends on a reliable system of comparisons.

Measuring with a Knitting Needle

Artists employ many self-correction methods. A process that I use in my own studio involves a knitting needle (or skewer or pencil)—the thinner and straighter the better. Hold your arm outstretched, elbow straight, close one eye, and place your thumb against your needle to mark off your unit of measure. Then, while maintaining your body position and your measure on the needle, either rotate the needle to check for widths or move it vertically to check for heights. You are looking for such things as the halfway marker of an object or how many units high or wide something appears. For example, the distance from one shoulder to another in a figure viewed straight on is typically about two head lengths. This technique can be especially useful for long horizontal subjects when it is difficult to guess accurately.

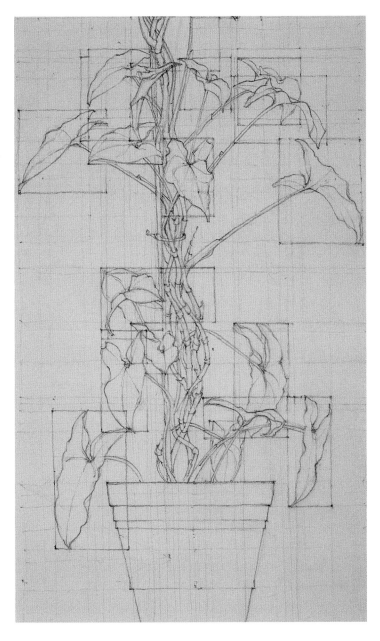

RUDI ELERT, *Measured Plant*, 2003, Conté pencil on paper, 17 x 9 inches (43.2 x 22.9 cm), courtesy of the Barnstone Studios

In this drawing the notional space of each leaf has been measured and all the horizontal and vertical relationships plotted. The result is an intellectually satisfying study of a plant. Attribute accuracy to one unit and use it as your standard of measure throughout the work.

Checking how things align horizontally and vertically catches many hidden errors. As such, measurements can offer a solid beginning for your drawing, but they are not foolproof. Many things can affect the accuracy of your measurements. If you inadvertently bend your arm or tip the needle away from you, your relationships will not be accurate. Not being stationary will also affect you, as will not being consistent with which eye you are using for measuring. So stand still and keep your elbow locked straight and your needle at

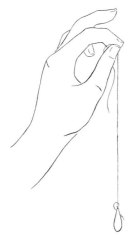

The artist's plumb line is a thin piece of thread with a weight at the end used to test true verticals.

JULIETTE ARISTIDES, copy after Peter Paul Rubens's drawings and annotations from *Theory of the Human Figure* (detail), 2010, walnut ink on paper, 12 x 9 inches (30.5 x 22.9 cm)

Rubens and Poussin had many pages in their sketchbooks showing the vertical weight line running through the figure. This imaginary line finds the center of the figure's gravity.

90 degrees to your body. Be careful to stand far enough away from your subject; if you are too close, your ability to see relationships across your whole subject will be limited. (A good rule of thumb is to stand back a distance of three times the height of your drawing.) And finally, keep in mind that big measurements (like the halfway point or quarters) are safer bets than tiny ones (like eye widths), which have a greater margin for error.

One of the biggest dangers of measuring is that it gives the appearance of fact. A false self-confidence can make a student insist on keeping something that is obviously wrong because "it measured correctly." Let the instincts of your eye trump any measuring you do. More often than not, if it looks wrong, it is wrong. Be open to making adjustments. Make sure you approach measuring with a willingness to see mistakes versus a desire to prove yourself right. Finding errors is a good thing, because it affords an opportunity for growth.

Using a Plumb Line

Commonly used since ancient Egypt, a plumb line is a weighted string used to check a true vertical. In my studio, I make plumb lines from thin black sewing thread with a weight on the end. The weight can be anything really; I have seen artists use fishing weights, bolts, even a tiny rubber chicken. Anything your personal dignity will allow is fine, as long as it is heavy enough to hold your line straight without swaying endlessly. Some people put a dowel along their easel (parallel to the floor) and loop their plumb line to it so that it hangs straight and they don't have to hold it.

Measuring double-checks your first instinct, revealing what can be improved.

To use a plumb line you simply look through one eye to check what forms intersect with the line. For example, when I align in my view the string against the side of a model's head it appears to intersect with the pit of the arm and the inside of the foot. The more forms you correctly line up in your drawing, the more it will hold together as a unified image.

This method of checking alignment has been used by many master artists. Once, when I was taking a tour through the Royal Academy in London, I noticed some metal grids attached to the ceiling. My guide explained that John Singer Sargent used them to attach plumb lines, which would then hang down around the model (eliminating the need for individual artists to hold their own plumb lines). I have also seen a centerline used to mark the weight, or gravity, of the pose. The sketchbooks of Poussin and Rubens

contain many drawings with a vertical weight line that runs from the top to the bottom of their figures. This line shows the figure correctly oriented to this imaginary center of gravity that keeps them feeling upright and balanced.

Siting Angles

We have talked about the importance of using vertical plumb lines to establish correct placement and alignment. Horizontal lines (which, as discussed, can be determined with a knitting needle or similar long, straight object) are equally essential. Now we are

Consistently apply sound drawing principles such as measuring and checking angles until you are so accurate it becomes unnecessary.

looking for angles and concurrences. Once you have checked your drawing for vertical relationships, locked in horizontal alignments, and confirmed everything diagonally, you can be confident you're on the right track.

BRETT DOWNEY, copy after Charles Bargue's *Young Woman, Life Cast,* 2008, charcoal on paper, 16 x 28 inches (40.6 x 71.1 cm)

This master copy of a Bargue plate, designed to train nineteenth-century art students, shows how simplified angles provide an accurate substructure for the finished image.

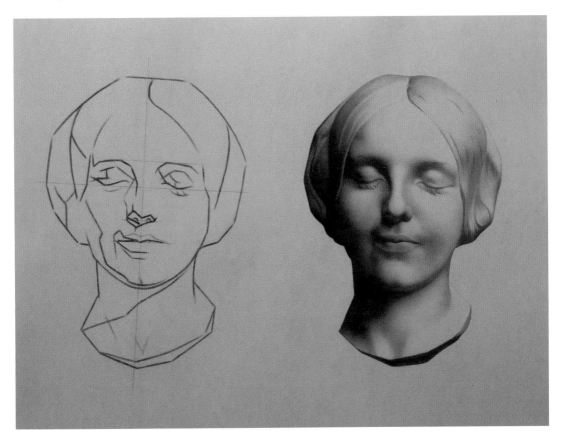

This drawing sequence by atelier student Bobby DiTrani shows the parameters of the skull. This first step features a light block in, with the halfway points marked. He used a knitting needle to simplify the angles around the skull. (The notional space is the rectangle formed around an object when you find its height and width. Imagine the notional space as being a clear glass box that perfectly fits around your object.)

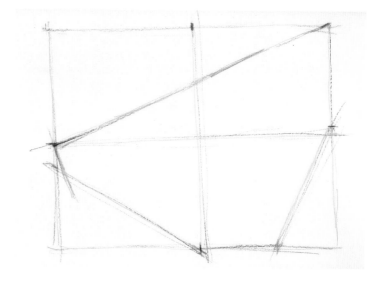

Next, Bobby transitioned angles with a few gentle arcs, accenting key lines to bring them forward in importance and breaking up large angles into smaller shapes.

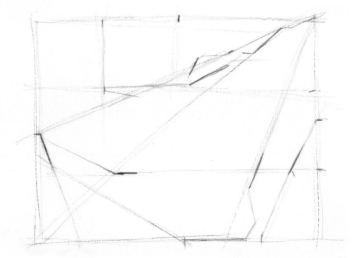

Siting angles helps you assess the degree of tilt in a particular line. It is surprising how tiny overstatements in tilts will cumulatively throw off your measurements and, ultimately, the overall proportion. A true vertical can help you determine how far an angle tilts in relation to that point. For example, by comparing an angle within the subject to the true vertical of your plumb line, you can see if the angle is tipped into or away from that line and to what degree.

The process of siting angles also involves triangulating key points on your subject. *Triangulation* is a term used in surveying and math, where two known points are used to find an unknown one. When you place one point you can assume it is accurate until shown otherwise. When you place a second point you establish a relationship. When you place the third point you lock in the shape.

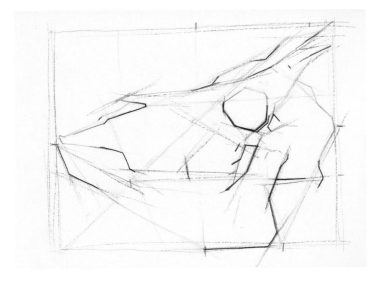

Then, he identified some of the critical angles, defining the overall gesture and proportions. He ran his angles through to formalize the placement of the rest of the skull.

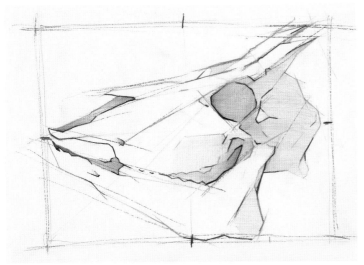

BOBBY DITRANI, *Block In of Skull*, 2010, charcoal on paper, 18 x 24 inches (45.7 x 61 cm), courtesy of the Aristides Atelier

To complete the work, Bobby erased the construction lines and placed an even tone to separate the lights from the darks.

In drawing we are always working from known elements to find unknown elements. It's important to understand what has been confirmed and what hasn't, so your drawing will develop in a positive way. Remember that things are only right or wrong in relation

Relational seeing helps integrate parts of the drawing into a stronger whole.

to other points. If all the points are found in relative correctness to what is around them, then the overall effect should be one of accuracy. Go slow and be thorough in checking these points against one another. See what type of triangle is formed when you connect three points in your mind. This is a great way to fend off early mistakes.

These two students are working from the same cast at the Angel Academy in Florence, Italy. Notice that the drawings are positioned adjacent to the cast; the artists stand back to look and walk up to draw.

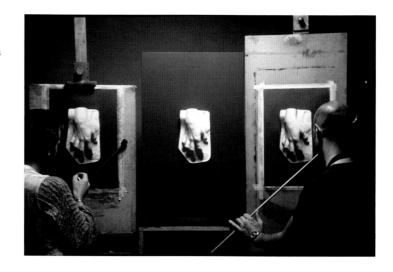

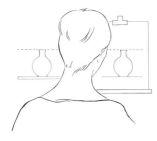

With the sight-size method, the artist's standing position lies between the still tlife and her easel. She can look back and forth to compare the two.

Understanding the Sight-Size Method

As a student I studied at the Atelier Studio Program of Fine Art in Minneapolis, with teachers Syd Wicker and Dale Redpath, where they taught a time-tested way of measuring called "sight size." This method allows for a direct comparison between your subject and your drawing. The studio configuration is such that from the artist's vantage point, the subject and drawing appear to be the same size.

It is easy to forget that objects often appear to our eye much smaller than they really are because of the distance between us. Try this: Take your knitting needle, hold it up to an object far away from you, and measure the size of the object. I am doing this now by measuring the height of a glass at the far end of the table where I am sitting. The glass measures about 1 ½ inches. I know the glass is really about 8 inches, yet to my eye it is 1 ½ inches, so that is its sight size.

When I draw normally, using comparative measurements, I am rendering the object several times larger than I see it. This makes things more difficult because I am trying to accurately draw it while also enlarging it. The advantage of drawing things at sight size is that you do not have to scale your image: The drawing and the object are the same size. This avoids the unintentional inaccuracies and distortions that are so easy to make because you can directly compare your image to your subject. Think of children's picture puzzles in which the challenge is to find the five things that are different in two side-by-side, nearly identical images.

The sight-size method can be adapted depending on the size you want your drawing to be. If you want your drawing to be the

same size as your subject, then place an easel with your drawing paper directly next to your subject so that the two are side by side, as pictured here.

When setting up your sight-size drawing, the recommended distance from your subject is about three times its height. From that point you can easily see the setup without having to turn your head from the paper to the subject. When you have located your viewing position, mark it with tape on the floor so that the tape runs along your toes and in between your feet. (This mark should look like a T.) With this method, you stand back at the T to look, and go up close to draw. You never draw by looking at the subject from your easel position, which would give you an entirely different view. It feels a little awkward at first, but it becomes seamless within a few hours.

If you want to use the sight-size method, but do not want to have a drawing that ends up the actual size of your subject, then try the following variation. (This variant is particularly helpful for figure drawing, as very few people want their drawings to be several feet high.) Move your drawing board away from your subject and closer toward your T until the subject appears at a desirable scale. So instead of the drawing being directly next to your subject, it would be somewhere between you and the subject. You stand by your mark to look, and move forward to draw.

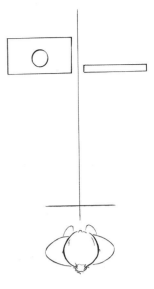

This is the artist's setup as seen from above. Notice that the artist stands back to look and walks forward to draw.

The sight-size method invites a literal comparison between the subject and the drawing.

It is hard to get a full sense of this process from a brief description. For more information, there are some books on the subject, including the Charles Bargue and Jean-Leon Gérôme book mentioned earlier (and listed in the bibliography). You can see artist Jordan Sokol using this method in the companion DVD. A step-by-step sequence of this process by Florence Academy of Art instructor Stephen Bauman can also be seen on pages 188–189.

Whichever approach you use, the advantage of the sight-size method is that it yields naturalistic results. It becomes obvious where your drawing differs from the subject, making it is easy to correct. The downside of this method is that you are locked into an easel position with a literal representation of your subject. The setup also needs to remain stationary throughout the course of the drawing to make sure your measurements lock in perfectly.

AMAYA GURIPIDE, *Fall*, 2009, graphite on paper, 10 x 14 inches (25.4 x 35.6 cm), collection of Kate Lehman and Travis Schlaht

This drawing transcends the medium. We look at it and see the soft texture of feathers rather than the hard graphite used to render them.

Correcting Your Work

The ability to self-correct, in any field, is a challenging skill to master. In fact, it is an attribute of genius. As you carefully measure with the needle, use the plumb line, and site angles, you are training your eyes to judge more correctly. Eventually you will be so confident that you will rarely need to go to such lengths to create an accurate drawing. Slowly, through careful checking, you will begin to see patterns of where you are consistently prone to veer off in your own unique way. (For example, I often initially draw my figures long waisted.)

When I studied with Jacob Collins in New York, he talked about how important it is to correct the weakest, or least finished, areas of the drawing first. It is natural to want to keep reworking the best areas of a drawing in hopes that they will be strong enough to support the whole piece. However, that rarely works. The most effective way to improve a drawing is to make sure each part reflects your full capacity as an artist.

I remember working on a portrait painting once that was an artistic disaster. I was in complete despair and getting ready to start over. Jacob told me to slow down and deliberately focus on each area, one at a time, starting with the worst area and working until it became the best area. I was skeptical, but I trusted him enough to give it a try. I found that by methodically working out the worst kinks I was able to bring the whole image up to the same level of finish. By the end of the process, that portrait was the finest I had completed up to that point.

Appraise your work critically. Revisions are part of the process. Your drawing will gain accuracy slowly by the careful application of measurements.

I tend to reach for a hatchet where only a scalpel is needed. Yet, I have learned that a drawing can feel terribly, even irreparably, wrong when really what I am seeing is just the compounded impact of many small inaccuracies—all of which can be collectively and successfully addressed.

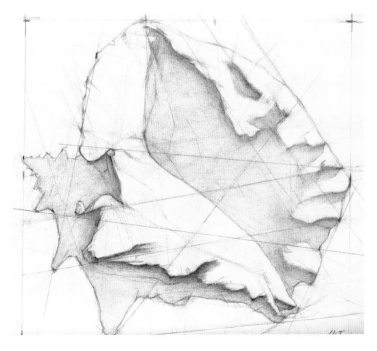

STEPHANIE JOHNSON, *Conch Shell*, 2010, graphite on paper, 11 x 14 inches (27.9 x 35.6 cm)

The block-in lines are visible, even at the conclusion of this drawing. We can follow the artist's logic. The interlocking relationships are articulated, with each individual part of the drawing remaining connected to the whole.

Refreshing Your Perspective

For better or worse, we only have a brief window of opportunity to see and correct mistakes in our work. Over time, we tend to become acclimated to the inaccuracies in our drawings and are unable to see things clearly. Elements that are stilted or distorted can look or feel correct. One simple solution to this problem is to take a break every now and then and remember to stand back from your work occasionally.

Looking at a drawing after a little time has passed will give you a fresh perspective and make it easier to assess what needs to be done. I know from experience, however, that this clarity of sight can result in panic and a lot of hastily made corrections. To curb this temptation, I recommend taking out a piece of writing paper instead. Create a list of everything that jumps out at you as wrong. This list can include such things as "the head feels too narrow, the lines are too dark, some angles need transitions, the tone in the background is spotty," and so on. Rather than making hasty changes, you can use the list to methodically and rationally make improvements.

Make a habit of pursuing accuracy. You have a window of opportunity to make corrections; a tired eye will not catch mistakes.

Another way to get a fresh perspective is to ask for a critique from friends. Most people have a maddening ability to see inaccuracies correctly in a piece. It takes some courage, but asking a family member or a friend is almost always worth the risk. You can make it easy for people to be honest by not reacting defensively and thanking them for their help, even if your pride is momentarily wounded. As a student who used to create computer programs once told me, "No one can debug their own software."

Other time-tested tricks include looking at your work upside down or reflected in a mirror. These practices can help extend the freshness of your vision by allowing you to see the work in a new way. This is essential because most work gets better, not by magic or willpower, but by a series of strategic revisions, improvements, and corrections made throughout the development of a work.

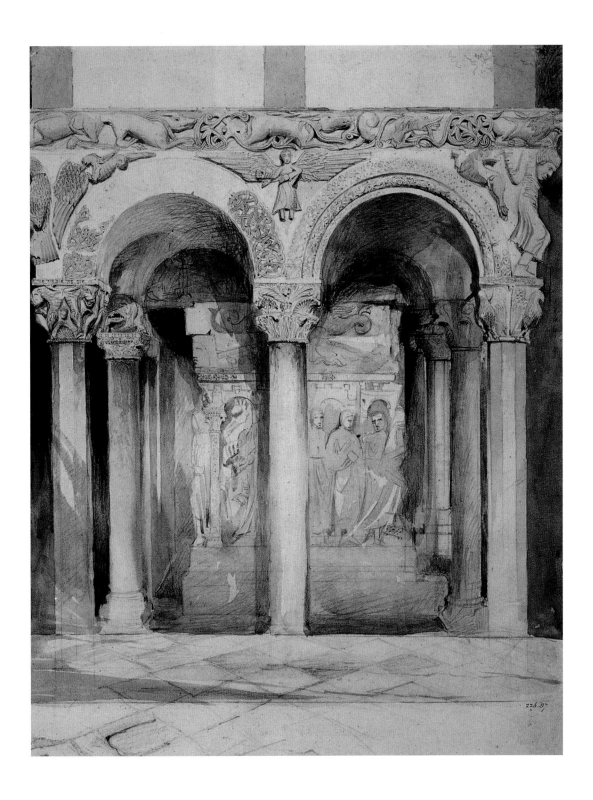

LESSON 2 MEASURED DRAWING

ONE OF THE HARDEST THINGS about drawing is knowing how to start. In this lesson you will see how I begin a drawing and bring it to a reasonable level of finish. Simple principles applied consistently are essential for your artistic growth. You do not need to have answers, just a strong set of questions. In this lesson you will learn what to look for and what questions to ask. You will determine what lines are important, practice measuring, and learn the benefit of working from general to specific. There is an adage that practice does not make perfect; perfect practice does, however. I take that to mean that continually learning from your mistakes will help you bring your best efforts to each page.

GATHERING YOUR MATERIALS

In preparation for your measured drawing, assemble the following materials:

> Still life objects
> Vine charcoal, Conté pencil, or graphite pencil
> Pencil sharpener or sandpaper
> Drawing paper
> Drawing board
> Kneaded eraser
> Tape
> Plumb line
> Narrow knitting needle or skewer
> Newsprint (optional)

SETTING UP YOUR STILL LIFE

Find a group of objects that are not too complicated. Anything can provide a good subject, but avoid having too many transparent things. (Better yet, paint a matte white finish on all the objects you want to draw.) Try to choose objects that feature a strong shape and that aren't too busy. You do not want to struggle to see what you are drawing.

Here I created a simple arrangement with a metal jug and a light bulb, setting up the objects on a table so that I was looking at them almost at eye level. I angled in my light from the left of my setup. Because my room was dark, I also put a clamp on my easel so that my paper was well lit.

CREATING YOUR STILL LIFE

Drawing the still life rarely qualifies as love at first sight. People seem to fall in love slowly as they progress in their studies. Drawing the still life is excellent practice for anyone—even the figure painter—who wants to sharpen their observational skills. It takes time and practice to coordinate the eye and hand. Furthermore, drawing still life objects will help you learn to measure, use a plumb line, and site angles, and then apply these skills as you see fit.

STAGE ONE: Place the top and bottom markers to lock in the height of the tallest element along with a vertical plumb to provide its centerline.

STAGE TWO: Lightly articulate the notional space of each object, and then site the major angles.

STAGE ONE: *Taking Your Measurements*

Place a mark at the top and the bottom of your paper. It can be whatever size you wish; however, I do not recommend making it larger than life size. In this way you can control the size of your drawing. Next, find a vertical line (if you are working with an upright subject, as I am here) that serves to show the orientation of your subject. This can be a weight line, or it can be a midway point in your subject. These few simple markings will give you a unit of measurement that you can compare against throughout the creation of the drawing. I chose to run the vertical line through the jug because it was the largest, most dominant visual element in my still life set up.

STAGE TWO: *Establishing Dominant Angles*

Lightly place a few key angle directions to define some dominant lines. This process is deceptively simple. It is easy to understand; yet doing it well requires careful consideration.

The best explanation I have heard to describe siting angles is to think of it like locating the hands of a clock. Close your one eye, hold your arm out with the needle, and align it with the direction you are finding on your subject. Imagine the face of a clock to remember the exact direction of the angle (for example, the hand is pointing to eleven o'clock). Now try to duplicate that angle in the drawing.

Here I established the ground plane and placed my key directional lines. The angle of the pencil, the right-hand side of the jug, and the diagonal relationship between the jug and the light bulb were implied. This quickly gave me the general scaffolding of the still life arrangement.

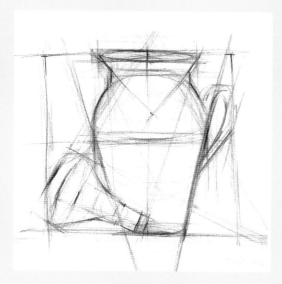

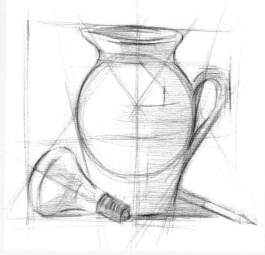

STAGE THREE: Locate angles that sculpt the individual objects. Be sure the construction lines run through the drawing. This ensures the objects have the right relationship with each other.

STAGE FOUR: Now that the larger structures are in place, locate the smaller aspects of the objects, such as the ellipses in my drawing.

STAGE THREE: *Blocking In Your Shapes*

Next, articulate the block-in for your still life. This is a key beginning stage of the drawing that locates the proportions of the objects in your image. It is also a good time to start measuring and being vigilant about proportional errors. With some objects this stage can look lumpy and non-descript. Don't worry if, at first, you feel as though you are swimming in your lines, you will soon learn how to read your own artistic shorthand.

To find the shapes in this stage, first site your angles around the perimeters of the objects. After you have correctly placed the main elements, you will have the necessary context for the lesser ones (such as the handle on the jug in my drawing). It is important not to place the small shapes too soon in the process, as you don't want the smaller considerations to dictate the direction of the drawing.

STAGE FOUR: *Finishing Your Block In*

Build up details in your objects in the same way that the larger shapes were developed. In other words, find the overall angles with clean, straight lines. (For instance, the handle and the spout of my pitcher are curved, yet I created them with straight line increments; later I attached the straight line segments together, weaving the transitions with arced line.) Next, distinguish between the lights and shadows of your objects. Start by blocking in the shadow shapes, keeping the shadow lines broad and simple. Separate the light shapes from the shadow shapes. Treat each line, even internal shadow shapes, as an important structural element. You can choose to keep your image a line drawing or you can add a very light tone over the surface of the shadows to imply a light source.

OPPOSITE: DAVID DWYER, *Measured Cast Drawing*, 2011, graphite pencil on paper, 13 x 9 inches (33 x 22.9 cm)

Everything aligns in this measured drawing of a cast. The artist created this as an example for incoming atelier students.

ABOVE: JULIETTE ARISTIDES, *Measured Still Life Drawing*, 2011, sepia pencil on paper, 10 x 8 inches (30.3 x 25.4 cm)

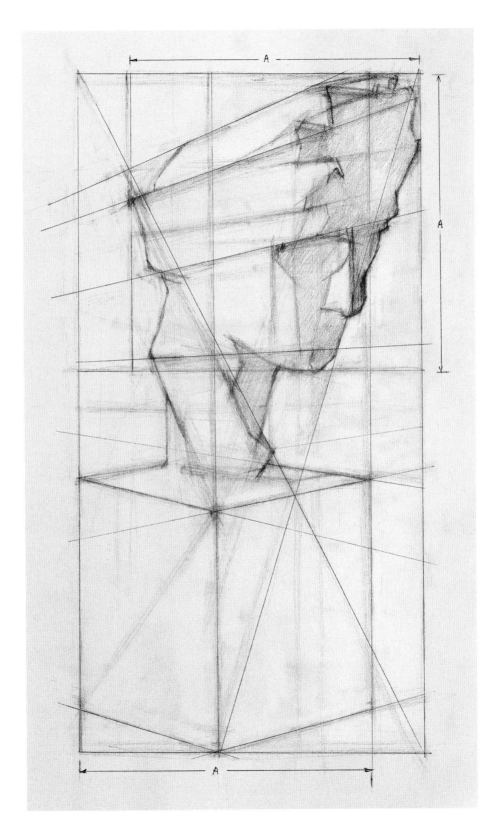

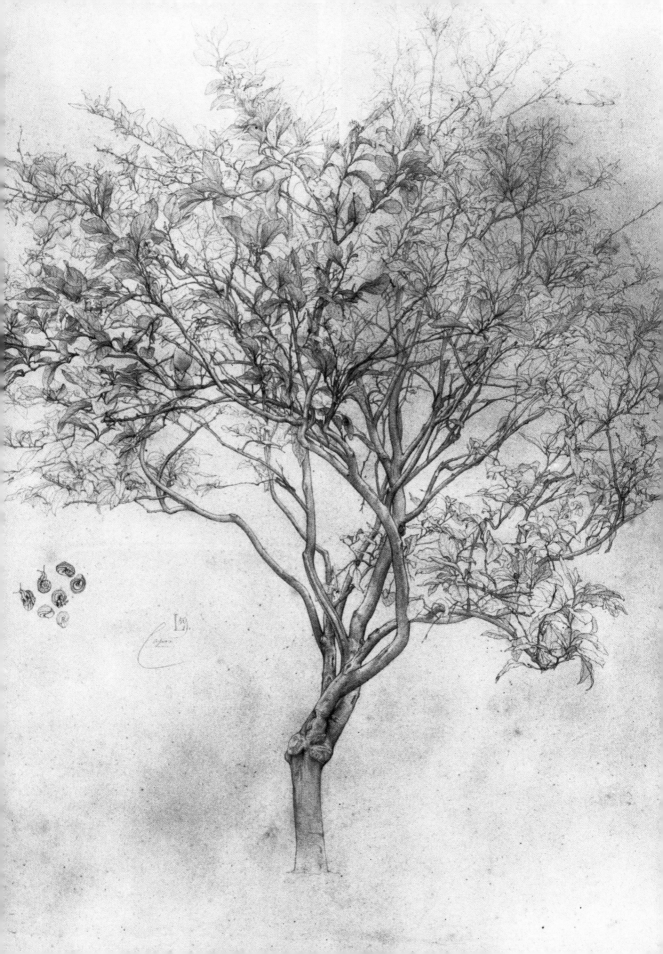

CHAPTER 3 THE ELEGANT CONTOUR:
A DISCUSSION ABOUT LINE

The contour of the body is extremely subtle, difficult to describe accurately, and quite fascinatingly beautiful. Perhaps for this reason research into the contour is almost a separate study unto itself.

—TONY RYDER (from *The Artist's Complete Guide to Figure Drawing*)

Many years ago, I went out for a celebratory dinner with my mom in New York City. She ordered us soup with truffles. The thought must have crossed her mind before I took my first bite that she was about to spend thirty dollars on a thimble-size bowl of soup for someone who would never notice or care. In an effort to foster appreciation, she tried a quick act of creative visualization: "Imagine you are in the forest. It is damp. Smell the air, the mushrooms. Now close your eyes and try the soup." Her tactic worked. I could taste the truffles and the forest. It later became my definition of culinary heaven on earth. The truffles had a unique flavor that I would not have been able to identify or remember without her creating a context of recognition.

If you put a line drawing next to a large, full-color painting, very few people will notice the drawing, even though it may be the superior work. Without contextual knowledge, someone may even consider the drawing as little more than overpriced soup. Without any framework, people often cannot recognize what makes one drawing better or more valuable than another—why one person would go to such great lengths to gain mastery of the discipline and another would spend a whole paycheck buying the end result.

A masterpiece of drawing has no room for error; every line is essential. Likewise, drawing hides very little; it lays bare the artist's skill for all to see. The more I know about drawing, the more I marvel at the skill found in even the simplest sketch of a master draftsman. Just like the palate can learn to appreciate subtle but exquisite cuisine, the student artist can learn to appreciate the ingredients of line that create magnificent drawings.

LORD FREDERIC LEIGHTON, *Study of a Lemon Tree*, 1858, silverpoint on white paper, 21 x 15 ½ inches (53.3 x 39.4 cm), private collection, courtesy of Art Renewal Center

Leighton worked from morning to evening for a full week on this drawing. He said that drawing plants is as difficult as drawing a head if you are conscientious about it.

The Power of a Quiet Line

When I was younger, I used to think that a drawing required vigorous line work, with the full value range of white to black, to be powerful. I equated emphatic mark making with strength. Now, I am of a different opinion: A beautiful line drawing should leave something to the imagination. Rather than providing immediate or obvious visual satisfaction, it demands savoring and creates an appreciation that grows over time.

The simplest line drawing can be the most challenging and personal to create.

Line features an austere, intellectual quality that makes it quietly compelling. It whispers, speaking only to those who can hear. In a world of noise, it can be truly refreshing to be around the quiet sophistication of a line.

PETER VAN DYCK, *Self-portrait*, 2006, charcoal on paper, 24 x 18 inches (61 x 45.7 cm)

The energetic line conveys the feeling of process rather than a fixed outcome. This is an appropriate visual metaphor for the artist at work.

OPPOSITE: LEONARDO DA VINCI, *Tête de Femme Presque de Profil*, circa 1480, silverpoint on prepared paper, heightened with white, 7 1/16 x 6 5/8 inches (17.9 x 16.8 cm), collection of the Louvre (Paris, France), courtesy of Art Renewal Center

In this exquisite head, a single line manages to capture the profile and create the illusion of volume. Notice that the artist left a significant amount of space for the gazing direction.

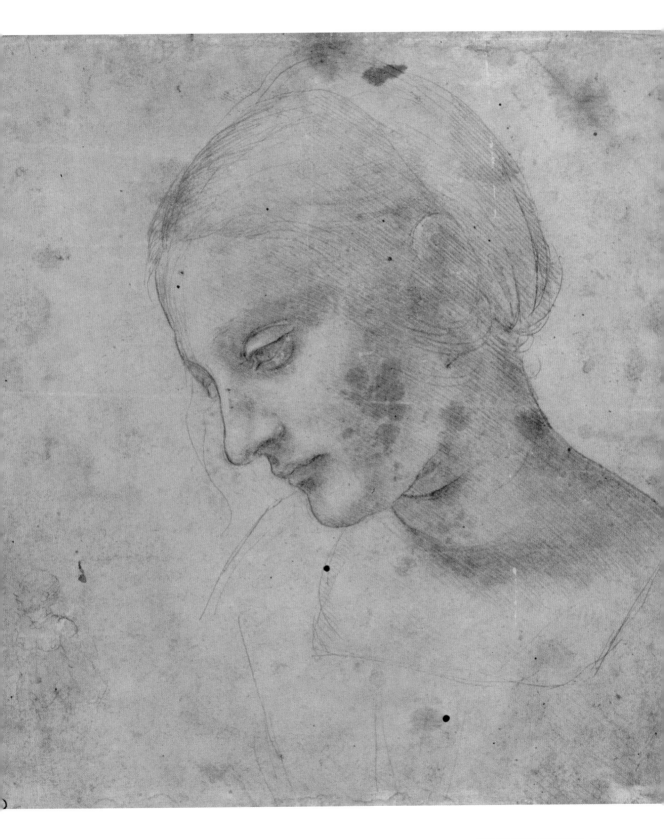

Intricate folds in drapery provide ample opportunity to practice accurately drawing shapes.

These two shapes—one geometric and one natural—echo each other. Forms found in nature lead the mind to their idealized version, as this leaf hints at the star.

Forming Shapes

One of my earliest memories from Montessori preschool was the sense of pleasure I got from tracing thin wooden shapes. Simple figures such as circles, squares, and triangles are ubiquitous throughout the art of the world's cultures. When I think of the word *shape*, what first comes to mind are these archetypal geometric forms. Yet, the shapes that comprise our visual world are not so clearly delineated or so cleanly organized.

The term *shape* in art refers to the contour or parameters of an object. It also refers to the more abstract concept of a division of space. In its most basic form, art itself is simply an arrangement of shapes that are delineated by such formal elements as value and color.

In art, unlike in preschool, these shapes are almost never geometric. Rather, they tend to be ill defined and organic. Furthermore, human beings are visually efficient and often condense information into easier-to-understand components. (For example, a display of fifty apples may register to my eye as a single pyramid.) Therefore, often the shapes we see do not coincide with the contours of an individual object.

Recognizing shapes is basic to our existence and survival. They help us identify a friend or ensure we are on the right road home. Without effort, and often without our realizing it, our eyes and minds work together to edit, simplify, and reconstruct the world in which we live. They also decipher partial information and create meaning from it.

Mathematical or geometric shapes have names—triangle, square, circle, and so forth. Artistic or organic shapes, on the other

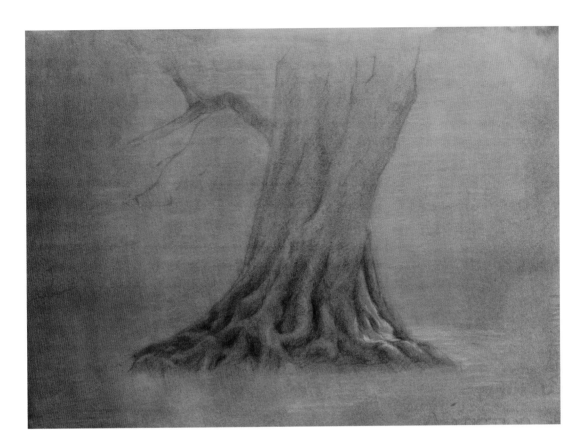

hand, remain unnameable unless we deliberately liken them to other things—like the free association of seeing animals in clouds. Consciously freeing yourself from the name of something can enable you to embrace its visual ambiguity and capture the shapes that are really there.

Embrace visual ambiguity and draw what you see rather than what you know.

Before you start to draw something take a moment to remember that you will be continually tempted to draw what you expect to see rather than the more unclear forms that are actually there. It takes a certain amount of trust to believe that if you actually follow the dictates of your subject—what you see rather than what you know—things will work out in the end. To help internalize this idea, it may be useful to render something that does not really look like anything—a rumpled up piece of fabric or the gnarled roots of an old tree, for instance. Then, after your initial block in, start drawing from the shadow shapes first. The shadow shapes will form the visual anchor on which you can base your whole piece.

D. JORDAN PARIETTI, *Old Growth at Carkeek Park,* 2010, pencil on toned paper, 12 x 18 inches (30.5 x 45.7 cm), courtesy of the Aristides Atelier

The tangled roots of trees lend themselves to a slow and careful study with line. Trees often contain implied spirals of movement. Like a still life, trees are immovable, yet they convey the rhythm of living things.

Using Schemas

Discussing shapes naturally leads us to the concept of a schema (or diagrammatic plan or template) that simplifies a complex subject. For example, a model of the solar system is a schema. In this case, a simplified model is an invaluable way for our minds to grasp a complex concept. In art, as with the solar system, it is often very difficult to understand what we are seeing at first glance. A schema gives us a simplified point of reference that we can use to compare with the visual world.

Most subjects you study require breaking complex principles into simpler ideas. You may have seen this concept at work in children's art instruction books, where, for instance, a series of circles and triangles might be used to guide the artist through constructing

a bird. This kind of conceptualization can give a young student a way to create convincing drawings and also show how a complex structure can be created by small shapes. While this approach to drawing has some obvious disadvantages, the process of simplifying can be extremely valuable when used as a means rather than an end.

Personally, I find schemas for drawing essential because if used in the right way, they can cause us to look more carefully at the visual world. When you find a way to identify and link a small line segment into a bigger shape, you enlarge its context. By finding circles, triangles, squares, and so forth, you are forced to move away from the "word picture" or pictograph mentality into a world of more subtle and astute observation. So think of the schema as a teacher leading you to greater observation. Breaking down the world into smaller abstract shapes can offer an efficient way of organizing the vast visual information at the beginning stage of your drawing.

A schema, or simplified model, provides an invaluable way for our minds to grasp a complex concept.

When I studied with Myron Barnstone, one of our first exercises was to deconstruct bottles. In this exercise, we broke down the contour into a series of angles and enlarged those angles into shapes. The vertical sides became a rectangle; an arch became a circle. In this way we were not just copying a line drawing of an object but constructing it from the inside out. When people draw bottles they often do it quickly, almost by rote; looking for these shapes actually slows the artist down, forcing them to look more carefully and with greater understanding. In this one assignment, we learned much of what it takes to make a good drawing, especially how to measure and interpret what we were seeing.

In closing, we need a template in our minds when drawing. In the past, this model was handed down in a rigid, inflexible form. Today, we still need a point of reference, but idealized shapes or proportion are only points of departure and are often derived from direct observation from life. We draw our own conclusions about what we see but are given a few pointers in the right direction. Your work will always benefit from having a coherent plan or structure upon which to hang your observations.

ELIZABETH ZANZINGER, *Analysis of Natural Objects* (detail), 2007, pencil on bristol, 8 x 10 inches (20.3 x 25.4 cm), courtesy of the Aristides Atelier

The pentagonal structure of the leaf and primrose are also found in many fruit blossoms. Training your eye to look for underlying patterns can help you identify simple solutions to complex drawing problems.

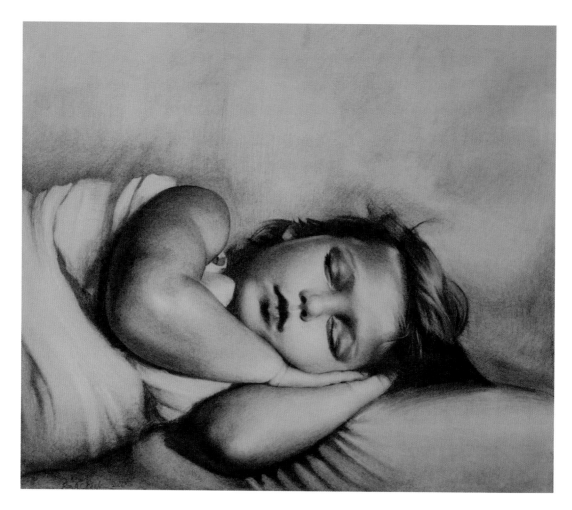

RON CHEEK, *Isabella*, 2006, charcoal and white chalk on toned paper, 15 x 19 inches (38.1 x 48.3 cm)

The artist captures the weight and innocent sleep of childhood with his studied use of line. The small, triangular negative shapes around the arms could help the artist locate the position and degree of curve found in the shape.

Finding Negative Shapes

The term *negative shape* refers to the space surrounding an object. We tend to be subject centered, seeing the object we are drawing (a pitcher, perhaps) in isolation from its environment (the space in which the pitcher sits). I am a big offender in this area, and I have had to consciously train myself to work on the whole picture.

Negative space, the areas around your subject, can help you double-check the accuracy of your angles.

If you add negative space to your artistic vocabulary, you will find that your work improves. It gives you a different lens in

which to see your subject. Furthermore, the small spaces between objects, such as the space between fingers or the air between leaves on a branch, can help us double-check the accuracy in our work. Negative shapes afford us another method of comparison to ensure that our drawings accurately reflect life.

Some artists, such as Norman Lundin, make negative shapes the major focus of their life's work. Lundin once said, "Just as one cannot have something 'long' without having something 'short' for comparison, one cannot have an 'object' without a 'void.' It is the void that interests me."

Be warned, however, that negative space is fragile. Unless the artist is very skillful, the space between or around a subject can, in fact, overwhelm it. For example, while the space around the head is an important element of a figure drawing, the head itself is not shaped by the air around it. Rather, it is shaped by the structure of the skull. Just getting the contour lines right will never re-create the power and form given to us by the skull. Train yourself to notice negative shapes, but be sure to use them wisely.

NORMAN LUNDIN, *Blackboard and Lightswitch,* 1974, charcoal on paper, 28 x 44 inches (71.1 x 111.8 cm), collection of the Museum of Modern Art (New York, NY)

Lundin has made a career of drawing things that go unnoticed by most people, such as sunlight hitting a wall. He gives each part of the drawing its own shape even when his subject is only air and light.

Consider the black shape of the pitcher on the right to fix the positive shape in your mind. Next, compare it with the black shapes around the pitcher on the left to see the negative space.

The continuous curve of the pot has been broken down into a series of straight lines and arcs, enabling a more deliberate study of its contour.

The studied contour line runs the whole length of the object, describing its parameters and providing clues to its internal structure.

OPPOSITE: ROBERT ARMETTA, *Portrait of a Young Man*, 2001, graphite on paper, 12 ½ x 11 inches (31.8 x 27.9 cm), collection of Theodore and Catherine Prescott

The precision of a beautiful contour line focuses our eye on the sharp relief of the profile against the background.

Crafting Contour

One of the hallmarks of a novice is a deep attachment to the edge of the subject, which artists call the "contour line." Beginning artists gravitate toward it because it can form the most recognizable, elemental shape of an object. Indeed, an object's silhouette can closely relate to our mental picture of that object. But there are essentially no lines in nature. Rather, what we often perceive as lines are changes in color, value, and edges, such as the dark edge of a tree trunk against a light sky.

Remember, the edge of an object is an artistic convention.

All this being said, contour lines serve a critical purpose for the artist. The first two chapters describe how to find your governing line and determine your measurements. You continue drawing and develop a rough, but proportionally accurate, block in. A study of the contour line takes your drawing a step further, with a focus on the small incremental changes that happen when you look carefully along the stretch of your major lines.

Keep lines open in the initial stages of a drawing. And look for high and low points along each line segment.

The extended length of a contour line becomes refined as it is examined. Because you have looked at the big picture and established how every element relates to the whole, you can now afford to study the character of the subject in detail. Just as you looked for the major angle changes in your subject to start the block in, you can now repeat the process in a smaller scale. Look and assess the intervals for each dip and swelling.

Having a logical procedure for this process can be helpful. In my own work, I take a particular broadly stated angle direction and subdivide it. I assess the line to see if it can be easily sectioned into subthemes. Each of these line segments will hover above or below the major line direction. At this point in the process I use a separate line of questioning, one reserved for helping me dive deeper into a more exact nuance (such as, Where is the high point and low point of this line segment?). Assessing the negative shapes surrounding the object can also help you see changes in the contour more easily.

CHAPTER THREE THE ELEGANT CONTOUR 75

After I have broken down the outline into ever smaller, accurate angles, I feel free then to chase any tiny ripple without concern that it will disrupt the unity and strength of the whole.

When accurately placed, a closed continuous line is beautiful; however, if it is inaccurate, it is difficult to correct.

When working on finding specific changes in the contour, it is helpful to identify any flat stretches found along the curves, as they can add strength to your drawing. In the outline, look for where your line gets lighter or dissolves as it passes behind another form. These subtleties give an informed accuracy to your work. Allow your eye to enjoy the contour millimeter by millimeter. In this way you will catch the unique personality of individual subjects.

JULIETTE ARISTIDES, *View from the French Academy in Rome,* 2009, pencil on toned paper, 6 x 10 ¾ inches (15.2 x 27.3 cm)

The single pencil line representing the skyline provides much information about this view. My drawing was inspired by a landscape of the same view that can be seen inside the French Academy in Rome.

OPPOSITE: JEAN-AUGUSTE-DOMINIQUE INGRES, *Study for Raphael and the Fornarina,* circa 1814, graphite on paper, size unknown, courtesy of Art Renewal Center

Ingres was famous for his graphite drawings. The delicacy and emotion of his line must be seen in the original to be fully experienced. He could stretch the limits of the medium to their fullest advantage.

Multiple forms that are identical feel mechanical and artificial.

The line of repeating dots is broken by one jumping formation. As a result, the singular event becomes the focal point.

Establishing Rhythm

Nature is the greatest teacher. You can learn much by simply studying what you see. The first time I saw heirloom tomatoes I had trouble believing my eyes. The tomatoes were the strangest shapes: ribbed, warped, and bulbous. Some were striped in various colors, including purple, orange, and yellow. None resembled the iconic red spheres commonly found in grocery stores. One of the basic principles of art is the interplay between theme and variation, unity and variety. Just as I discovered with the heirloom tomatoes, nature contains enough peculiarity to keep us guessing. In his book, *The Artist's Complete Guide to Figure Drawing*, Tony Ryder wrote, "The patterns of orderly form found everywhere in nature always have this kind of 'imperfection,' an imperfection that amplifies, rather than diminishes, the mysterious beauty of nature."

If any interval, or rhythm, in your drawing becomes too repetitious or regular, it feels mechanical and unnatural. Likewise, when a work gets stylized (or formalized into a distilled, more generic rendering), it often means the artist has stopped thinking—or stopped looking. This remains a classic problem that afflicts beginners, but it also happens to me all the time. Always look for differences to create variety and a sense of lively observation. Try to focus on any small distinctions and capitalize upon them. Through these differences, your eye will move more easily throughout the picture.

In art, the principle of line rhythm is important in creating a hierarchy of information that feels easy and natural for your viewer to interpret. Without variety, your drawing can become wallpaper fading into the background of our attention. Like an endless row of fence posts or the beating of a heart, we cease to notice or pay

Alternate between straight and curved lines, between lost and found edges, between dark and light areas.

attention. Repetition is not all bad, however. While variety creates interest and credibility in your work, predictable rhythms establish unity that holds it all together. Too much variety is incredibly disruptive. Just ask any sleep-deprived new parent, and you may get an earful about the importance of respecting our biological rhythms.

Each choice you make when putting pencil to paper has visual implications. Not enough unity and you have chaos. Too much unity and you are bored. Look for a number of key points to create rhythm in your work. Try to alternate between curved and straight lines throughout your drawing, as this creates an undulating effect of action and pause points for the eye. Look for lost and found edges,

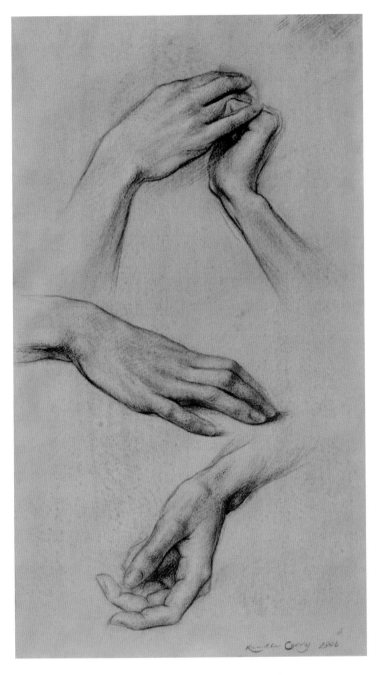

KAMILLE CORRY, *Painter's Hands*, 2006, charcoal and pencil on paper, 12 x 7 inches (30.5 x 17.8 cm), courtesy of the Ann Long Gallery, Charleston, South Carolina

The dynamic rhythm of hands, alternating between action and rest, move our eye down the page.

as this allows some parts to move back in space while others pull forward. Oscillate between dark and light line weights, as this adds emphasis and hierarchy of importance to the subject. Play with the thickness and thinness of strokes, as this creates a lively variation of weight. In these ways, and others, you will add life and movement to your work—not copying nature in detail, but in essence.

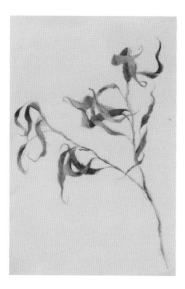

JULIETTE ARISTIDES, *Willow Branch*,
2010, walnut ink on paper, 10 x 8 inches
(25.4 x 20.3 cm)

The natural forms found in plants, such
as this branch of a willow tree, provide
ample opportunity to study the concepts
of negative shape, contour line, rhythm,
and line weight.

Determining Line Weight

The concept of line weight thrives under well-applied principles of
unity and variety. The old masters varied the lightness and darkness
of a line to convey a sense of going or coming in space, generate
a feeling of movement, and establish a focal point. When the line
weight in a drawing is not varied, it is as if the artist is talking in a
monotone voice.

It is easy as a beginner struggling to find proportion to let your
outlines get too heavy and dark. As you struggle for certainty, the
contour can get thicker and darker. Sometimes the line gets so thick
that it can start to throw off the overall proportion. It takes very
little to distort a subject that has a small margin for error. With
figure drawing, in particular, a fraction of an inch here or there can
make the difference between accuracy and deformity.

Like a dark line, a closed, continuous line can easily become
locked in and hard to correct. Both types of lines convey an
emphatic statement—a certitude. They tell the viewer that that the
drawing is found and accurate. A locked-in drawing is frozen into
a single moment. Many beautiful drawings are created in this way,
but using these kinds of lines successfully requires uncanny accuracy
unless you are specifically aiming for whimsy or mannerism.

*The darkest and sharpest marks are accent points
that draw the eye.*

By comparison, a line that is broken and searching is already
in a state of flux, making it easier for both artist and viewer to see
the possibility for improvement. It breaks into a series of segments
that can be looked at independently and assessed for accuracy.
Remember that something can be technically correct, yet said in
a way that makes it appear untrue. For example, a line can be well
placed but still be unbelievable because it is too dark. Strive to have
your intention align with your expression.

I recommend making all your lines light and thin at the
beginning of a drawing. If you are having a hard time doing that,
switch to a harder pencil or charcoal. Use multiple thin lines to
find your drawing rather than one thick one. Get comfortable with
ambiguity. Leave gaps in your contour line if you are not sure how
something connects. It is not necessary to have all your lines come
together, especially when you are in an ambiguous area of a work.
Once you are confident that your overall drawing is accurately in
place, darken lines in areas that require a more emphatic statement,
a harder edge, or a thicker mark.

The concept of lost and found edges relates to line weight.
Imagine a spectrum of lost and found edges much like a value

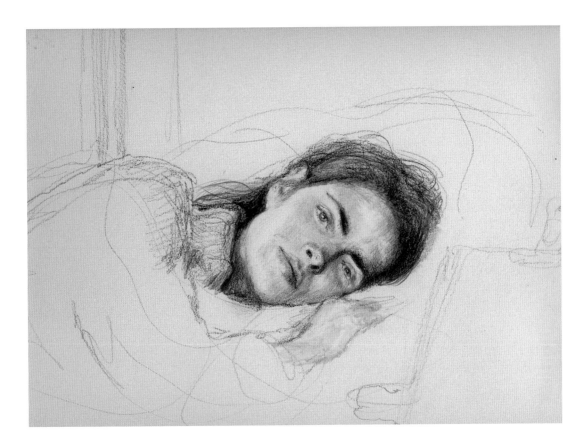

chart that ranges from white to black. The area of a drawing that is sharpest or darkest draws the eye most clearly to itself. It becomes a focal or accent point. By comparison, a lost edge creates atmosphere and allows for ambiguity. It moves behind and away from us. It adds variety and interest.

The drawing by Paul McCormack of his daughter on page 82 offers an excellent example of how line weight and lost and found edges can lead the viewer's eye. Here he uses the limited means of pure line to full effect. The image is anchored by the darker accents in the facial features. As your eye moves away from the girl's eyes toward the ear, and then to the back of her head, the line becomes very thin and light. As your eye moves down the shirt, the line dissolves entirely, fading out to the paper tone. In this manner, we as viewers know exactly where to look.

I recommend locating two edges—one very sharp and the other very soft—as points of comparison for the other edges in a drawing. As you work on a piece over time, your eye acclimates, and it can become hard to see the differences. To correctly judge I need to compare one edge to another. I flick my eye quickly from an edge I am drawing to one I've chosen for comparison. In this way I establish a consistency throughout the drawing.

BO BARTLETT, *Untitled* (Betsy, August 3, 2008), 2008, graphite on paper, 15 x 22 ½ inches (38.1 x 57.1 cm)

The energy of line captures the intimacy between husband and wife (artist Betsy Eby). It remains a mystery of art that in the hands of a master, a small point of graphite can be used to express the wealth of the human experience.

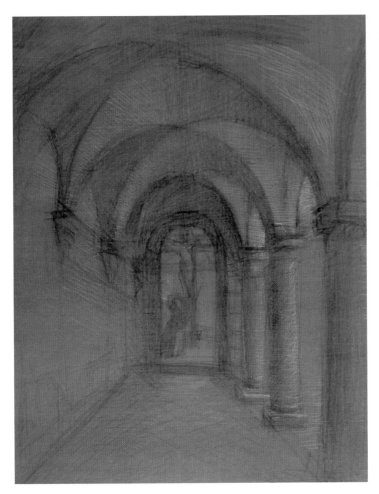

JULIETTE ARISTIDES, *San Marco*, 2009, graphite heightened with white on prepared paper, 10 x 8 inches (25.4 x 20.3 cm)

Architecture affords endless opportunities for sketching. Notice how this particular groin-vaulted ceiling offers a unique opportunity to capture the depth of space with line.

OPPOSITE: PAUL MCCORMACK, *Abigail Rose (Portrait of the Artist's Daughter)*, 2007, pencil and white charcoal on toned paper, 20 x 16 inches (50.8 x 40.6 cm)

The sensitivity in the handling of the line captures the tenderness of emotion between the artist and his daughter.

Notice how the same line weight in both cups creates a competition for the focal point. The back one recedes because of its placement, but threatens to attach itself to the first cup.

This drawing has a clear visual hierarchy. The front cup moves forward, and the back one recedes because of the difference in line weight.

Depicting Aerial Perspective with Line

Perspective is the study of how the eye perceives objects receding in space. Aerial perspective (also known as atmospheric perspective), in particular, is the expression of space as articulated by gradation of color and value. In line drawing, the illusion of aerial perspective can be created by varying line weight.

An artist recently brought me a painting to critique. She was frustrated with the outcome and unsure what was going wrong. The drawing was technically correct; indeed, it was copied from a photograph. Yet it felt inaccurate. It took me a minute or two to find the problem: Instead of allowing the main subject to be surrounded by atmosphere, the artist had rendered the scenery in the background as dark, crisp, and colorful as the central figures in the foreground. Our eyes simply do not see that way. We need a diminution of intensity on all accounts—in value, line, and color—in order for things to appear to recede. The sense of atmospheric perspective in line is created when the lines decrease in contrast as they go back in space.

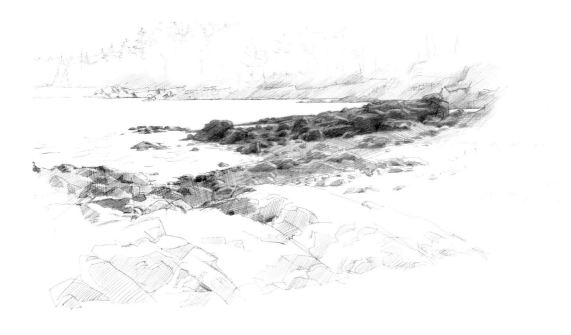

JACOB COLLINS, *Eastholm Rocks*, 2007, pencil on paper, 10 x 13 ½ inches (25.4 x 34.3 cm)

Our eye is lead to the darkest, most finished part of the piece before moving throughout the drawing.

OPPOSITE: JEAN-AUGUSTE-DOMINIQUE INGRES, *André-Benoît Barreau, dit Taurel*, 1819, graphite on paper, 11 ¾ x 8 inches (28.8 x 20.4 cm), private collection, courtesy of Art Renewal Center

Famous for capturing an insightful portrayal of his sitters, Ingres was able to communicate a lot with just a few lines of a pencil.

Let's examine Ingres's drawing on the facing page to determine the tools the artist used to help us read the image. The lines in the drawing grow lighter as they move farther away from the viewer. Ingres concentrated the darkest value notes in the head and neck, showing us that this area is his principal focal point. The value of the lines in his shirt and pants are not as dark as the outside of his coat, so we understand that these areas are set back. The city behind the gentleman is considerably lighter than the figure, which enhances its appearance of being farther away. Ingres has also minimized the size of the buildings, which establishes distance between the subject and the setting. (This characteristic of perspective will be discussed further in chapter four.)

Aerial perspective causes objects to lose contrast in color and value as they recede.

In summary, Ingres consciously used artistic conventions to produce a coherent and lovely work of art. As viewers, we can delve into the piece and explore it—not only without any confusion but with pleasure. When you only have a few ingredients, as you do in drawing, it is important for each one to be used to its fullest. In this drawing, Ingres used every tool at his disposal to the utmost.

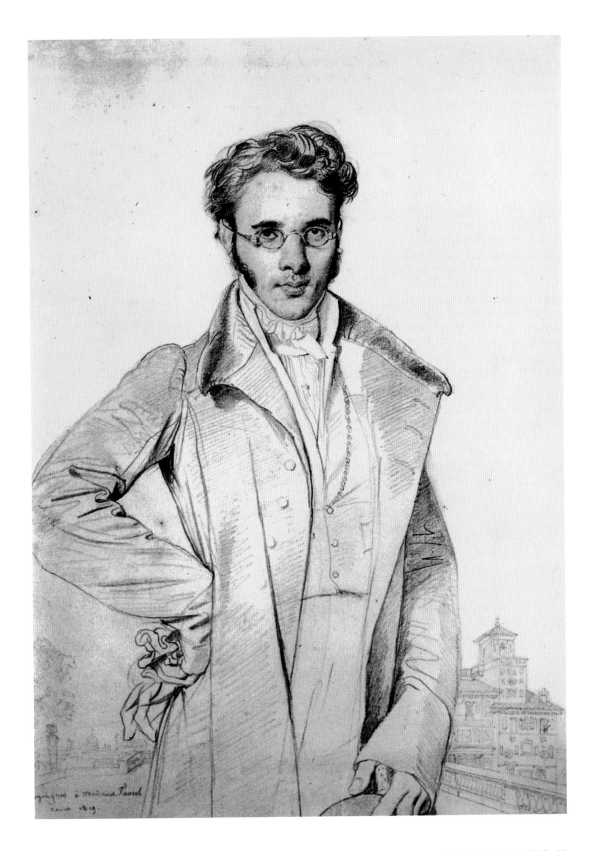

LESSON 3 RHYTHMIC LINE DRAWING

THE NATURAL FORMS FOUND IN PLANTS are a wonderful resource for the artist. The rhythms of the leaves in relation to the branches, of the branches in relation to the trees, create a visual essay in theme and variation. Even among the regular intervals, surprising differences abound—often unlike anything that we could imagine. Because leaves do not follow familiar and easily stylized shapes, they lend themselves to a detached kind of observation. This exercise serves two useful goals: First, it will help you learn how to create cautiously controlled curves, similar to those found on the human body. Second, it will allow you to carefully study negative shapes and contour lines, which are partially responsible for the beauty of natural forms.

GATHERING YOUR MATERIALS

In preparation for your contour drawing, assemble the following materials:

> An interesting branch, with leaves, fruit, and/or flowers
> Graphite pencil or piece of hard charcoal
> Pencil sharpener or sandpaper
> Drawing paper
> Drawing board
> Kneaded or hard eraser
> Artist's tape
> Plumb line
> Narrow knitting needle or skewer

SETTING UP YOUR DRAWING

Place your branch a comfortable viewing distance in front of you. If it is delicate, you might want to place it in a small vase. You might want to add a white or light gray piece of paper as the backdrop of the still life if your background feels distracting. For this drawing you do not need any particular lighting, unless you find that it is hard to clearly see the shapes of your leaves.

CREATING YOUR BRANCH DRAWING

Your drawing should be a lighthearted exploration of edges and space. Most likely, no one who looks at it will know if it bears a likeness to the actual plant. You are not doing a botanical illustration. Nevertheless, the drawing must capture a sense of felt accuracy. It must look and feel true. In other words, the drawing must capture the quirky feeling of life. With this lesson, do not try to create an imaginative masterpiece. Simply strive for accuracy.

STAGE ONE: *Finding Directional Lines*
Begin by identifying a single line that can capture the overarching movement of your plant. (With my branch, a strong diagonal served as a better guide than any vertical or horizontal marker.) Next, indicate where the object will rest on the ground plane; this will help define the space and designate the shadow. (See page 80 for an example of a branch done with no ground plane.) Then, indicate the top and bottom of your specimen, and mark any other defining angles. (For instance, in my branch, the longest line rests along the direction of the leaves.)

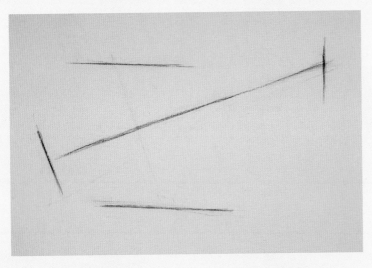

STAGE ONE: Capture the dominant movement of your specimen. Then mark the top and bottom to locate the overall size.

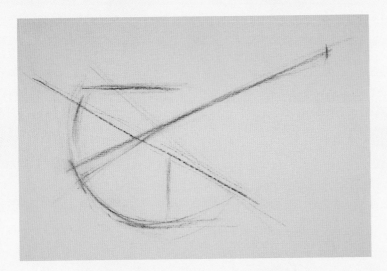

STAGE TWO: Subdivide the general preliminary lines into more descriptive linear gestures.

STAGE TWO: *Subdividing the First Lines*

Next, subdivide the simplified directional lines into something that more closely resembles your setup. (At this point, I found the angle changes along the stem and indicates the positions of the apples and leaves.) Keep your lines straight and open. Do not enclose your objects with a perfect contour line. Instead, use straight lines to generate measurable increments that you can use to cross compare. The open gaps in your shapes should enable you to move things around easily because nothing is yet fixed. Everything can shift slightly if necessary. The angularity of your lines, the openness of your contour, and the lightness of your touch should create an effective block in.

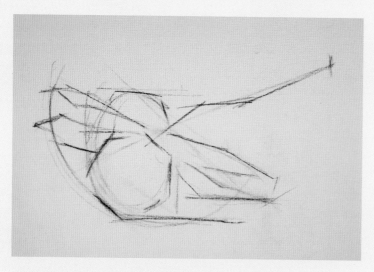

STAGE THREE: Measure the individual lines to transform your block in into a more accurate, measured drawing of your specimen.

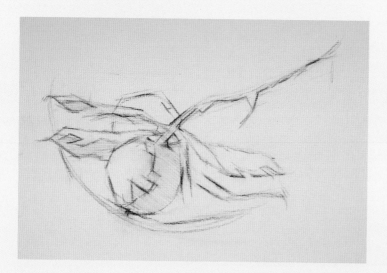

STAGE FOUR: Once the overall shapes appear to be accurate, find the shadow shapes and lightly tone them.

STAGE THREE: *Locating the Shadow Shapes*

It is now time to push your highly abstracted drawing to the next phase, one defined by more cohesive shapes. (In my drawing the shapes began to resemble rudimentary branches, leaves, and apples.) Start to include shadow shapes into the structure of your drawing. As you work, however, continue to leave your lines generally angular and open rather than lock into something that

may not be perfectly accurate. Tone the shadow shapes very lightly to help visually separate them from the light areas. This process, called "mapping," will enable you to cross compare shapes rather than lines, thereby pushing your drawing subtly toward greater accuracy. You will be ready to move on to the next stage when you have achieved a broad likeness.

STAGE FIVE: Accent various elements for visual emphasis and for a more careful study of the core shadow lines.

JULIETTE ARTISTIDES, *Branch of an Apple Tree*, 2010, charcoal on paper, 9 x 12 inches (22.9 x 30.5 cm)

STAGE FOUR: *Finding Smaller Forms*

Identify a single line in your drawing and articulate the smaller, staccato angle changes and shadow shapes. You will soon notice that the angles change many times along a length that was once a single line direction. Repeat this process for the other lines. At this stage continue to keep your shadow shapes large. Create a few darker moments, which will establish the position of future hard contour lines and serve to draw the eye. This process preserves a balance between lost and found edges even at this early stage.

STAGE FIVE: *Checking the Likeness*

During this stage you should lose any remaining reference to your initial structural lines. You will still feel the structure, yet the broad, generic lines are absorbed into the likeness of your plant. Keep the shadow shapes fairly flat. Don't worry about light and shadow; a true contour drawing doesn't need tone. Simply stay focused on the quality and expression of your edges. Push the accuracy of the small lines and accents until it feels like you have captured a sense of your specimen. Again, this lesson is not intended to generate a drawing defined by photographic accuracy, but rather artistic accuracy.

CHAPTER 4 THE ILLUSION OF DEPTH:
THE THIRD DIMENSION

The artist usually has no wish to duplicate appearances. He translates, indicates, and perhaps exaggerates. He goes to Nature for inspiration, but his work bears the stamp of his own personality. He is an interpreter rather than a copyist.

—ARTHUR L. GUPTILL (from *Freehand Drawing Self-Taught*)

I remember sitting with an advanced student one day at the Barnstone Studios when Myron appeared. He had brought a reproduction of Caravaggio's *Supper at Emmaus*. (This image is shown on page 92.) He placed it before us and asked what we thought made the composition so unified and powerful.

I knew he did not expect me to answer, as I had been there six months and had yet to utter a single audible word in his presence. The advanced student stared for a long time before confessing that he did not know. So Myron showed us that the figures sitting at the table were resting inside a sphere; the figures hug the one side and we (the viewer) complete the circle. The effect draws us powerfully into the painting. Caravaggio was not after a kind of photographic accuracy with this image, but a profound interaction between art, artist, and viewer. I was duly impressed and never forgot the lesson that simple geometric forms can be implied in a work of art—thus heightening our emotional response, although we might never know how the effect was achieved.

Art is not created by a direct transcription of the visible world. If you want to test this concept for yourself, trace a photograph; it obviously would be accurate in a basic way, yet you would find it surprisingly unconvincing, lacking both in life and artistry. The art comes in through the artist's intention. Transforming ordinary life into art requires becoming an astute observer. Infusing flat images with volume can unify diverse elements, creating a coherent whole. In this chapter, we identify ways of seeing these volumes and applying them to your drawing.

NICHOLAS RAYNOLDS, *Fire Escape*, 2009, pencil and gouache on paper, 20 ½ x 13 ¾ inches (52.1 x 34.9 cm)

The use of perspective and the diminution of value create the effective illusion of a large depth of field.

Identifying Geometric Solids

I was introduced to the concept of geometric forms in art in my first drawing class with Myron. He held up a wine bottle so that we saw it at eye level (with no ellipses—just a flat view of its contour) and asked, "How many two-dimensional shapes—squares, triangles, and circles—can you see in this bottle?" At first nobody knew what he was talking about; all we saw was the shape of a bottle. Then, after a few minutes I could see how the swollen shape in the center, which resembled a snake that had swallowed a ball, could be a circle. Next, someone found the rectangle, which was the body of the bottle. Someone else found a triangle that transitioned the circle into the rectangular neck of the bottle. (See additional image on page 70.)

Then Myron asked if anyone could find six triangles. At first there was silence. But, gradually, we started to see that every transitional angle was a portion of a triangle. Presto. In a matter of an hour, we were on our way to really seeing.

Being able to identify the simple two-dimensional shapes that make up a subject is an important first step. Once you understand this concept, the next challenge is to take those flat shapes and shift them into the third dimension. The circle becomes the sphere, the triangle a cone, the rectangle a cube (or a cylinder), and so forth.

ULAN MOORE, *Analytical Drawing of Bottles* (detail), 2011, graphite on paper, 18 x 24 inches (45.7 x 61 cm)

A simple object can be remarkably challenging to draw because it so easily reveals distortions. This image is based on the first drawing lesson taught at the Barnstone Studios.

MICHELANGELO MERISI DA CARAVAGGIO, *Supper at Emmaus*, 1601–1602, oil on canvas, 4 feet 6 ¾ inches x 6 feet 4 ¾ inches (139 x 195 cm), collection of the National Gallery (London, United Kingdom), courtesy of Art Renewal Center

Artists use elements of design to help convey their message. Caravaggio includes us at the table by having us complete the ellipse started by the figures in his painting.

All the objects in the natural world inhabit three dimensions, meaning they have height, width, and depth. Your vantage point will determine how much depth you see at any given moment.

The complex objects seen all around us can be more easily understood when thought of as a composite of basic solid forms.

The infinite number of complex forms found in the man-made and natural world can be represented with just a few building blocks. The knowledge of simple volumes will grant you a reliable entranceway into our three-dimensional world.

BENNETT VADNAIS, *Roman Forum,* 2004, graphite on paper, 10 x 15 ¼ inches (25.4 x 38.7 cm)

Our man-made environments are often constructed and filled with geometric shapes forged from architects' plans and designers' sketches.

I have pulled out a few geometric solids concealed in Vadnais's drawing. See how many more you can find.

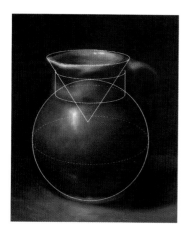

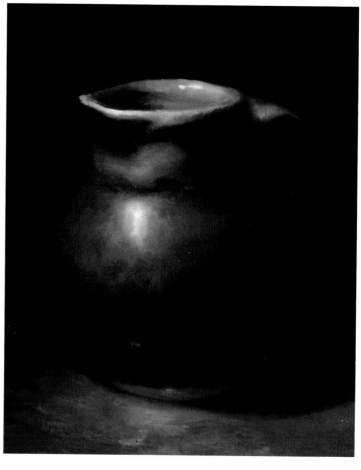

The knowledge necessary to create a convincing rendering of volume comes from the ability to visualize an object's underlying shapes.

JULIETTE ARISTIDES, *The Milk Jug*, 2003, oil on panel, 10 x 8 inches (25.4 x 20.3 cm)

Common everyday objects, like this jug, are a treasure trove of shapes to study.

OPPOSITE: REMBRANDT VAN RIJN, *Cone Shell (Conus Marmoreus)*, 1650, etching (ink on paper), 3 ¾ x 5 ⅛ inches (9.7 x 13.2 cm), collection of the Rijksmuseum (Amsterdam, The Netherlands), courtesy of Art Renewal Center

Here the closely packed shape never loses its geometry. Yet this drawing contains all the imperfections that make it beautiful, unique, and carefully observed.

The Sphere

A sphere is a globe. It is a highly versatile shape found in more places than you can imagine. A sphere has a few main ellipses that anchor it as a volume rather than allowing it to flip into the shape of a two-dimensional circle. Spheres are easy to spot in architecture: Look for a sphere every time you see an arched dome. If you go into an apse of a church and look up, you'll notice the space is anchored around the design of a sphere. Likewise, all arcs hint at a circle or sphere. For example, the flat shape of an eye can be graphically enhanced by imagining it as an orb sitting in a socket, the rim of the lids as full ellipses wrapping around the globe of the eye. An orange is obviously a sphere, yet the base of a water pitcher, teapot, or a bulging muscle may be based on the sphere as well.

The Cylinder

A cylinder can be found in fire extinguishers, candles, bottles, silos, and so forth. If the object looks like a rectangle when seen straight on, yet has a circular end when tipped, it is a cylinder. The sides of this shape are expressed with straight lines, yet its width is best described with arcs. Describing both attributes—the strength of the straight lines and the continuous curve of the surface—gives a lot of information to the viewer.

The Cube

Any right-angled form can be represented by a cube or rectilinear solid. Boxes, houses, books, and computer cases are obvious examples of these structural solids. Yet, some more hidden uses of cubes can be found in organic forms, such as knees, wrists, and ankles. As seen on page 117, the torso, pelvis, and head can similarly be imagined as cubed forms. The faces, or facets, of these cubed forms helps give objects a distinct orientation, allowing us to identify in what direction they are headed.

The Cone

A two-dimensional triangle can be transformed into several different three-dimensional constructions; the cone is perhaps the most common. Cones have a circular base that comes to a point

DEREK GUNDY, *Structural Drawing of Caulk Gun,* 2009, pencil on paper 18 x 24 inches (45.7 x 61 cm)

A fundamental geometric shape, this cylinder is defined by its parallel sides and elliptical extremes.

KATHERINE LEEDS, *Still Life Sketch,* 2010, charcoal on paper, 10 x 8 inches (25.4 x 20.3 cm), courtesy of the Aristides Atelier

The three planes of the brick give the viewer a sense of the height, width, and depth, all of which are necessary to have the image sit firmly in space.

Rembrandt. f.1650.

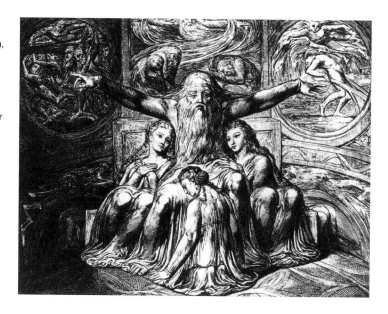

The geometry found in art does not only exist in individual objects but also in their composition. Here Blake has organized his figures into a memorable unit, the pyramid, conveying unity and hierarchy to the viewer.

This nineteenth-century artist conceptualized the giant press as a geometric solid. Although it was subdivided into countless smaller forms, it never lost the compact impression of a singular unity.

at the center of the very top, the apex. Anytime I see an object that has straight sides that are not parallel, it suggests the cone. An ice-cream cone or a tepee is obvious, yet a paper coffee cup or the neck of a wine bottle both have a slight tapering and would be represented by a cone as well. Some trees can appear conical. Look at an evergreen tree, for example, and see how the expansive bottom branches get smaller and closer together as you move up toward the top. Some gourds also reveal a creative, organic use of the cone.

The Pyramid

A pyramid or a tetrahedron (a three-sided pyramid) is essentially a cone with a square or triangular base. If you have tapered angles but see planes rather than ellipses or arcs, consider the pyramidal form as the way to go. Pyramidal forms are found mostly in architectural

A pyramid is a highly stable structure, both physically and visually. Most of its mass rests upon the ground.

elements, such as the rooftop of a tower. (Think Big Ben.) Any square-shaped base that tapers into a narrower neck forms a segment of a pyramid. My saltshaker has a faceted base and transitions into a round silver cap; the transition between the two is pyramidal in character.

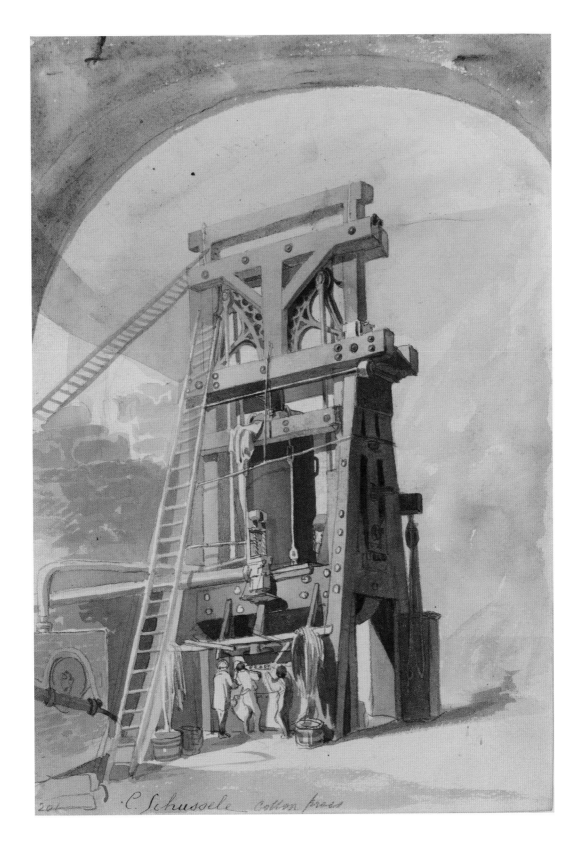

C. Schussele cotton press

MICHAEL MENTLER, *Hand Studies,*
2009, pen on toned paper heightened
with pastel pencil, 13 x 10 inches (33 x
25.4 cm)

Drawing hands causes students no end
of anxiety. Having a way to formalize the
soft anatomical curves into planes and
volumes provides a reliable entranceway
to begin your drawing.

Using Simple Geometric Forms

Mastering the ability to identify the underlying structures in what
you see makes drawing those things easier on two fronts: First, you
can use these large volumes to help you conceptualize what you are
looking at. Second, articulating the three-dimensional shapes in
your drawings can help you orient your forms in space.

When you start thinking of internal shapes in this way, a subtle
but important shift frequently happens: The fullness of your forms
becomes undeniable. Matter pushes out; it has girth and fatness.
By visualizing internal shapes you inadvertently leave more room
for the form. Also, you create an interesting integrity across the
body of the image when you construct it from volumes. This type
of thinking by its very nature precludes you from contour drawing
(just tracing the outline of your subject) without any thought of
what is happening on the other (unseen) side of the object.

In chapter two you learned to find accurate angles in your
subject by noticing the changes in orientation as they relate to
your knitting needle or plumb line. Larger shapes can be also
determined with your needle when you realize that anytime a line
angle moves away from your needle it also indicates a change of
shape and a change of plane. When you see angle changes, it is a
good indicator that what you are drawing will not be a single shape
but a composite of different forms. Eventually you will get so com-
fortable with this process that when you see an angle change you
will automatically understand that it is also a plane change, even
without formally siting it.

*Memorize the anatomy of geometric solids, as they
form the building blocks of complex structures.*

Take time to practice identifying the geometric shapes you
see around you. Try to see them in everyday objects, and also try to
sketch them in a notebook dedicated for this purpose. For instance,
as seen in Mentler's studies on the facing page, the human hand can
be visualized as a sequence of rectilinear solids. Creating drawings
such as this will help you begin to become sensitive to the ubiqui-
tous nature of volumes. Start with easier-to-decipher, man-made
objects and work your way up to the organic forms of nature.

Once you understand this concept, you will no longer just copy
what you see. Rather, you will begin to have insight into your sub-
ject, enabling you to disassemble it and reconstruct it on your paper.
Furthermore, you will enhance the sense of form in your work by
pushing the illusion of volume.

SYDNEY MCGINLEY, *First Tulip Series #1*, 2004, Conté pencil on paper, 30 x 20 inches (76.2 x 50.8 cm)

A long-time student of Myron Barnstone's, McGinley here draws the cross-contour lines that wrap around the petals, describing the flower's topography. She has altered the soft curves of the flower into formalized geometric structures, such as a cylinder for the stamen and a stylized pyramid for the overall form.

Lines that just touch are visually ambiguous. The bird on the right appears to be farther away than the one on the left because it is smaller. But because these forms do not clearly overlap, their spatial relationship is unclear.

Implying the Third Dimension

Before linear perspective was discovered (or rediscovered, depending on your opinion) in the Renaissance, artists had a number of effective ways of creating the illusion of space, or the third dimension, in their work. Certain visual clues helped them create objects that seemed to be closer or farther away. We can use these same concepts today in combination with linear perspective to achieve believable three-dimensionality in our work.

The closer an object is to the front of the picture plane, for example, the larger it appears. Therefore, when you make an object or figure larger than another in your work, it naturally seems closer. In addition, because objects with a completely continuous outline appear to read in front of objects with a broken contour line, overlapping a

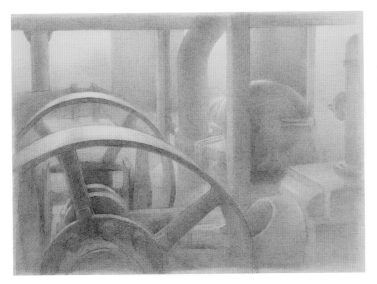

ELIZABETH ZANZINGER,
Gasworks, 2009, pencil on paper, 9 x 12
inches (22.9 x 30.5 cm), courtesy of the
Aristides Atelier

The artist introduced a strong depth of
field by darkening the foreground element
and sharpening the focus of the closest
object.

FOLLOWING PAGES: GEORGE FENNEL
ROBSON, *View from the Grounds of Penrhyn
Castle Looking towards Nant-Ffrancon*, date
unknown, watercolor on paper, size
unknown, collection of Penrhyn Castle
(Gwynned, Wales, Great Britain)

Photograph by John Hammond

*Photo Credit: National Trust Photo Library/Art
Resource, New York, NY*

This image perfectly shows the use of
aerial perspective. The large mountains
fade into the background while the
foreground advances toward the viewer.

form can anchor it firmly in a given location. For example, if I see
someone's head and shoulders overlapping the line of a door frame, I
understand that the person is in front of the door frame.

*Distance can be implied in art in many simple
ways, such as playing with edges, value,
placement, and scale.*

As we learned on pages 83–85, edges also indicate position;
sharper edges move an object forward, and softer ones push it back.
Fading a line out entirely will push it behind whatever form is in
front. According to the laws of aerial or atmospheric perspective, the
farther something is from the observer, the more it is enveloped in
air and loses its distinctness. Dark objects get lighter the farther they
retreat, and light objects get darker. Color also becomes more muted
and grayer as it recedes. Including these ideas in your lines and tone
really will make the space in your drawings read more effectively.

Depth can also be implied by the relative position of objects
within the picture plane. Objects that start lower on the picture
plane read as closer in space; objects that are higher read as closer to
the horizon line and, therefore, farther away. Looking out the win-
dow of my third-floor studio, for instance, I see that the ground is
low. In fact, from my vantage point the ground visually rests against
the windowsill, with the buildings, lake, and trees climbing up the
pane of glass as they move back in space. I could take a dry-erase
marker and actually make marks on the glass to document how they
incrementally creep up the pane. If you have the chance to try this
yourself, it is a great way to grasp this concept.

JORY GLAZENER, *Medieval France*, 2006, bister ink on rag paper, 11 x 8 inches (27.9 x 20.3 cm)

We are brought into the picture by the artist's use of perspective. The angles along the road lead our eye toward the horizon line.

Utilizing Linear Perspective

Artwork made prior to the Renaissance often contains contradictions in perspective. For instance, a table may be depicted as if it was seen from above, a chair as seen from the side, and a figure towering way beyond all sense of proportion or scale—all in the same drawing. These visual impossibilities were accepted because of the spiritual worldview of the time. If, as they believed, God sees from all vantage points at once, it made philosophical sense to show objects in this manner. Since the development of linear perspective during the Renaissance, however, we are more comfortable utilizing a single vantage point. Today, inconsistencies found in drawing are generally not philosophically based, but simply the result of careless drawing.

Many mistakes in drawing are easily prevented by paying more careful attention to perspective. Perspective offers clues to visual perception, helping us grasp things that we intuitively know but do not necessarily register on a conscious level. The more accurately we can show three planes (height, width, and depth) to describe every form, the more solidly it will sit in space. Luckily, clues to aid you in drawing are all around; you just need to know what to look for. Keeping track of a few simple rules can help you make thoughtful decisions in your drawing. Even if you do not plan on doing a fully worked-out perspective drawing, noticing these elements can make you a more careful and accurate observer. The three main concepts are eye level, horizon line, and vanishing point.

Note your eye level and the placement of your vanishing point before you begin a drawing.

Many aspects of drawing require a fixed point of viewing. This is the position from which you will site all your angles and capture the scene at which you are looking. Even if you are not formally working out the linear perspective, being able to envision your eye level becomes important for establishing consistency in your work. To determine your eye level, ask yourself if you are looking down or up at your subject. If you are looking down at something (for example, you see inside a cup), it means your eye level is above the object. If you are lying down and someone brings you the cup and you see its bottom, your eye level is below the cup. If you cannot see either the top or bottom of the cup, just a profile or silhouetted side shape, then the cup is at your eye level.

The horizon line is the line (either visible or imaginary) that runs across the picture at your eye level. The easiest ways to envision the straight line of the horizon is to picture where the ocean or a wide-open field meets the sky. The horizon line is always at your eye level, whether you are on land, at sea, or in the sky.

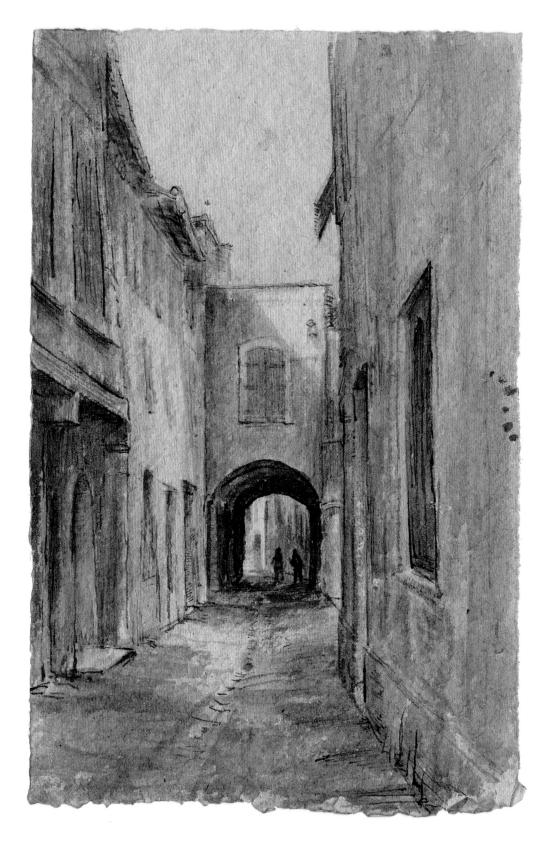

IDA BENDHEIM, *Kimberly Road,*
circa 1929, watercolor on paper, 12 x
18 ½ inches (30.5 x 47 cm), collection
of Juliette Aristides

The artist naturally creates a feeling
of correct perspective in this African
landscape by carefully observing and
drawing her subject.

Follow the lines of the road to see how
they appear to converge at a single spot,
called a "vanishing point." The horizon
line divides the earth from the sky and
signifies our eye level in this picture.

The vanishing point is the spot where angles visible to your eye converge. The vanishing point always exists somewhere along the horizon line. The most classic example of visualizing lines that converge to a single vanishing point is to stand between two railroad tracks and look as they recede into the distance. You do not need to use your imagination; you can actually see the two straight lines recede toward a point in the distance.

Perspective turns the two-dimensional world of drawing into a believable illusion of three-dimensional space.

The railroad scenario is an example of single-point perspective because it features one vanishing point. Most situations, however, require two or more vanishing points (or two-point perspective) to be rendered accurately. Because this book is a survey course, we can only touch on this subject briefly. Whole books are written about the laws of perspective. Suffice it to say, you can get a good start just by trying to implement a little at a time. If your interest compels

you to do further research, many books are available, including *Drawing from Observation* by Brian Curtis and *Design Drawing* by Francis Ching, two easy-to-understand books on perspective.

Many drawing inconsistencies can be avoided by having knowledge of some basic rules of perspective and by careful siting key angles.

Most perspective issues found in still life and figure work can be solved just through very careful drawing. But some understanding of perspective is helpful in recognizing what you are seeing and increasing your sensitivity to where you are in error. Gary Faigin, artistic director at Gage Academy of Fine Art, has a perspective rule that he calls Faigin's Law: "If it looks right, it is right." You can get away with a lot, but learning some rudimentary perspective correctly from the start will help you wing it when necessary.

LEONARDO DA VINCI, *Perspectival Study of the Adoration of the Magi*, circa 1481, pen and ink, traces of silverpoint, 6 ⅜ x 11 ⅜ inches (16.3 x 29 cm), collection of the Galleria degli Uffizi (Florence, Italy), courtesy of Art Renewal Center

In this remarkable preparatory drawing, da Vinci worked out the formal perspective of the space and sketched on top the action of the horses and figures.

ALEX CURTIS, *Untitled*, 2005, graphite pencil on paper, 8 x 10 inches (20.3 x 25.4 cm), courtesy of the Barnstone Studios

Here the artist formally plotted each element of the object. Through the correct placement of the ellipses we get a real sense of the three-dimensionality of the object just with line.

The Importance of Ellipses

Ellipses are quite important in drawing; they crop up everywhere. You can run, but you cannot hide from this shape. A classic ellipse example can be seen by holding a coin in between your thumb and forefinger and gradually rotating it. Depending on where you are in the rotation, the shape can be a circle, an extremely narrow ellipse, or something in between.

Incorrectly drawn ellipses always draw attention to themselves. Indeed, ellipses have caused the downfall of many drawings. Your ellipses do not have to be plotted mechanically, but they should be believable.

An ellipse is a circle that has been uniformly pushed down either from the top or from the sides. It has two axes; the longer one is called the major axis and the shorter one is called the minor axis. The long axis will remain the same but, as the object tips, the short axis gets narrower.

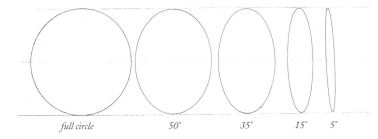

full circle 50° 35° 15° 5°

A circle on a tipped plane forms an ellipse. In this progression you can see the height stays the same; however, the width drastically compresses. Also notice that the shape of the ellipse is a continuous curve, with no straight lines or points.

Diagram by John Clark

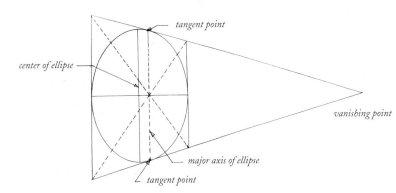

tangent point

center of ellipse

vanishing point

major axis of ellipse

tangent point

This circle is shown in perspective, with the important major and minor axis lines indicated. Note the difference between the visual center and the true halfway line.

Diagram by John Clark

It is interesting to note that the true halfway line that runs through an ellipse in perspective is different than the visual center of the object. The visual center resides in front of the measurable halfway point. The ellipse swells in space and pushes out the front of the arc toward the viewer, burying the halfway point behind. One common mistake among beginning artists is to make ellipses with points at the ends instead of carefully gradated arcs. Another big mistake is having a number of vantage points in the same drawing. For instance, without realizing it a beginner may draw a cup from several perspectives, ending up with an arced top and a flat bottom. Very often this happens because the artist is drawing too close to his object or is drawing what he expects to see.

Incorrectly drawn ellipses detract from the excellence of a work.

Alternately, not showing a careful change of ellipse as objects move back in space makes those objects feel as if they are not anchored. Sometimes artists mismatch the two sides of the ellipse, so the curvature feels wonky. Inconsistent ellipses and angles send strange messages about where your vantage point is and how to read a piece.

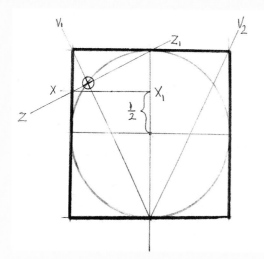

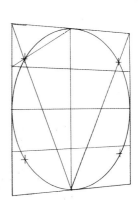

This illustrates how to make a circle (which is a special ellipse) in a square. Using geometry, you can locate the key points from which to swing the arcs. These same key points can be identified to form an ellipse, as shown in the adjacent diagram, which is really just a circle in perspective.

Diagram by John Clark

Artists typically do not use formal construction for most freehand ellipses; however, practicing helps you understand what correctly drawn ellipses should look like.

Diagram by John Clark

A HIGHLY ACCURATE METHOD OF creating ellipses was introduced to me by the aviation artist John Clark, who once visited my atelier. Draw a square and mark the halfway points along each of the four sides. Connect the dots on opposite sides, forming your major axis lines and creating four quadrants. Then draw a V, connecting the bottom center of your square to each of the two top corners. Divide the upper-left quadrant in half horizontally. Then draw a diagonal line from the vertical halfway point on the left perimeter of the quadrant to the horizontal halfway point on the top of the full square. The intersection between this diagonal and the diagonal of your V gives you your critical point for the ellipse. Repeat this process on all four sides and you will have the four points needed to swing your ellipse.

This same system also works for an ellipse seen in perspective. Find the halfway point on a plane in perspective (not shown here) by drawing the major diagonals from corner to corner and then placing the halfway marks where they intersect. Clark shows an in-depth illustrated sequence of this construction on my website, **www.aristidesatelier.com.**

Drawing Three-Dimensional Objects

When drawing generally symmetrical still life objects, start off the same way as you would with a contour line drawing. (See page 52.) Mark the top, bottom, and halfway measurements of your object on your paper. Then determine the relationship of the overall width to the overall height. In this manner, you delineate the overarching proportion of your subject.

The next step—moving from two dimensions to three—is a quick one. For example, when drawing a pear, I may find the height to be something like twice the width. Within that overall proportion I identify a circular form at the bottom of the pear that transitions into a triangular top. These geometric clues make it easy to imagine this object in the third dimension—with a spherical base and a conical top. When drawing, envision that you are reaching around, behind, on top of, and beneath your object. In this manner, you will be able to imply its tactile bulk.

MARK ANTHONY GUCCIARDI, *Moka Pot*, 2008, pencil and chalk on toned paper, 9 ⅜ x 5 ⅞ inches (24 x 15 cm)

This espresso maker is rendered with striking effectiveness. Because the planes are drawn correctly, the addition of light and shade creates a convincing illusion of weight and volume.

JULIETTE ARISTIDES, *Concepts for Figure Drawing*, 2010, sepia pencil on paper, 24 x 18 inches (61 x 45.7 cm)

Conceiving of the figure as three major masses (head, torso, pelvis) and correctly orienting these masses over a dominant line of action provides a strong start for any figure drawing.

OPPOSITE: MICHAEL MENTLER, *Five Figure Studies*, 2009, pen on toned paper heightened with white pastel, 13 x 10 inches (33 x 25.4 cm)

The artist has distilled the figure into the three basic building blocks—the head, torso, and pelvis. Notice how the lines of the boxes correspond to key anatomical relationships.

Drawing a Three-Dimensional Figure

Your study of the figure will benefit greatly from learning to visualize the composite forms. Artists like Robert Beverly Hale and George Bridgman, who taught at the Art Students League in New York City, gave a wonderful gift to students by writing and teaching structural anatomy. Bridgman formalized the muscles into larger groups that could be represented by blocky shapes. I highly recommend his books on the subject.

Artistic anatomy will grant you insight into how the figure is constructed. This knowledge will enable you to infuse clarity into obscure areas.

The clues on the body are often difficult to interpret. Most models are not chiseled enough that their muscles and bones are clearly seen. We need a little insight to give us a leg up, so to speak. Books on artistic anatomy give artists an effective and intelligent way to shorthand information.

A common figure drawing exercise using this approach involves breaking down the body into simple masses. The skull can be formalized as a globe, with an egg depicting the mask of the face. The neck can be treated as a cylinder. The rib cage can be an egg or a rectilinear cube; the wrists, cubes; the forearms, eggs; and so forth.

Many artists contest this transcription of the human form because it is not based on direct observation. Rather, it is a series of mental constructs derived from artistic convention. I encourage you to study this approach, however—because it works. It will aid your understanding as you look at your figure.

In the words of Rudolf Arnheim, a brilliant perceptual psychologist, in the book *Art and Visual Perception*, "All perceiving is also thinking, all reasoning is also intuition, all observation is also invention." However, I caution that you should use this formalized treatment of the body only in studies and not directly in your finished work. A case in point: By visualizing the head as a cubed form you will be able to exploit the tip of the face, the angles of the skull, and its orientation toward the light. Yet, if you draw a box for the head, with dark lines on your paper, you will create a block head, and no amount of modulation later will fix it.

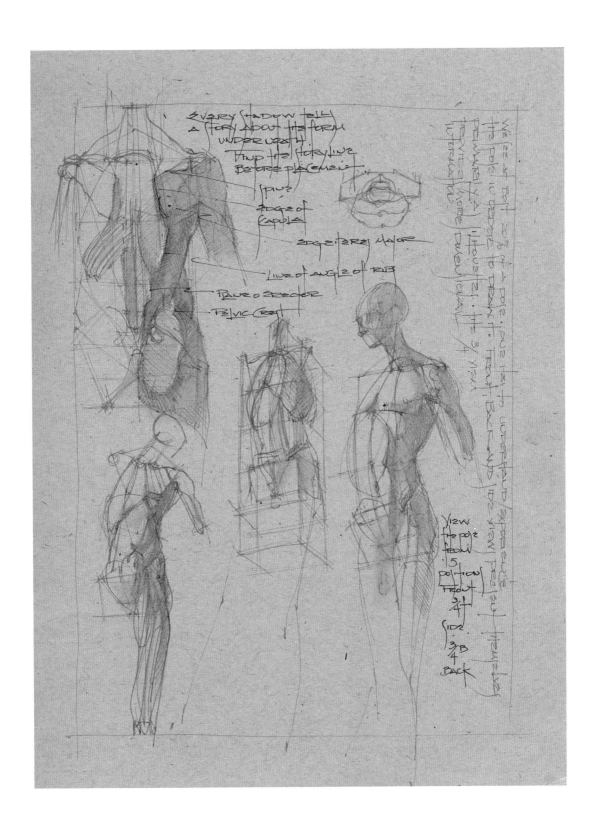

EVERY SHADOW TELLS
A STORY ABOUT THE FORM
UNDERNEATH

FIND THE STORY LINE
BEFORE PLACEMENT

SPINE

EDGE OF
SCAPULA

EDGE OF TERES MAJOR

LINE OF ANGLE OF RIB

PLANE OF ERECTOR

PELVIC CREST

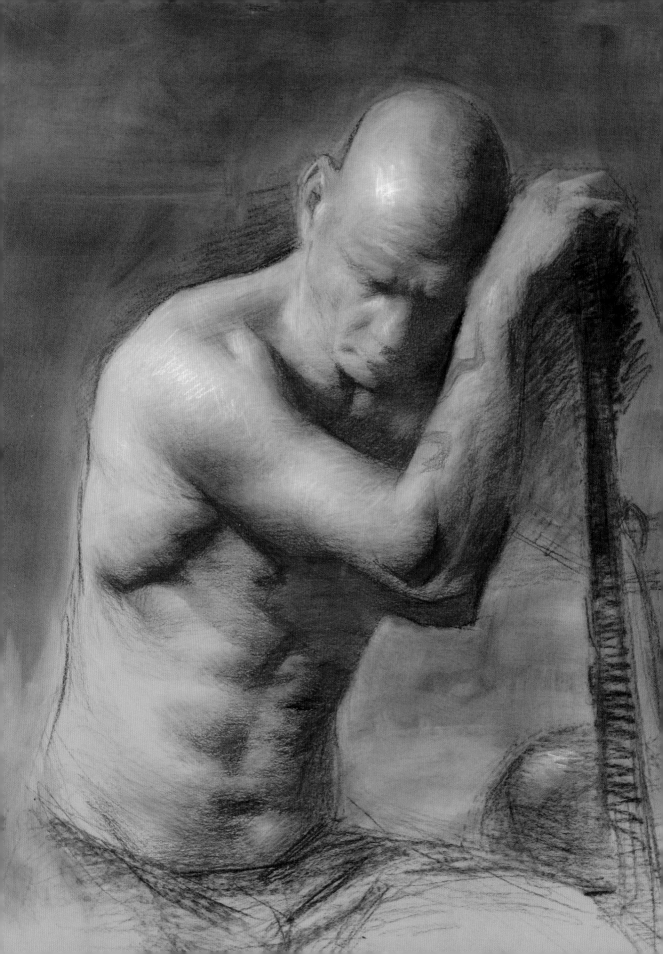

Drawing the Three Major Masses

At times, I enjoy looking at comic-book superheroes and villains. They are drawn to feel larger and more powerful than life, resembling a cross between a machine and a bodybuilder. As fine artists, we do not aim to have our figures look like Superman, but we do want to borrow his sense of volume and maybe his laser sight. A few clues from artistic anatomy can help you conceptualize the various geometric forms for the figure. I find it especially useful to visualize the three major masses of the body—the torso, the pelvis, and the head.

The Torso

Curved forms are hard to position in space. Creating a box that orients the torso is a helpful way to visualize the mass of the rib cage buried beneath the shoulder girdle. I like to start with the rib cage before placing the head and the pelvis, because the large, central form of the torso immediately anchors the figure. I envision the three major masses—the torso, pelvis, and head—as being strung along a single line (such as a weight line) that spans the length of the figure.

Always draw both sides of the body simultaneously. After you place the first side of the ribcage, your hand should immediately swing to draw the enclosure on the other side.

To find the rib cage, start by drawing the collarbone, which runs across the front of the figure from one shoulder to the other. You can feel it on yourself if you touch the pit of your neck and run your fingers along as it moves to either side. The collarbone is always perpendicular to the breastbone, which runs down the center of the rib cage.

The shoulders can be hard to position because they are rounded. (A circle shows no orientation; it doesn't matter how you turn it, the circle remains unchanged.) However, the right-angle relationship of the collarbone to the breastbone makes a reliable point of orientation for the angle of the shoulders. Draw a line across the shoulders representing their tip in space in relation to the breastbone.

Next, find the two sides of the rib cage, which can be described by two parallel lines or two egg-shaped arcs. Look for the point where the waist is the narrowest to position where the end of the box or egg shape will be. This can be seen in the image on page 112.

OPPOSITE: JULIETTE ARISTIDES, *Soldier*, 2010, charcoal and sepia pencil on paper, 24 x 18 inches (61 x 45.7 cm)

Imagining the torso as if it is a three-dimensional construction provides a visual aid for drawing it. This also creates a logical framework upon which to place the smaller forms.

JACOB COLLINS, *Ribcage and Pelvis*, 2010, graphite and pencil on paper, 14 x 11 inches (35.5 x 27.9 cm)

Collins has filled sketchbooks with studies of the human skeleton. Here you can see the slight forward tip of the pelvis in relation to the tilting back of the rib cage.

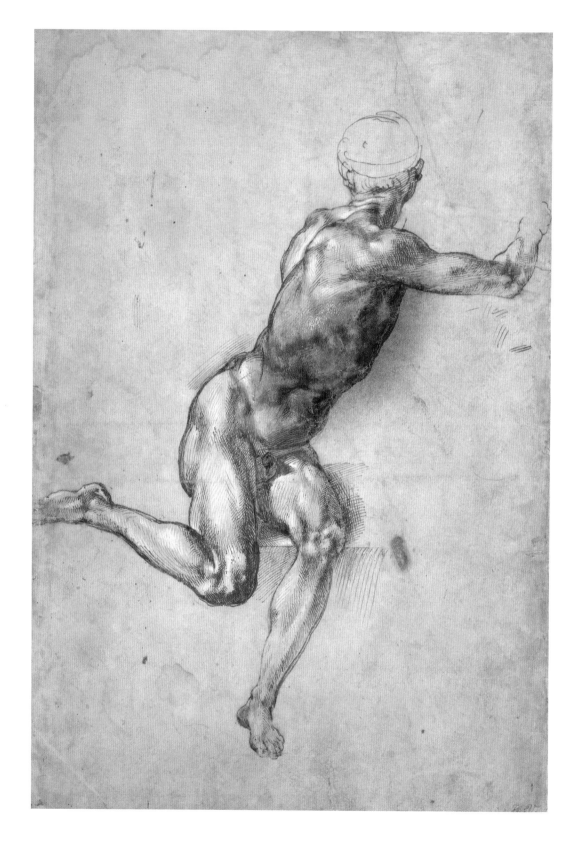

Remember that to create a convincing volume you need three dimensions—height, width, and depth. The process indicated thus far indicates the height and width. The depth orientation is noted by marking the plane along each side of the figure, under the armpits down to the waist. Unless you are viewing the figure straight on, you will naturally see more of one side or another. The girth of the top of your box will span the width of the shoulder girdle.

Make sure to determine if you are looking at the box of the chest at eye level, or from above or below. Create emphasis by darkening the front-facing edges, so the box appears to sit properly in space.

When you are drawing the figure from the back, it is helpful to have a few landmarks. The tip of the back of the rib cage can be determined by identifying the points of the shoulder blades and running a straight line across from one side of the body to the other. This line will help you orient the rib cage the same way the collarbone did from the front. The spine will further aid you in finding the centerline along the back. Measure from the spine to the side of the figure to see if it is dead center or if you are seeing more on one side. This shows which way the box of the rib cage is leaning. And finally, run two lines or arcs down the sides of the rib cage.

The Pelvis

The pelvis is based on three major points. First, find the two hip bones. (I recommend finding these boney protrusions on your own body; once you feel them it is easy to see them.) If you are working with a model, sometimes a very kind and understanding one will let you put a piece of colored tape on each of these jutting bones, allowing you to visualize how those two points connect together to form a strong angle, which alters as she or he changes poses. The third point in the triangle of the pelvis is between the legs. Drawing the triangle of the pelvis will effectively orient the whole pelvic mass.

The boxy nature of the pelvis creates a strong visual anchor for the continuous curves of the body.

To create a block for the pelvis I first draw the angle between the hip bones; then, I draw two parallel lines along each side of the figure from the hip bones to imaginary points a little way down. Next, I find the bottom of the rectangle by running a line at approximately the widest point across the thigh. Next, establish your eye level. Are looking down into the box of the pelvis, like you would in a seated figure, or up at the box, as you would in a figure climbing a ladder? If you are seeing more of one side of the figure than the other, the side of your box will be visible on this area of the figure.

Drawing on tracing paper on top of master works affords a wonderful opportunity to practice finding the major masses of the body. I found the three major masses of this body and the orientation of the limbs.

OPPOSITE: MICHELANGELO BUONARROTI, *Study for Battle of Casina*, 1504, chalk and silverpoint on paper, 13 ⅞ x 9 ⅛ inches (35.6 x 23.5 35.6 cm), collection of the Galleria degli Uffizi (Florence, Italy), courtesy of Art Renewal Center

Michelangelo was a master at formalizing the human body into a well-orchestrated series of volumes, thereby giving the illusion of three-dimensionality.

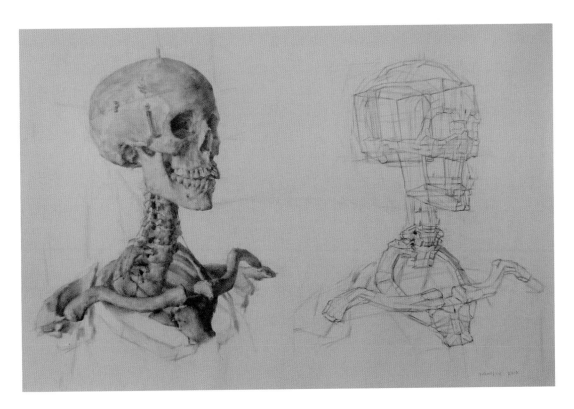

The back of the pelvis has two dimples that hug the tailbone. Establish the third point at the top of the natal cleft to make a triangle. This triangle will indicate the tip and tilt of the pelvis. Keep in mind that, on a normal standing figure, the pelvis tips forward slightly and the rib cage tips back, forming a distribution of weight between the two masses. The bottom of the pelvic block is the shelf underneath the buttocks. (See image on the facing page.)

The Head

The head has clearly identifiable top, front, back, and side planes. The front of the head is distinguished by the facial features. The centerline, which runs between the eyes down to the chin, tells us if the features are straight on or if the head is turned. When seen directly, the features—such as the eyes, base of the nose, and the center of the lips—form perpendicular angles to the centerline and help us see the tip and tilt of the face.

The sides of the face start at the temples and move through to the back of the head. To feel the side plane of your head, simply place your hands over your ears and feel the flatness. Now gently move your head around. You can feel the angle of those side planes adjust along with the movement of your head.

DAN THOMPSON, *Structural Drawing,* 2010, graphite and colored pencil on paper, 19 x 25 inches (48.3 x 63.5 cm)

This outstanding drawing records an exploration of the skull, not in an abstracted or theoretical way, but as a carefully observed image. On the right side of the page Thompson shows us he has a firm understanding of the dimensions that make up the human skeleton.

OPPOSITE: SCOTT NOEL, *Teaching Drawing: Evolution of Figure from a Skeletal Armature,* 2007, Conté crayon and pastel on paper, 30 x 22 inches (76.2 x 55.8 cm)

Noel constructs his figures from the inside out. His astonishing knowledge of anatomy enables him to see through the skin to the skeleton and the muscle masses underneath. The diagrams on the right show the correct drawing of the pelvis as a bucket tipping forward in space.

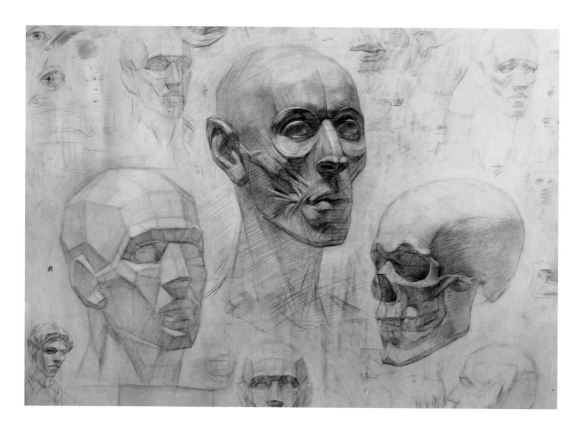

FARIGH GHADERI, *Dissecting the Head,* 2005, pencil on paper, 19 ⅜ x 23 inches (49.5 x 59 cm)

This drawing shows an interesting combination of the artist's knowledge. The skull is on the far right, a conceptualization of the planes of the face is on the left, and in the middle are some of the major muscle groupings of the face. All of these ideas are important for understanding the head.

The back plane of the head is synonymous with the back of the skull. It is smaller than the front of the head and is often represented by a cube or sphere. The underside of the mask of the face can be seen by the bottom of the jawline. Often this is easy to see because in normal lighting conditions you can see a shadow shape underneath the jaw.

The features so dominate our understanding of the face that it can be difficult to draw a convincing head. Visualizing the head as a volume aids the artist in capturing the entire frame of the skull.

To continue your study of the major masses of the figure I recommend you overlay tracing paper on drawings or pictures of figures to practice finding these volumes, such as the one I analyzed of the Michelangelo drawing on page 117. If you have access to a skeleton or cast of a figure, you can further your comfort level with the material by drawing these objects. And finally, it is helpful to further your studies with a thorough anatomy book, such as Eliot Goldfinger's *Human Anatomy for Artists.*

Drawing the Smaller Forms of the Figure

The same concepts used for blocking in the three major masses of the body can be translated to the smaller details as well. If you are drawing a forearm, for instance, you may envision the major muscle mass as a series of ovoid forms tapering into more of a cylinder and ending in a box of the wrist. Most subjects, man-made or organic, can initially feel overwhelmingly complex; yet when broken down into a composite of simpler forms that can be isolated and studied, they end up become manageable.

The advanced draftsman understands the importance of spending time learning to create the illusion of three-dimensional form. Volume provides a sense of mass and weight that will always make your work more believable. While it takes time and training to identify and depict volume, as you learn to decipher visual clues, it will eventually become second nature.

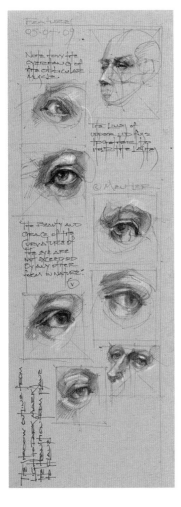 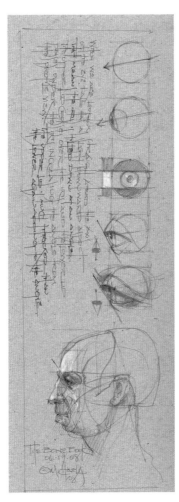

FAR LEFT: MICHAEL MENTLER, *Eye Studies*, 2009, pen on toned paper heightened with white pastel, 13 x 5 inches (33 x 12.7 cm)

Mentler's formal understanding of the structure of the eye helps when finishing his image. Notice the solidity of the lids as they wrap around the orb of the eye.

LEFT: MICHAEL MENTLER, *Study of the Eye*, 2009, pen on toned paper heightened with white pastel, 13 x 5 inches (33 x 12.7 cm)

Mentler studied the tip of the eye and the progression from two to three dimensions, starting with a circle before transforming it into a characteristic orb.

LESSON 4 VOLUMETRIC DRAWING

SOME PEOPLE ARE NATURAL STILL LIFE or landscape artists and feel no desire to work from a life model; however, very few artists can avoid the figure for long. Historically, being able to render the human form was considered the highest attainment for the artist. Even though the hierarchy of subject matter has changed, today we still find the human condition most easily mirrored in the figure itself.

That said, the figure remains a difficult subject to master. I recommend that you acknowledge the difficulties that lie ahead and set aside your worries. Instead, focus on sound principles, such as capturing a believable gesture, measuring accurately, running your angles through, and identifying and rendering geometric forms. Calmly and deliberately break the process down into the artistic stages necessary to progress from start to finish. And finally, plan on doing a lot of life drawing. Your drawings will get stronger and more confident with time and practice.

GATHERING YOUR MATERIALS
In preparation for your figure drawing, assemble the following materials:

> Drawing paper
> Drawing board
> Vine charcoal or graphite pencil
> Pencil sharpener or sandpaper
> Kneaded or hard eraser
> Tape
> Plumb line
> Narrow knitting needle or skewer

SETTING UP YOUR DRAWING
Fasten your paper securely to a drawing board. Then analyze the position of your subject to determine the orientation of your drawing. Remember to stand at a comfortable viewing distance, far enough away from your model to see him or her without moving your head. If your subject is wider than it is high, you may want to work with your paper positioned horizontally. If your subject is taller than it is wide, you probably want the drawing to be vertical.

CREATING YOUR FIGURE DRAWING
Successful drawing often starts from the inside out. I recommend establishing a few governing lines to capture the overall gesture before trying to locate the major masses of the figure. This project touches on visualizing the geometric forms contained within the human form. If you consider these volumes carefully early on, your figure will naturally contain mass and logically reside in space. The contour of the figure can be found progressively, affording you time to gradually get it right. Meanwhile, aim for a solid drawing rather than a likeness. With this as your goal, you will attain a better outcome.

STAGE ONE: *Capturing Proportion and Gesture*
Begin by determining the proportional accuracy and capturing the broad gesture of your figure. (I always start by marking the top and the bottom of the form; then, I drop a plumb line to determine the center of gravity.) Keep your lines very light at this stage. I often find it helpful to mark the direction of the shoulders and the hips. The horizontal line near the top (along my vertical plumb line) marks the slightest tip of the shoulders. The diagonal line toward the bottom shows a more marked inclination. I placed a C-shaped arc from the back of the head down to the hips, and repeated it again toward the front. Every drawing is going to have a different series of lines that account for its unity and power. Determine which lines are important by squinting down and identifying the dominant lines in the gesture.

STAGE ONE: Focus on a clear directional line, such as the length of the figure. Then look for the overall gesture or any strong design elements.

STAGE TWO: Locate the orientation and shape of the torso, pelvis, and head. Look for simple planes, such as the side- and front-facing planes of the head, the flat of the back, and so forth.

STAGE TWO: *Blocking in the Figure*

Now start to focus on the more obvious elements of the figure. Identify geometric forms that can articulate the torso, pelvis, and head of your model. Visualize how these forms are situated in space, and especially how their planes correspond with the surfaces of your model.

Block in the torso, then move to the pelvis and the head. Check that the head is correctly placed and that the arms and legs are in good relationship to one another. Try to develop your drawing as a single unit, with everything working together. Stay in this stage as long as you need to. Much of what makes a drawing strong happens at the beginning.

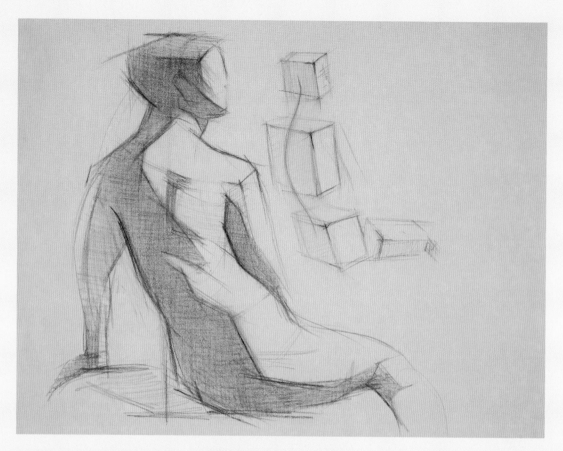

STAGE THREE: Lay a solid tone over the planes of the body that are in shadow to show how they turn away from the light source. Keep them unified and simple to start.

STAGE THREE: *Moving Toward Accuracy*

Now find some of the three-dimensional structural elements that will give your figure volume and mass. Think in terms of volume as well as line. I recommend drawing a small sketch to help you conceptualize the direction of the drawing. (Immediately to the right of my main drawing I created a small diagram that uses simple geometric forms to orient the three main masses of the figure, plus the thigh and the top of the calf.) Note how these planes are used to organize the structure of the figure in the progression of the image.

With the major geometric forms now in place, start connecting areas with a more fluid contour line. In the beginning, big lines should dictate all of your decisions. As you develop your drawing, however, start to find smaller line segments, shapes, and more subtle corrections.

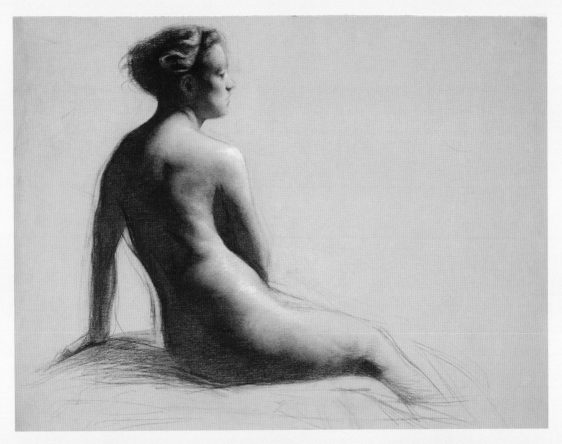

STAGE FOUR: Modulate the large planes of dark and light into a more subtle series of observations. Soften straight lines, temper edges, and indicate halftones.

JULIETTE ARISTIDES, *Isabelle*, 2011, sepia pencil and charcoal on paper, 18 x 24 inches (45.7 x 61 cm)

STAGE FOUR: *Articulating Halftones and Accent Points*
During the last stage I mapped out the core shadow (the dividing line between light and dark) and placed a light general tone over the shadow areas. This broadly placed value afforded me another way to reflect on the accuracy of the image. As I began this stage, I tried to determine if my large planes were effectively sitting in space and hanging together as a unified structure.

Now your goal should shift to finishing the piece without losing the structural foundation. It can be challenging to develop the small shapes without violating the larger ones. I tried to reconcile these two goals by keeping in mind the larger volumes that I had established in my small sketch. This involved slowing down and gradating the transitional tones, bridging one area into another.

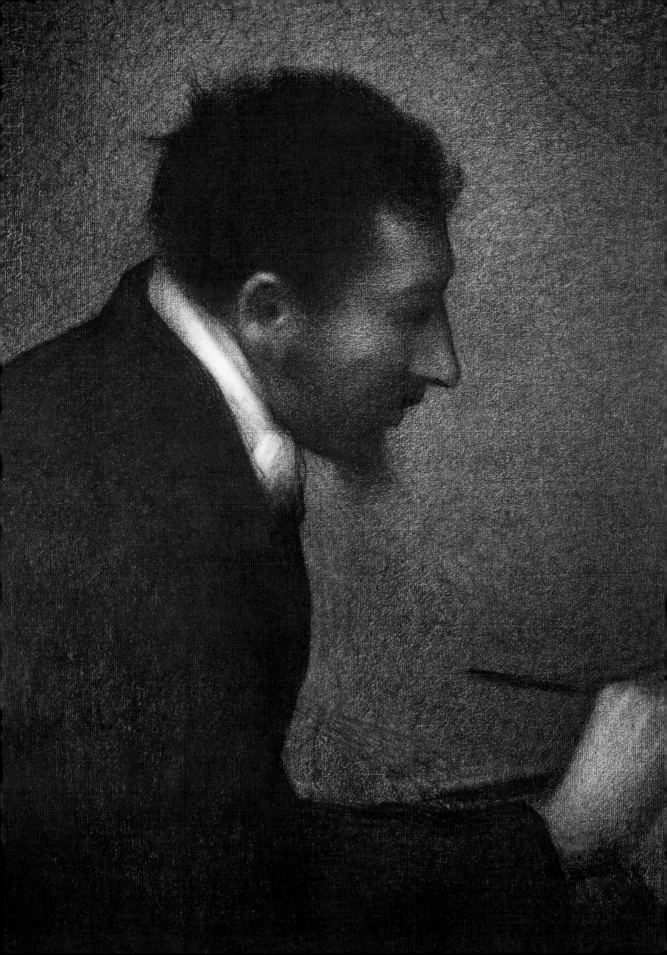

CHAPTER 5 TONAL COMPOSITION:
A PALETTE OF NUANCED GRAY

The word beautiful *is defined as eminently satisfying to the senses and the mind. It seems to be applicable whenever a series of disparate elements are brought together to form a memorable pattern, a cohesive whole, a physical or conceptual unity.*

—KROME BARRATT (from *Logic and Design in Art, Science, and Mathematics*)

We live in an age when we are constantly bombarded by imagery. The average person, in fact, sees thousands of images a day. At a certain point, they blur together into a sea of pictures that are forgotten as quickly as they are seen. In order for your work to stand out, you must understand the fundamentals of value pattern. It will compel viewers to pause and appreciate the totality of your artwork.

I recently juried an art competition in which over a thousand artists entered. To get an initial impression, I reviewed printed sheets of thumbnail images of the submissions. When the images were shrunk to the size of large postage stamps, the lesser forms and extraneous elements disappeared; the subject matter became secondary to the tonal composition. I circled the ones that grabbed my attention. Subsequently, I studied the works at their actual sizes. At this phase, some images that I initially circled did not hold up. However, the majority of images that appeared strong in thumbnail form remained the most compelling works when enlarged.

Value refers to the range of tones between black and white that underlie our world in color. When I first started studying art, I had trouble understanding this concept until I associated it with a black-and-white photograph. Although the color is gone, much of what makes the scene recognizable remains intact, because the way light falls on an object tells us more about its makeup than any color could. Value reveals the light source, time of day, shape of objects, and depth of space.

GEORGES SEURAT, *Aman-Jean*, 1883, Conté crayon on paper, 24 ½ x 18 ¹¹⁄₁₆ inches (64.8 x 48 cm), collection of The Metropolitan Museum of Art (New York, NY), bequest of Stephen C. Clark

Photo Credit: Image copyright © The Metropolitan Museum of Art / Art Resource, New York, NY

Large, clear value shapes give this drawing a strong graphic presence. Note the light halo behind the man's head, which forces the contour of his face and head into stark relief.

MARK ANTHONY GUCCIARDI,
Cloth Study, 2007, pencil on paper, 23 x
14 inches (58.4 x 35.5 cm)

Gucciardi has simplified his vision into
a strong value pattern. Despite the
austerity of this image, it remains infused
with warmth and sensitivity.

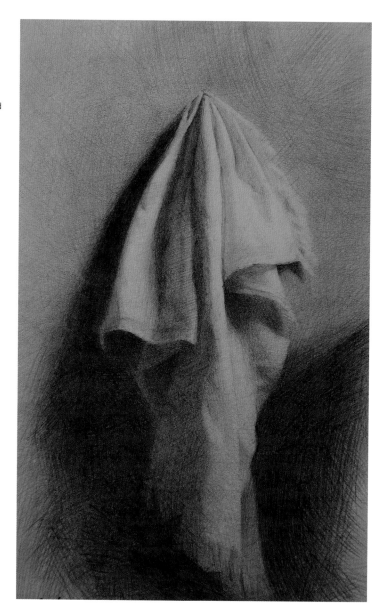

When handled well, the composition of tonal values in a work of
art can become visual poetry. Successful wielding of value pattern
attracts the viewer to one picture among thousands. Once your
audience is drawn to your image, however, it remains to you to keep
them there, not only with your subject matter, but also with your
sensitivity of expression. This chapter discusses the different aspects
of tone that affect the initial impact your work.

Creating Pattern

The early twentieth-century art teacher and artist Arthur Wesley Dow advocated the Japanese concept of *nōtan,* the idea that relationships between light and dark create pattern in art. The flat treatment of space and the high-contrast values form a key concept in art and design. As one of many artists influenced by Eastern woodblock prints, Dow believed that the nineteenth-century emphasis on subject and representation in Western art obscured the fundamental decorative aspect of art.

Creating visual interest through abstract pattern is one of the primary responsibilities of value. Value can be used to produce designs that are largely ornamental, such as a Persian rug with a geometric theme. However, it is also essential to the depiction of realistic subject matter, such as the reflection on a silver vase. We need some range of value contrast to see.

Value pattern provides the visual structure around which to create a picture. These patterns of values are sometimes called "spotting of tone." Value can be high in contrast, as with a black spade on a white playing card, or value can be subtle, as with the changes in tone across a ripple of water. Your image will be pleasing or discordant, largely depending on the placement of this spotting of tone. If your value composition has a coherent plan, the image will feel unified and controlled. If you have not considered the value distribution, your image may end up feeling chaotic and accidental.

The alternation between light and dark in this drawing of lilies of the valley produces a basic design. This flat, two-dimensional use of value is a fundamental building block in the language of art.

SCOTT BURDICK, *Man from Katmandu,* 2001, pencil on paper, 12 x 12 inches (30.5 x 30.5 cm), private collection

The clever spotting of dark and light shapes shows a mastery of the abstract elements underlying good realism.

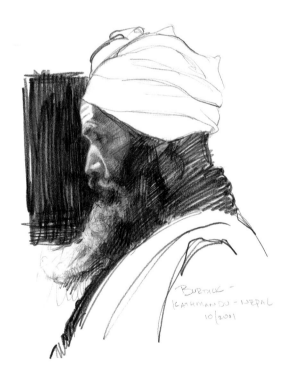

The extreme value contrast forcefully projects a graphic pattern in this pen-and-ink drawing of camellia.

Notice that when the value is reversed the overall mood changes drastically.

Simplifying with Value

Well-trained artists start their education with years of focused observation of nature. Yet a problem can arise as we begin to match exactly what we see. The visible world contains infinite information, but when we draw we use finite tools. Even if it were our goal, it is simply not possible to duplicate nature. We cannot re-create the luminosity that exists in a real light source, for example. Capturing the brightness of a lit bulb is impossible when your brightest white is the paper itself.

Fortunately, the goal of art has never been to duplicate nature, but to interpret it. Nature is filtered through the personality, experience, and emotions of the artist. We have all seen pots and pans, but we have never seen them the way the French still-life master Jean-Simeon Chardin did until he gave us his vision through his work.

In art, simplicity is often more difficult to master than complexity. But when a few clear tones solve a complicated problem, the result can be elegant and satisfying. A smaller number of value steps necessitates that the artist orchestrate large blocks of tone to create a beautiful composition. The end result can be a substantial visual experience—the complexity of nature communicated in a few sweeping tones.

A pleasing value composition can provide an aesthetic experience in and of itself. In this case simplicity is more effective than complexity; a powerful orchestration of tone bears the stamp of a master artist.

The power of much artwork comes from the organization of the large tonal shapes. Many great artists were also printmakers. The confines inherent in many printmaking techniques provided them with excellent design experience. Working within the extreme limitations imposed by the medium, they used predominantly black ink and white paper to create graphically powerful images. A drastically restricted tonal palette forces artists to creatively stretch the confines inherent in the medium. As a result, they master the art of simplifying value, saying a lot with a little and using few values to maximum effect.

When artists like Seurat create a drawing, they "mass in," meaning that they use blocks of value rather than line, to produce a harmonious arrangement. Each tone is accurately matched to the subject, but, more importantly, they work together to generate a pleasing overall effect. I encourage my students to squint in order to see these larger structures. We also do assignments starting with just black ink and white paper; some examples can be seen on pages 134, 136, and 138. This process forces the artist to make decisions about how to group values together so that resulting light and dark shapes work as an overall piece. It is a tricky problem to solve, yet the end result can be beautiful. Limitations are a huge gift to the artist. Too many possibilities can leave you overwhelmed, but a simplified value range can provide an essential scaffolding for building your work.

GEORGES SEURAT, *Courbevoie: Factories by Moonlight*, 1882–1883, Conté crayon on paper, 9 5/16 x 12 1/4 inches (23.5 x 31.1 cm), collection of The Metropolitan Museum of Art (New York, NY), gift of Alexander and Grégoire Tarnopol

Photo Credit: Image copyright © The Metropolitan Museum of Art / Art Resource, New York, NY

The moon in this drawing forms one anomalous moment, called the "minority entry." It stands alone by virtue of its shape, value, and size. Our eye is immediately pulled to that corner.

Making a Value Step Scale

The digital camera I use has 256 values. I was taught to use nine. Some artists use six; others use twenty-two. The point is not the exact number, but that you are thinking in terms of clean, simple steps of value that can be organized to create different images. Keep in mind that if you cannot manage six values to good effect, it is unlikely you will handle fifty any better.

A restrained value palette provides an elegant scaffolding for great art.

The goal and challenge to creating the perfect value step scale lies in making perfectly even blocks of tone with a consistent progression from one end to the other. There should not be any white between steps, nor should there be any hard lines, either or which would upset the fragile evolution of tone. When the steps are done well, an optical illusion called "simultaneous contrast" will appear, meaning the same square will appear to be either light or dark, depending on what it is placed next to. One value square will appear dark on the edge next to a lighter tone and light on the edge adjacent to a darker square. This illusion helps a single tone appear to have more variety than it has in actuality, extending your palette to say a lot with a little.

Whenever possible, integrate smaller value notes into larger shapes.

The exercise of creating a value step scale has technical merit because it gives you practice with your drawing medium, be it charcoal or graphite. However, *using* your value step scale will help you better understand your values, empowering you to have a vast range of expression. Use it to help compare what you see. Some artists even make holes in each value so they can look through at their subject and see if the values match.

This value step scale has nine gradated tones. The most effective value scales juxtapose one evenly toned step against another without any white line between them.

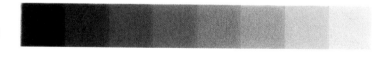

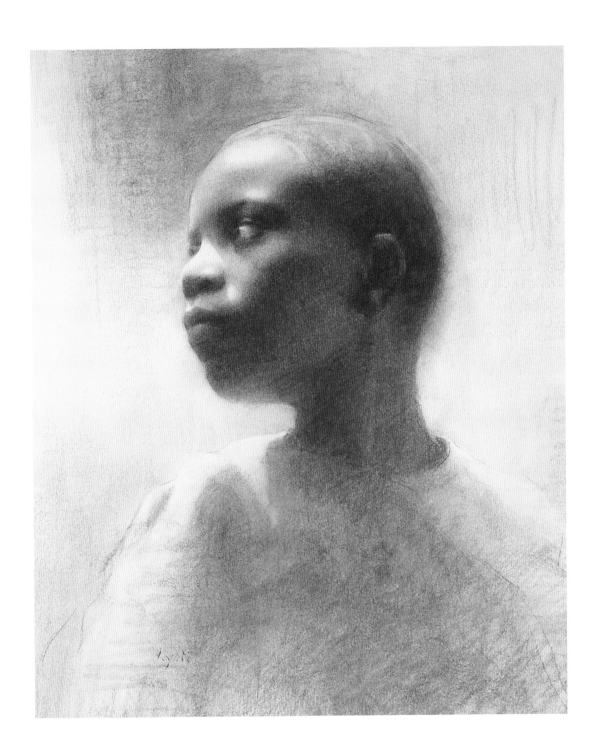

STEPHANIE JOHNSON, *Imaginative Landscape Study*, 2010, pen and ink on paper, 7 x 5 inches (17.8 x 12.7 cm), courtesy of the Aristides Atelier

There is much more white than black in this image. For that reason, the eye focuses on the dark accents (the trees) as an anomaly and focal point.

OPPOSITE: PATRICIA WATWOOD, *Lisa Hargus*, 1999, pencil on paper with copper watercolor on paper, 15 ¾ x 11 ½ inches (40 x 29.2 cm)

The girl in this drawing appears to be radiating light. The focal points in the composition are the dark accents in the features and behind the ears.

Using Value Composition

It is easy for a beginning artist to get so wrapped up in thinking about the subject that he or she forgets the important role light plays in the success of the artwork. But the atmosphere that envelops a subject will change based on the qualities of the light source. Bright daylight reveals each color and value note, whereas evening and night obscure and soften the tones.

The artist Claude Monet is famous for painting the same subject at different hours of the day. His haystack paintings, for example, tried to capture all the minute changes that were happening not in the haystack itself but in the way the light changed the appearance of the haystack. Each painting contains the same subject, yet each picture is unique.

Paying attention to the consistency of light in the scene and reflecting that mood in your work can be difficult, so it is helpful to establish a set of value rules for yourself at the beginning of each piece. I find that working within one of the following three value scenarios or schemes will help you to improve your work, as it will force you to think through your value composition. Your best work will not be achieved accidentally, but with deliberation and forethought. Even if you discard these modes later, the lessons you learn while experimenting with them will inform your future decisions.

Light Scheme

When creating a drawing in a light arrangement, cluster the values toward the light end of the value scale and a delicacy will envelop the whole work. The darkest note may in actuality be from the center of the value range, as true black often provides too much contrast. In any event, the darker notation is likely to be tiny and yet offer a powerful contribution to the hierarchy of the picture. Light schemes, sometimes called "high-key images," are typically uplifting in tone, if not in content.

One masterful example of a high-key image is the line drawing by Ingres shown on page 85. Ingres worked directly from life, and obviously he saw the same full spectrum of color and value that we see; however, he intentionally limited the range of his values to accomplish his goals in this piece of artistic poetry. Notice how he reserved his dark notes only for key features, such as the eyes. This image is far from photographic, yet it is thoroughly believable. Indeed, his accuracy feels uncanny, but it is a metaphor, a suggestion.

On the facing page New York artist Patricia Watwood creates a high-key composition. The drawing's luminosity, forged by the pale value scheme and soft edges, implies innocent spirituality. Our eye is drawn to the few key dark accents in this light-filled space.

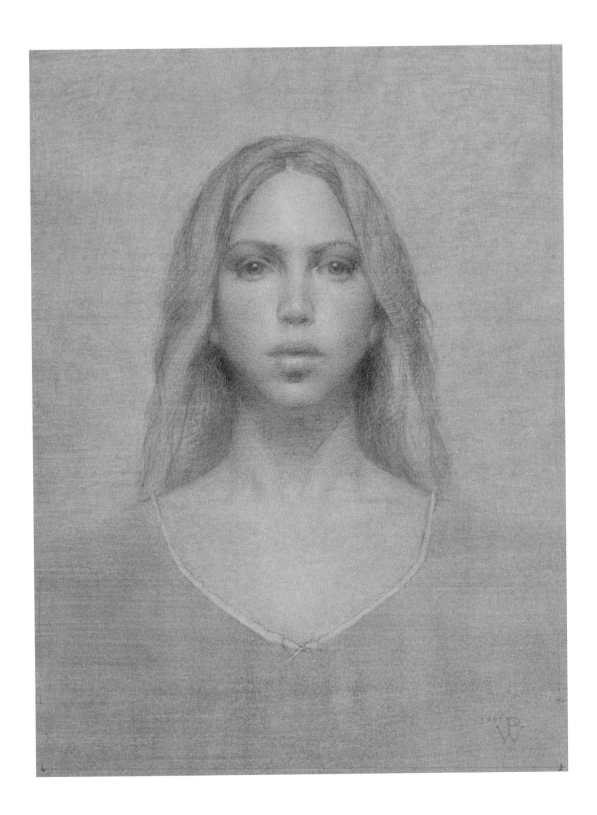

BOBBY DITRANI, copy after a detail of Caravaggio's *Entombment of Christ*, 2010, pen and ink on paper, 9 x 5 inches (22.9 x 12.7 cm), courtesy of the Aristides Atelier

The two-tone analysis of a detail from a Caravaggio painting shows an equal balance of white and black.

JACOB COLLINS, *White Pines*, 2007, graphite and white on paper, 9 ½ x 12 inches (24.1 x 30.5 cm), collection of the Hudson River Museum

The graphic light and dark shapes interweave to form an interesting pattern for the eye, leading the viewer from one block of tone to the next.

Middle Scheme

In the middle scheme, there is a balanced amount of value from the light side and dark side of the step scale. This arrangement can be metaphorically represented as encompassing the time from midday to the golden hour of evening. The sun is shining and casting deep shadows from every object. The drawing by Daniel Garber shown on the facing page displays this clear alternating of tone. Because of the brightness of the light, the darkness pushes back with equal intensity; the resulting patterns lend a clarity and cadence to the image. Another example is Pierre-Paul Prud'hon's drawing on page 164. His dark, full shadows and luminous light areas express a boldness of vision. Each block of value works together like pieces of a puzzle.

Alternating light and dark values creates a rhythm of tone that moves the viewer's eye throughout the picture.

Often in this kind of picture, the areas of contrast lead the viewer's eye throughout the image. Middle-scheme images feature an undulation of tone that flickers back and forth—from a light against a dark to a dark against a light—allowing the viewer's eye to move throughout the image easily. Furthermore, usually viewers can see a middle value pattern from a great distance; the patterns carry themselves to the eye rather than requiring the viewer to walk up to them.

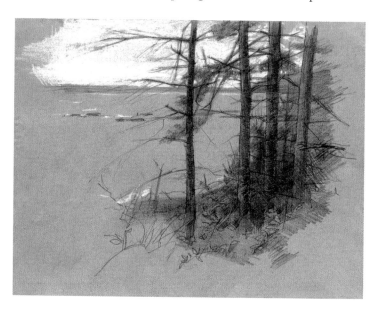

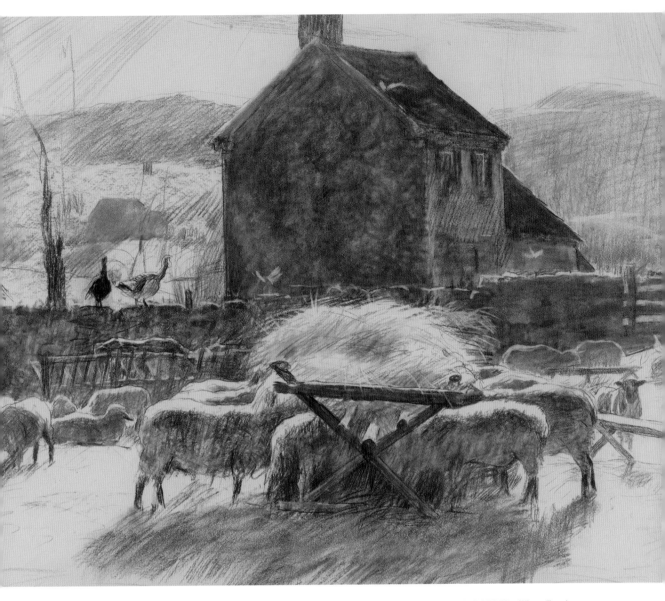

DANIEL GARBER, *Winter Evening,*
date unknown, charcoal on cream
paper, 18 x 33 inches (45.7 x 83.8 cm),
collection of the Pennsylvania Academy
of the Fine Arts (Philadelphia, PA)

Our eyes move easily throughout this
picture. The sheep, hay, and geese
lead us up to the dark mass of the
Pennsylvania farmhouse.

VALENCIA CARROLL, copy after Bernardo Cavallino's *The Virgin Annunciate*, 2010, pen and ink on paper, 10 x 8 inches (25.4 x 20.3 cm), courtesy of the Aristides Atelier

The darkness of the picture does not overwhelm the girl; instead it sets her apart in high relief. She appears like a tiny flame in a sea of darkness, and we are drawn to her.

RIGHT: NICHOLAS RAYNOLDS, *Empty Room I*, 2007, pencil and Conté pencil on paper, 9 ½ x 8 ½ inches (24.1 x 21.6 cm)

This empty dark room with the single lit window exemplifies a low-key image. The smaller value notes have significantly more visual weight because of the surrounding darkness.

OPPOSITE: AFTER REMBRANDT VAN RIJN, *Study of the Head of an Old Man*, date unknown, engraving (ink on paper), 9 ¾ x 7 inches (24.8 x 17.8 cm), collection of Juliette Aristides

This remarkable image telescopes our focus on the careworn face of the old man through its manipulation of value. The brightest lights are concentrated strongly onto a small space in the forehead.

Dark Scheme

A dark value scheme, or low-key image, is one of night, taking its values from the lower end of the step scale. Because the majority of the picture is comprised of mid-tones and darks, the few light tones generate a focal point. Rembrandt was fond of this arrangement. His dark, cavernous spaces are melancholy and mysterious. The light elements stand out in a compelling way, and it is here that he typically places the narrative aspects of the piece.

The more the darkness looms, the brighter the light shines. It is a truth in art and a powerful metaphor for spiritual understanding. Knowing this principle, Rembrandt deliberately telescoped value in his images. He did not literally see his subjects in this manner any more than Ingres saw his figures as a light line. Rembrandt did this as an effect. He gave us information based on the way the human eye sees, but pushed these qualities for emphasis.

A dark value composition would be a good choice anytime you want to create a dark and dramatic piece of art. It is perfect for drawings that celebrate a particular shape of light, one that is full of form and volume, such as the wrinkled eyes of Rembrandt's old man as seen on the facing page. This low-key value scheme sacrifices everything for a moment or two.

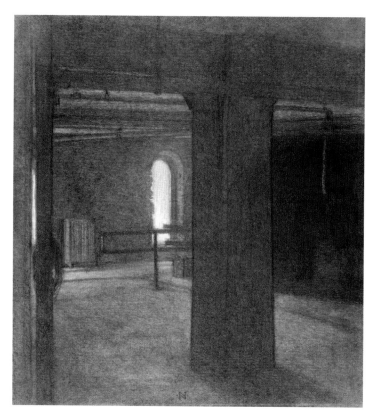

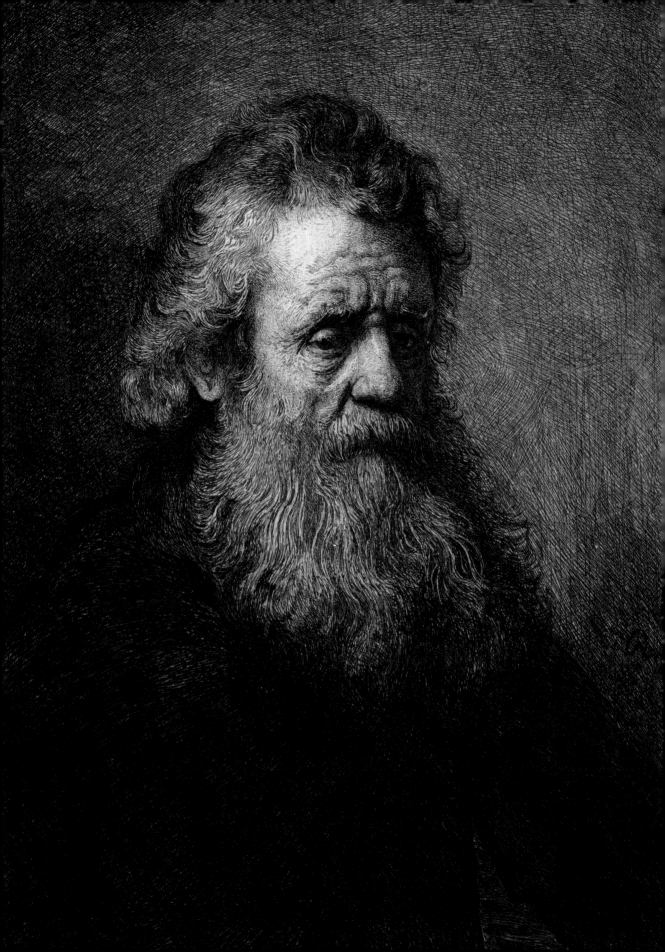

DANIEL GRAVES, *Olive Trees*, 1990, etching (ink on paper), 4 ¾ x 4 ½ inches (12.1 x 11.4 cm), courtesy of Ann Long Gallery, North Carolina

The artist gives us the sense of being in sun-dappled woods. He allows the brightness of the lights to decrease as we visually travel back farther into the forest.

Understanding Relative Brightness

How light or dark something appears to our eyes is determined in large measure by what is adjacent to it and the overall environment. The setting provides us with the context and clues about how to interpret the value of any given object. For instance, because the human eye is efficient and will factor in the surroundings, a white teacup and saucer left on my kitchen table will still feel white by moonlight, even if in actuality it remains a mid-tone gray.

The value of any object is determined by its context— by how light or dark the things are around it.

The correct assessment of values in a work of art is of utmost concern to the artist. Inconsistently placed tones can quickly cause many problems. This relative assessment of values is tricky due to the temptation to make an object the value we think it should be rather than what it actually is—in other words, to make our moon-lit cup white rather than gray.

The value of an actual object under normal midday lighting conditions is called its "local tone." The local tone of our white cup may be Value 1, yet when placed in the shadows will read as Value

4 or 5. Likewise, the local tone of a walnut-stained chair might be a Value 5, yet it can look black depending on where it is placed in relation to the light source.

Leonardo da Vinci, and many others, considered the correct assessment of values to be one of the benchmarks of good artistry. In his notebooks he described a method of comparison to correctly assess these tones: Notice the dominant light and shadow tone and use it as a basis of comparison for every other dark or light. Thomas Couture, the nineteenth-century academician and painter, wrote about the same thing: "Look well at your model and ask yourself where the light is greatest, and place the light in your drawing at the point it appears in nature." This dominant light is not to be exceeded in your drawing; all other lights must be subordinate. The same rule should be followed with shadows.

There are times, however, when you may not want to choose your value composition based solely on what you see. For example, one artistic convention encourages making a figure more strongly lit than the landscape behind it would allow in reality. (The sky in the background may show a cloudy afternoon, whereas the person is illuminated by a raking light.) Once you have a good grasp of value you can choose to forgo what you see to create a composition of your own choosing, but it is helpful to have a solid understanding of relative brightness before you deviate from this path.

NORMAN LUNDIN, *Rural Road at Night*, 2009, charcoal on paper, 14 x 22 inches (35.5 x 55.8 cm), private collection

The close value range in this dark landscape captures the viewer's imagination with the feeling mystery and foreboding.

This image relies on a few simplified shadow masses to tell us about the direction of the light and the structure of the head. The shadow shapes fall on her face and neck and merge into the dark local tone of the hair and shirt.

HUNTER EDDY, *Elisa*, 2008, charcoal on paper, 18 ¾ x 13 ⅝ inches (48 x 35 cm)

This regal portrait portrays an elegant head created from a few clear, uninterrupted value notes.

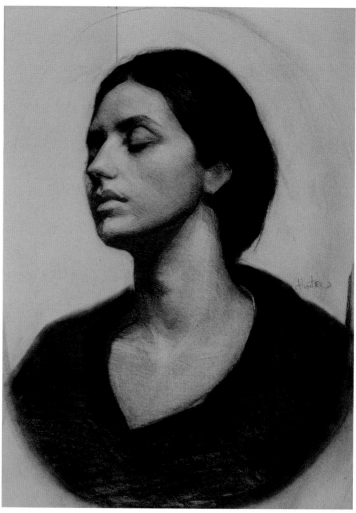

Identifying Shadow Shapes

In art, the term *value* can mean a number of different things. In this chapter, we are primarily discussing the abstract or decorative use of tone, where light and dark act as a flat pattern. In this way, values are a means of dividing space, creating pictorial balance and interest. Value can also be used to describe volume and character through light hitting form. The next chapter is entirely devoted to the subject of volume through light and shadow. By subdividing the discussion of value into two chapters—one focused on two-dimensional qualities and the other on three-dimensional—we can better understand the power and range of this subject.

My students and I recently went to see a show of seventeenth-century Japanese woodblock prints. These artists favored using traditional calligraphic lines and flat blocks of tone to express their artistic vision. Studying the work, we found it was hard to believe

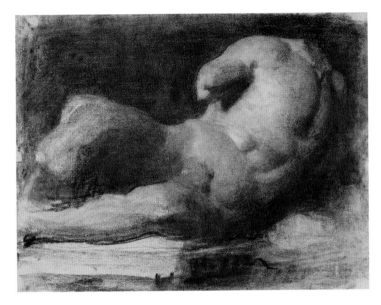

This overlay shows where the shadow shapes lie, not to be confused with the dark background tone.

THOMAS P. ANSHUTZ, cast drawing of unknown artist's *Cephissus*, date unknown, charcoal on cream laid paper, 18 ⅝ x 24 ⅜ inches (47.3 x 61.9 cm), collection of the Pennsylvania Academy of the Fine Arts (Philadelphia, PA)

This drawing relies on large value masses for its effectiveness. Notice the large simplified shadow shapes, which are an integral part of its structure.

the artists could convey so much emotion with such economy of means. Simple blocks of values were used in a decorative way to depict objects. Unconcerned with rendering light and shade, the printmakers instead utilized an elegantly restricted palette to full advantage, creating a convincing and complete world.

Learning to separate light and shadow shapes is an early and critical step that should be mastered before focusing on creating volume. The process of locating the darks in your picture is called "mapping the shadow shapes." Just like a cartographer maps a terrain, making a two-dimensional schematic of a three-dimensional world, the artist maps the uncharted coastline of shadows. This simplification is highly effective at capturing the character of the surface of the object and contains the nuanced information that can only be discovered by careful observation.

When mapping shadow shapes it is best to keep the shapes large and simple. Rather than looking into the variations within the shadows, squint to try to see and capture the exact nature of the shape in the largest way possible. The edges of the shape, on the other hand, should be as nuanced as possible. The graphic nature of a distilled light and shadow shape creates a powerful visual impact. Keep in mind that the shapes formed by the lights and shadows are very different than the object on which they rest. Just as we carefully studied the strange shapes to be found in line, we use similar criteria to develop value.

The process of dividing the drawing into light shapes and shadow shapes is an important step in the drawing process. We begin with a few simple lines, creating a sense of the broad gesture. Through the process of measuring, using a plumb line, and siting

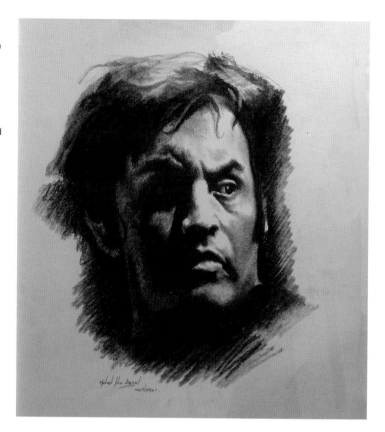

MICHAEL JOHN ANGEL, *Con Brio; Portrait of a Musician*, 1981, Conté crayon and carbon pencil on paper, 10 ⅞ x 9 ¾ inches (28 x 25 cm), collection of Nancy and Thomas Galdy

The intensity of the musician's gaze is matched by the striking value pattern. The content and the medium work well to send a unified message of focused energy.

OPPOSITE: JULIETTE ARISTIDES, *James*, 2010, charcoal on toned paper, heightened with white chalk, 25 x 18 inches (63.5 x 45.7 cm)

In this charcoal sketch, you can see the careful mapping of dark shadow shapes as it charts its course down the length of the body.

angles we begin to close in on a likeness. Over time our thoughts crystallize into a more concrete image. The drawing goes from an idea to having a life of its own. I think of this as the drawing's adolescence—and as such it can be a little rocky. While the piece no longer contains the limitless possibilities of childhood, it is also more fully developed. And yet, much can change in the next few stages.

Learning to separate light from shadow is an early and critical step for the creation of a strong image.

When I have made the piece as accurate as I can in line, I lay a flat light tone on the shadow shapes. This often enables me to have a second chance at identifying inaccuracies. It becomes easier to flick my eyes back and forth and see where there is something off in my drawing. When this stage is as accurate as I can make it, I am ready to move forward in the drawing process.

Identifying the shadow shapes of your objects will give you a solid entranceway into the world of tone and form. It affords you one last opportunity to make big drawing corrections using the filter of mass rather than line. These shadow shapes set the stage for a great finish by enabling you to pursue the small forms with accuracy.

DANIEL GARBER, cast drawing of a detail of Michelangelo's *Il Giorno*, from the tomb of Lorenzo de' Medici, 1904, charcoal on buff laid paper, 18 ⅝ x 24 ⅜ inches (47.3 x 61.9 cm), collection of the Pennsylvania Academy of the Fine Arts (Philadelphia, PA)

In this drawing you can see an example of a well-mapped shadow shape. Look at the side of the body and the abdomen and try to copy the intricate coastline as it undulates from swellings to recesses.

Choosing a Focal Point

I once did a painting of some fruit. I knew early on that I had two contending principal shapes. Next to my dominant pear was another pear of almost the same size, shape, and color—a twin. I thought that, just this once, I could get away with having a competing focal point; however, I fought with that second pear the entire time I worked on the painting. I pulled out every trick that I knew

When mapping shadow shapes, it is best to keep the masses large and simple.

to win the battle: I darkened it, softened its edges, reduced the intensity of its color, and made it smaller. In the end, the repetition of shapes was too strong—impossible to subordinate. I ended up titling the piece *Duality,* in acknowledgment of the battle I had lost, and I learned an important lesson: It would have been better to address the problem while constructing the actual setup, rather than trying to make up for it later on the canvas.

The drawing by Seurat below shows how he managed a similar problem, but with an effective outcome. He has taken multiple elements—a house, horse with a farmer, and open fields with people walking across—and created a unified vision. The people, land, and even part of the sky are forged into one substance. Seurat established visual hierarchy by allowing the lightest area of the sky to silhouette the two foremost figures. Our eye hovers between these figures for two reasons. First, it is the area of greatest contrast. Second, people almost always draw more attention than objects in a work of art. Now compare this drawing with Seurat's image on page 131 and see another—completely different but equally effective—use of a single focal point.

Viewers need a visual hierarchy of value and a focal point to lead their eye throughout an image. In the drawing by Thomas Anshutz on page 151, the triangle formed by the woman's hat and head create an inescapable focal point. Not only is it the darkest shape in the picture, but it has the hardest edge. Furthermore, because this feature is in the dead center of the picture, it ensures that we have no doubts about our subject.

GEORGES SEURAT, *Tilling*, 1882–1883, Conté pencil on paper, 10 ¾ x 12 ½ inches (27.5 x 32 cm), collection of the Louvre (Paris, France)

Photograph by Michèle Bellot

Photo Credit: Réunion des Musée Nationaux / Art Resource, New York, NY

In a drawing as harmonious as this one, every element counts. Seurat has made the house, figures, and horse feel unified with the ground—it is one large shape. Our eyes then move to the differences where the light and dark meet.

Myron Barnstone used to say that the spot in an image where the lightest light and darkest dark meet become its principal value focal point. It is this place that first captures the attention of the eye. This focal point may not be the area that is your actual focus as a subject—but it will lead your eye to the area. For example, historically, it was a common convention to put a bright white, crisp note on the collar of a shirt in a portrait. (For instance, in the image on page 126, Seurat adopted, and adapted, this convention.) No one would think that the shirt is the subject of the picture, but it leads your eye to the head and contrasts effectively with the soft forms found in the skin.

A visual hierarchy created by value guides our eye throughout an image.

When creating a work of art, how we perceive our subject changes with time. This can become confusing, as we literally see differently over the course of a sitting. Our eyes take in our subject in an instant. For instance, when the model takes a pose, I see it at a glance. Because I work from general to specific, I start by broadly blocking in the picture. Yet as I finish, my attention focuses on specific areas of detail. This enables my eye to become acclimated to what is going on in a small section, but it also disrupts my sense of the whole, including the value hierarchy. Therefore, it is essential for me to determine the location of my visual focal point early in the drawing process; this provides an important anchor for subsequent stages.

ZOEY FRANK, *The Medici Gardens,* 2009, pencil and walnut ink heightened with white, 6 x 9 inches (15.2 x 22.9 cm)

The artist has distilled all the elements of this Italian landscape into a few broad swatches of tone. The light road guides the viewer's eye to the focal point of the image.

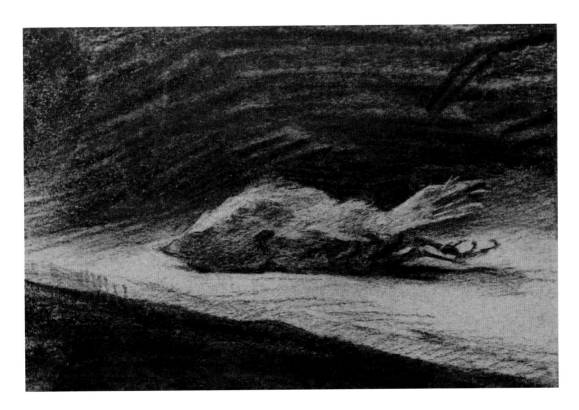

Finding Tonal Balance

There are artists who love to create absolute clarity with every form. The shadows are dark yet do not obscure; the lights are rendered yet not blasted out. This work can be beautiful when done from life; however, it can appear unnatural in the sense that it takes in an entire visual field without honoring our natural human tendency to focus on one element. With this method, small areas are painstakingly recorded for accuracy. But these details do not always lead to a greater whole or deeper truth.

When dark and light meet, a natural focal or accent point is created.

On the other end of the spectrum, there are artists who sacrifice everything to achieve a general effect. These artists leave most of the image hazy toward the edges or generally unfinished, yet push a single element to a high degree of finish, forcing a focal point. If this approach is pushed too far, it feels like a gimmick. Yes, it works, but it can be an easy way out if it is used habitually to solve the problem of creating a focal point.

TOBY WRIGHT, *Study of a Dead Sparrow*, 2007, charcoal on paper, 7 ⅞ x 11 ¾ inches (20 x 30 cm), collection of the artist

The sketch of the tiny bird on the table is a well-balanced tonal composition and deceptively simple. We have only a few large shapes and a hint of detail, yet it feels carefully observed—a genuine expression of an unhappy fact.

JAN VERMEER, *A Maid Asleep*, circa 1656–1657, oil on canvas, 30 ⅛ x 34 ½ inches (76.5 x 87.6 cm), collection of The Metropolitan Museum of Art (New York, NY), courtesy of Art Renewal Center

Vermeer masterfully controls the value in this picture—leading our eye to the maid asleep at the table and allowing an exit for the eye through the open door. Notice how he placed the principle value contrast on the figure.

OPPOSITE: THOMAS P. ANSHUTZ, *Woman Drawing*, circa 1895, charcoal on paper, 24 x 18 ¼ inches (61 x 46.4 cm), collection of the Pennsylvania Academy of the Fine Arts (Philadelphia, PA)

The artist effectively pulls our attention to the triangle of the woman's hat— through its central placement, its strong value contrasts, and the sharpness of its few edges. Notice that this image shows a student drawing the same cast at the Pennsylvania Academy of the Fine Arts that the artist drew in the image on page 143.

One reason the paintings of artist Jan Vermeer remain so relevant hundreds of years after their creation is their accuracy to nature. His work feels honestly observed, in spite of its amazing artifice. It is a pinnacle of naturalism and artistry combined. My eye moves easily throughout the image, just as it does when looking at the visible world. There is clear hierarchy and clarity of vision. Like a perfectly crafted garden, a Vermeer painting leaves the visitor free to wander, yet we are

Our eye is attracted to idiosyncrasy, so a tiny element can dictate a composition, depending on its value and placement.

never lost, and there is no area that feels unworthy of our attention. When working to achieve tonal balance in your own work, it is important to realize that a small note of a single tone can outstrip the visual weight of a large one, simply by virtue of its uniqueness. As we saw on page 131, a bright moon rising in a dark sky can rule the composition. Likewise, a small dark log will have a strong visual pull when positioned on a vast misty morning beach. In short, the smallest element can carry a lot of visual weight, depending on its value and placement within the composition.

JOHN SINGER SARGENT,
Scrapbook, Marine Subject Drawings,
circa 1874–1880, pencil on paper, size
unknown, collection of The Metropolitan
Museum of Art (New York, NY), gift of
Mrs. Francis Ormond

*Photo Credit: Image copyright © The
Metropolitan Museum of Art / Art Resource,
New York, NY*

These thumbnail sketches demonstrate
how one artist plays with composition
before embarking on more finished works.

MOST ARTISTIC PURSUITS—from architecture to music—benefit by an
effective juxtaposition of objects (notes) and space (silence). In the
visual arts, the space around an object affects not only how that object
is perceived but also how effective the image is. This placement of
your subject within a defined (often rectangular) area and the division
of space that you create within this area is called "composition."

Even a blank piece of paper has governing lines dictated by its
proportion (the vertical and horizontal edges that articulate the top,
bottom, and sides). These in turn naturally pull our eyes across the
diagonals. Compositional forces are at work even before you pick
up a pencil.

Some people do not like to think about composition because
it feels overwhelming and constraining. It takes something that
is often intuitive and brings it into a conscious focus. I highly
recommend that you devote some energy to this important subject.
Practice making thumbnail drawings, so that you, like Sargent, can
keep track of your ideas and gain experience. I also suggest that you
read Henry Rankin Poore's book *Pictorial Composition.*

These thumbnail sketches—a detail
from a page of John Singer Sargent's
notebook, shown in full on the facing
page—play with different maritime
themes within the same proportional
rectangle.

LESSON 5 TONAL SKETCH

THE TONAL SKETCH IS OFTEN DONE in preparation of a larger work. It is a way of thinking out loud, allowing an artist to process his or her thoughts about a subject and play with different compositions, objects, and lighting. Doing a finished painting or drawing requires a large investment of time, but creating sketches is a quick way to determine if an idea is interesting and has merit. The process allows an artist to take risks, because there isn't much to lose.

In contrast to drawings, where lines generally predominate and contribute to the variation and interest of the work, value sketches provide a vehicle for employing and analyzing tonal masses. One could almost think of this sketch as a mosaic of polygonal pieces of construction paper—in varying shades of white, gray, and black. These tones fit together to form a picture.

GATHERING YOUR MATERIALS

In preparation for your tonal sketch, assemble the following materials:

Still life objects

Graphite pencils or vine charcoal*

Drawing paper**

Drawing board

Kneaded eraser

Tape

Plumb line

Narrow knitting needle or skewer

Rolled paper tortillon or stump

Newsprint (optional)

*If using pencil, try a variety of grades, from 2H through 3B; alternatively, use medium and hard charcoal.

**Select a paper with a smooth surface for graphite or a light tooth for charcoal

SETTING UP THE SKETCH

In creating a setup for this exercise, choose a handful of still life objects that have a clear delineation of values and are not too complicated. Group your objects in a pleasing manner and illuminate them with a single light source. Take a moment to squint while observing your still life setup. If all the objects merge together as one value, change the way they are lit, with an eye to creating a composition with both darks and lights. The objects that David Dwyer selected provide a wide range of values, from the stark white of the brightly lit eggs to the darker shadows and background. He taped a piece of dark brown drawing paper to the wall behind the composition to provide good contrast with the lit objects. Often simplicity is the key to a good composition. Avoid cluttering the setup with too many objects and consider how objects can be grouped together.

CREATING YOUR SKETCH

Although tonal sketches can be done in a sketchbook, they can also be accomplished on paper attached to a drawing board and held upright on an easel. David placed several sheets of newsprint on the drawing board underneath his drawing paper, and used bulldog clips to hold the paper in place. Don't use drawing paper that has an overly coarse surface because you want to create areas of solid, even tones, and you'll end up fighting the tooth of the paper. Keep your sketch small, no larger than 6 inches (15 cm) in any dimension. This will allow you to keep focused on the large shapes and cover the paper with tone fairly quickly.

STAGE ONE: Create the initial line drawing, establishing the proportions of the objects and locking in the composition.

STAGE ONE: *Blocking In the Objects*

First, delineate the format of your composition, making sure to leave ample margins around the edges of your rectangle (or square). A tonal sketch is a great way to explore the proportions of a composition, and as you work you may decide to add to (or, alternatively, crop off) one of the edges. Although this sketch will ultimately focus on large, tonal shapes, start by spending a few minutes blocking in the objects with a few basic lines. Use a knitting needle or skewer to analyze the relative width and height of objects and their positions. Draw lightly and with a loose line. Here David established the horizon line, the forward edge of the tabletop, and the basic size and position of the eggs, espresso pot, and cup.

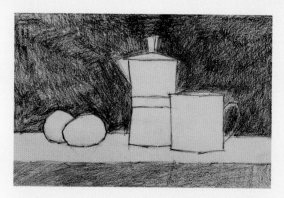

STAGE TWO: Block in the largest areas of tone, moving from background to foreground and establishing the overarching tonal environment.

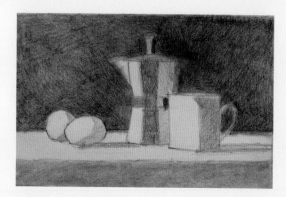

STAGE THREE: Locate the shadow shapes and establish areas of passage (a lost edge that links one object to another) in the drawing.

STAGE TWO: *Laying In the Preliminary Values*

Next, lay in large, even areas of value. It is often easiest to start with the largest, darkest area of the drawing; this blocks out some of the bright white of the paper, making it easier to evaluate value relationships. Don't jump to the anticipated final value of an area immediately; build up value gradually.

Experiment to find what pencil works best for you. David used a 2B pencil at this stage. A softer pencil, such as a 2B or 3B, will allow you to shade in darker values fairly quickly but may make it difficult to gradually build up an area evenly and accurately. A firmer pencil, such as a 2H or HB, will allow more gradual laying in of a value but can lead to burnishing of the paper, making it difficult to get more graphite to adhere to the paper later if a darker value is desired. Once you have applied a fairly even tone to an area, use the tip of a tortillon or stump to push the graphite into the surface of the paper.

STAGE THREE: *Refining the Values*

Now fill in the mid-range areas of value in your drawing. At this stage in the process, it is crucial to compare different areas of value. Let your eye jump from one area to another, continually analyzing which is darker. You may find that areas in two adjacent objects have the same value. (For example, the side of the cup that is out of the direct light in David's image is close in value to the adjacent tabletop.) This is your opportunity to create areas of "passage" in the drawing, linking objects together and thereby giving the drawing unity and cohesion. Don't think about individual objects; think about areas of value. Squinting while looking at the still life setup may be useful in analyzing value relationships as well as discovering areas of passage.

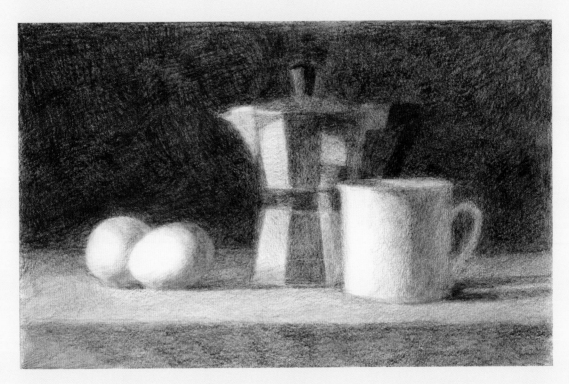

STAGE FOUR: Find the last shadow shapes and integrate them into the background. At this point your eye should easily move throughout the image.

DAVID DWYER, *Breakfast Study*, 2010, graphite pencil on paper, 7 x 11 ½ inches (17.8 x 29.2 cm)

STAGE FOUR: *Finishing the Sketch*

As you work on the tonal sketch, keep in mind that this is a preliminary study. Avoid getting trapped into adding small details and instead try to maintain larger areas of value and basic shapes. Drawings (and paintings) in which these larger shapes predominate are often the most successful in attracting the viewer's interest and showing a unity of vision.

As your drawing nears completion, take a step back and evaluate how well large areas of value fall into place and whether or not you're satisfied with the overall proportions of the composition. (At this point, David wondered, would it be better to add a little space to the shadowed area on the right side? Is the darker forward edge of the tabletop too dominant in terms of size?) The beauty of working with a tonal sketch is that these changes can easily be made before you proceed to a more finished drawing.

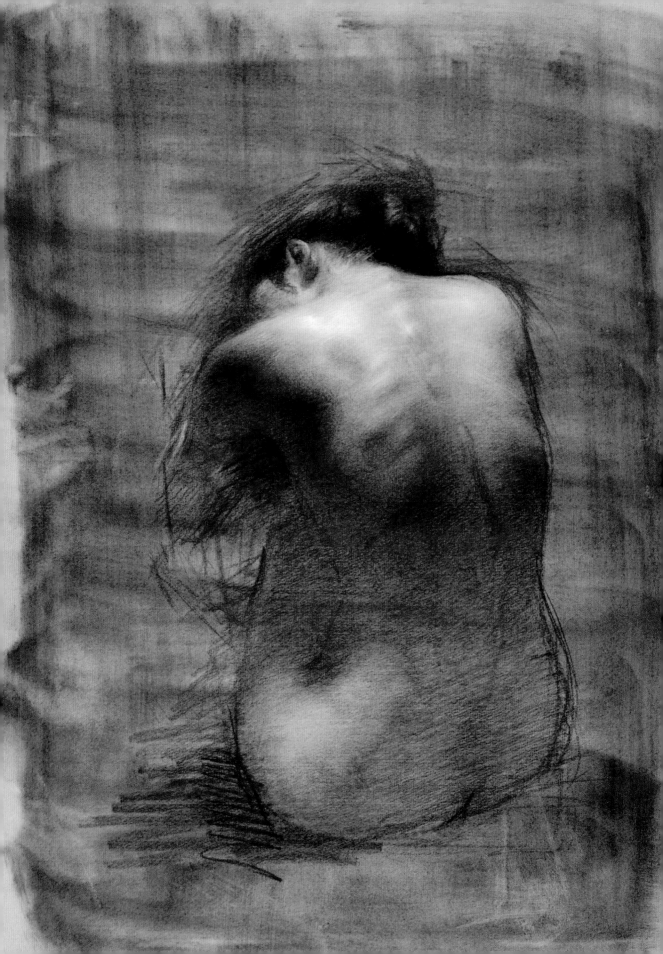

CHAPTER 6 LIGHT AND SHADOW:
THE CREATION OF FORM AND CHARACTER

In good work, unity is the dominating quality, all the variety being done in conformity to some large idea of the whole, which is never lost sign of, even in the smallest detail of the work.

—HAROLD SPEED (from *The Practice and Science of Drawing*)

While studying with Myron Barnstone, I had my first introduction to the concept of creating the illusion of volume with light and shade. On a mid-tone surface, Myron drew a simple circle. With rapt attention, the class watched as he slowly transformed this two-dimensional circle into a three-dimensional sphere that projected forward into volume-inhabiting space. Myron was able to create this fully realized, believable object entirely from his imagination. It felt like magic.

Myron followed a simple but effective progression: First he marked a crescent shape on the circle to describe a shadow. Next he placed an ellipse (to articulate the shadow shape on the ground plane) and rendered a dark tone over both shapes. Then he took white chalk and colored the light part of the circle and placed in a brighter highlight. Finally he blended to create key halftones to finish the work.

Each of the steps Myron followed describes a particular, unique aspect of light and shadow. Each of these elements has a name that can be talked about: highlight, light, local light, light halftone, dark halftone, core shadow, form shadow, reflected light, and dark accent. In this chapter we will discuss form drawing, which is the use of light and shade to create the illusion of volume. At the heart of this process is a love of the particular, the nuanced awareness of small things. The process of studying form necessitates an intense study of nature, looking at small structures that are almost invisible to the casual observer but that lie at the core of what it means to be a fine artist.

JULIETTE ARISTIDES, *Nadia*, 2010, charcoal on toned paper, heightened with white chalk, 25 x 18 ½ inches (63.5 x 47 cm), collection of Jordan Sokol

The study of light hitting form remains essential for the artist if she wishes to create the illusion of volume.

Creating Volume with Light and Shade

One of the most encouraging discoveries for beginning artists is that the laws of light falling on an object can be portrayed convincingly by knowing a small amount of information. Taking time to grasp the basic principles will save time down the road and help avoid rudimentary errors. The visual reality we encounter every day

The laws of light are consistent; knowing them will help you understand and interpret what you see.

is often subtle and confusing. It would take a long time to understand any of these foundational points on your own. But luckily, for centuries artists have used the order of light Myron displayed in his chalkboard drawing of a sphere. This knowledge—discussed on the facing page—will help you make sense of what you see as you try to portray it.

The clarity with which you can see the elements of light will depend on the physical makeup of your subject and the direction and strength of your light source. Some objects, such as metal, glass, and dark velvet, do not lend themselves to form studies as their

ELIZABETH ZANZINGER,
Circumference, 2008, charcoal on paper,
6 ½ x 9 ½ inches (16.5 x 24.1 cm),
courtesy of the Aristides Atelier

This exquisite rendering appears to have transformed vine charcoal into mass and atmosphere. Many important principles were employed, including the careful modulation of edges, the extended halftones, and the controlled range of shadow values.

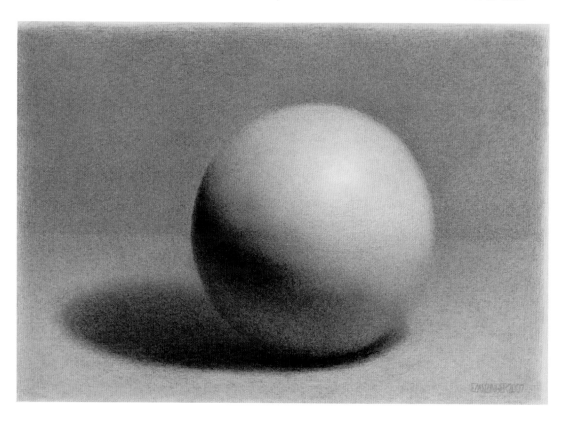

IT IS NO COINCIDENCE THAT the classic order of light corresponds to the value step scale we discussed in chapter five. It is very useful to think of them together. Take a look at the sphere below. You will notice that Value 1 aligns with the highlight; Value 2, the light; Value 3, the local light; Value 4, the light halftone; Value 5, the middle halftone; Value 6, the dark halftone; Value 7, the form shadow; Value 8, the core shadow; and Value 9, the dark accent. Of course, this is just a conceptualization of an idealized situation. In reality, things may not be as extreme. For example, if I put an egg on a piece of white paper and light it, the shadow side may be very pale, maybe a Value 4. Nevertheless, the same logic would still apply.

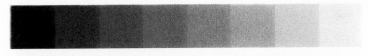

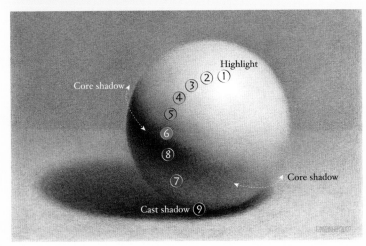

Tens of thousands of values are found in the visible world. The master artist needs just a few, however, to say everything necessary for her self-expression.

The nine components of light and shadow identified above and listed below will help you make sense of what you see as you try to portray it. This classically rendered sphere contains the following:

LIGHT

1) *highlight*
2) *light (halo surrounding the highlight)*
3) *local light (local value)*

MIDDLE

4) *light halftone*
5) *middle halftone*
6) *dark halftone (also can be used for reflected light)*

DARK

7) *form shadow (includes reflected light)*
8) *core shadow (terminator, bedbug line)*
9) *dark accent (cast shadow)*

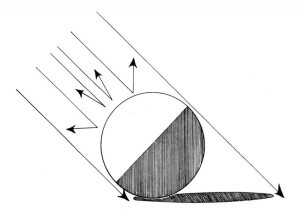

Artists have traditionally lit their subjects from the upper left, creating what was called "the Baroque diagonal." (By contrast, light that reads from right to left, as shown in the drawing on this page, is called "the Sinister diagonal.") You can see the tangent line of light that creates the core shadow. Everything above that line turns in the direction of the light.

JULIETTE ARISTIDES, *Form Drawing
Demonstration*, 2008, charcoal on paper,
12 x 14 inches (30.5 x 35.5 cm), private
collection

The drawing on the right shows the block
in of a male torso; the one on the left
reveals how those large shapes create
the substructure necessary for form.

OPPOSITE: EDWARD MINOFF,
Santiago, 2009, pencil on prepared
paper, 11 x 10 inches (27.9 x 25.4 cm)

This drawing combines careful
measuring and observation from life
with the intuitive sensitivity of the
artist. The large and small shapes work
together to create a harmonious image.

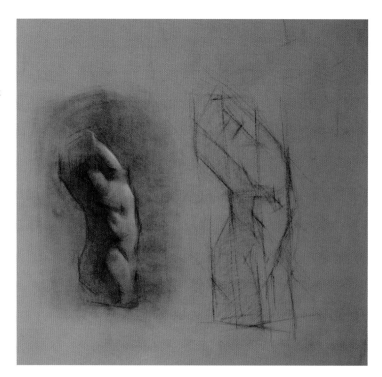

surfaces are either too reflective, transparent, or absorptive to reveal
subtle halftones. In most situations, however, the elements of light
and shadow will be your road map for understanding and portray-
ing these principles.

The impression of volume and reality in drawing is created by the quiet halftones that bridge the shadow to the light.

The correlation between the classical order of light and the
value step scale will help you keep your tonal renderings logical and
sequential. Whenever you render the lighter tones of your subject,
you are describing an object turning toward a light source. This idea
is represented by moving to the lighter end of the step scale. As you
render darker shades in your drawing, you describe a form turning
away from the source of light. This corresponds to the darker end
of your step scale. The scale becomes a metaphor for this progres-
sion. When working in the shadow area of your drawing, if you are
tempted to use a tone from the light end of the spectrum, you can
be sure it will destroy the value integrity of your piece. Likewise,
any tone that is too dark in the light side will read as a shadow and
disturb your system.

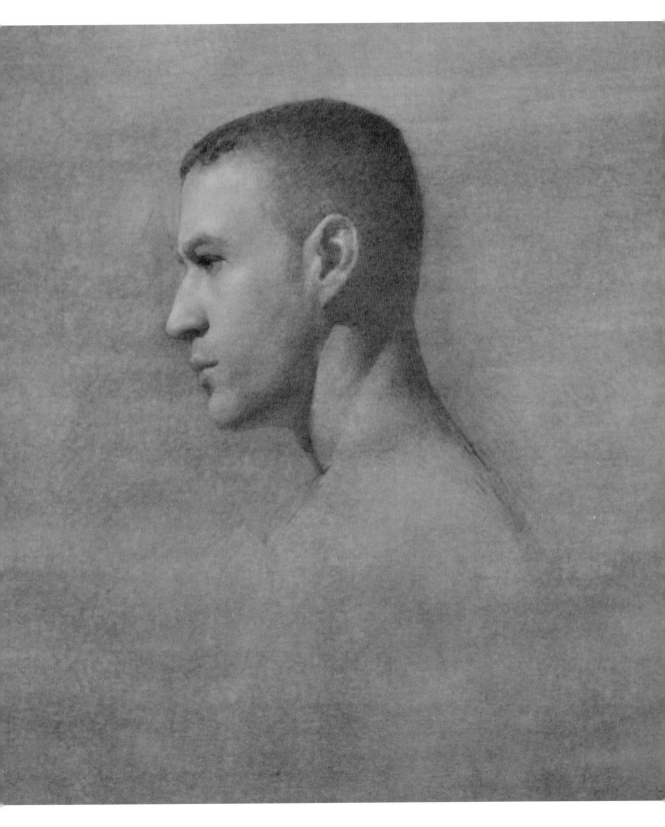

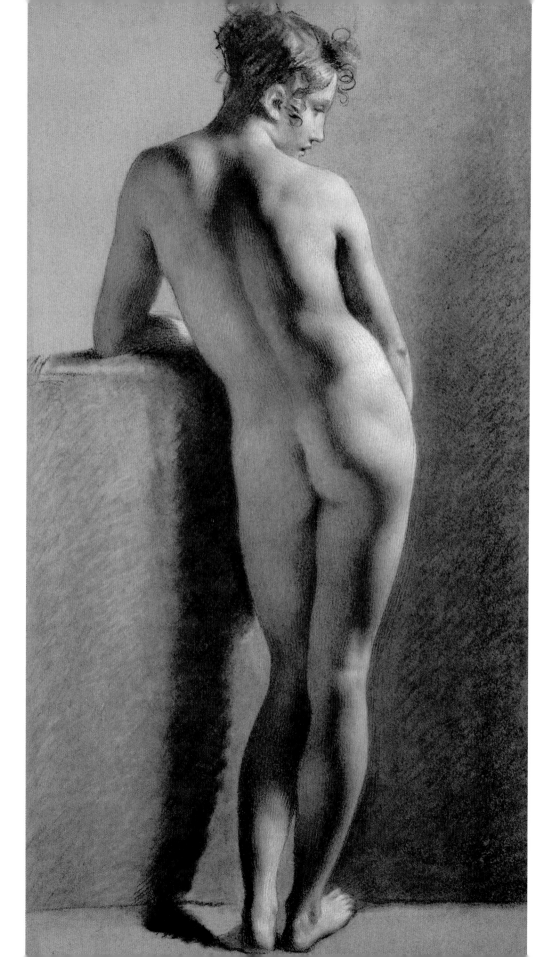

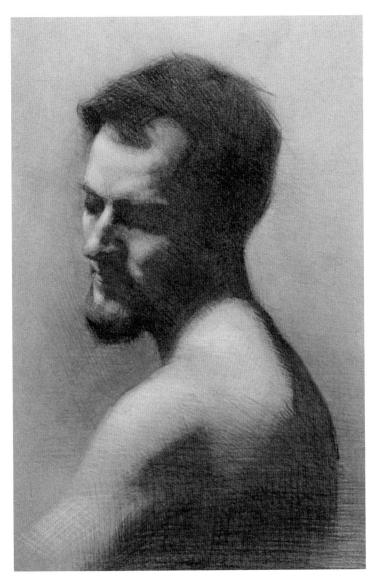

The logic of tones and how they create convincing volume and form is a bedrock artistic principle. Through practice you will memorize the progression between shadow and light. Over a short period of time this will become internalized into your repertoire. You will own it and will not have to struggle or even think about it anymore. It will be as effortless as riding a bike.

The value step scale simplifies the complex world of values. Artists utilize these values to create a believable visual universe.

Lighting Your Subject

Light is to art as air is to life. In and of itself, it may not appear to be of much interest, but it is a vital necessity upon which everything else depends. Ignoring light has been the inadvertent downfall of many pieces of art.

It is strange but true that light itself has its own beauty. Light is often considered the primary subject in art regardless of what it is hitting. In fact, I have done paintings of a crumpled sheet of white paper because the light on it was so beautiful. Great light can transform an average model into a goddess; poor lighting can cast her mercilessly down from Mount Olympus. Planning your light source stacks the cards in your favor and makes for a more pleasurable drawing experience.

PIERRE PAUL PRUD'HON, *Académie of a Seated Woman with Raised Arms,* circa 1800, black and white chalk with stumping on blue paper, 23 5/16 x 16 5/16 inches (59.2 x 41.4 cm), courtesy of Art Renewal Center

Prud'hon is considered one of the masters of form drawing. His light source is coming from above and toward the left front of the figure.

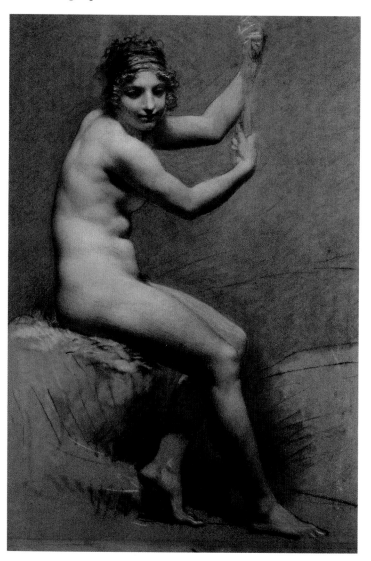

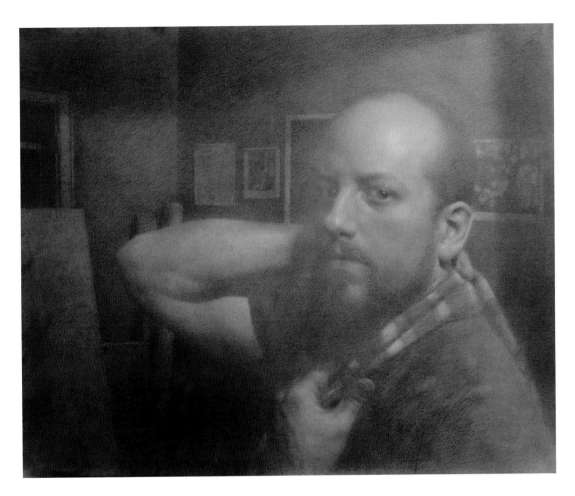

Insufficient lighting flattens form and obscures the character of your subject. However, too much light can be equally problematic. I once taught a workshop in which the university had no focused light on the model. I walked into the life room to find the overhead florescent lights ablaze, obliterating all descriptive shadows and forms. For advanced artists, this environment would be extremely difficult. For beginners, it was impossible. No wonder everyone was having such a hard time.

Bad lighting is disorderly. It comes from all directions, either creating no shadows or imparting random shadows that obscure rather than inform. Poor lighting confuses forms, hiding essential landmarks that could otherwise help you map out your drawing. More often than not, if you have not actively thought through the lighting of your subject, it will inevitably feel random in your finished work. The good news is that, when lighting your subject, you have choices. Variations in light placement impart different characteristics and moods to your subject—and, therefore, to your work.

DARREN KINGSLEY, *Self-portrait— Winter '07*, 2007, pencil on paper, 12 x 17 inches (30.5 x 43.2 cm)

A solid understanding of the diminution of light enables the artist to bring all our attention to his dominant eye, while the room fades behind him.

CAROLYN PYFROM, *Portrait of Peter*, 2000, charcoal on paper, 23 x 18 inches (58.4 x 45.7 cm), collection Pamela Trimingham

Here the artist draws her husband, artist Peter Van Dyck, half in light and half in shadow. The closer the light and shadow come to being represented in equal measure, the more graphic and abstracted the image becomes.

Upper Left Lighting

Traditionally, artists have chosen most often to light their subjects from the upper left, which helps the viewer read the image from left to right. I find this lighting scenario—which is often called "Rembrandt light" since he, too, preferred this setup—to be the easiest for beginners. (See image on page 139.) The light source is placed in front of and to the upper left of the subject so that it shines down at a 45-degree angle. This lighting casts the subject in two-thirds light and one-third shadow. The thin shadow shape created on the subject is ideal for revealing the form and character. When rendered successfully, these clear shadows can transform a two-dimensional representation, almost magically, into a three-dimensional solid.

Get to know the elements of light and form so well that even if you do not clearly see them, your mind can fill in the missing information.

Side Lighting

Light coming from the side of your subject will evenly divide it in two—half in light and half in shadow. This approach has a tendency to flatten the form. Imagine a sphere with a straight line down the center; while dramatic, it does not show the curve of the surface. This lighting scenario may be useful if you intentionally want to flatten the form to create a more graphic image.

Lighting from Below

Light coming from below a subject feels mysterious and haunting. We rarely see light coming up from below except when generated by candlelight, campfires, or flashlights. Light from below casts shadows upward, creating an inversion of the sunlit world to which we are accustomed.

Lighting from Behind

Light coming from partially behind casts your subject mostly into shadow except for a dramatic light around the edges. This can be visualized if you have ever watched an eclipse. You see the lit form gradually darken into a mass with a gleaming rim of light shining from behind. This creates a halo effect, a supernatural quality of divine light.

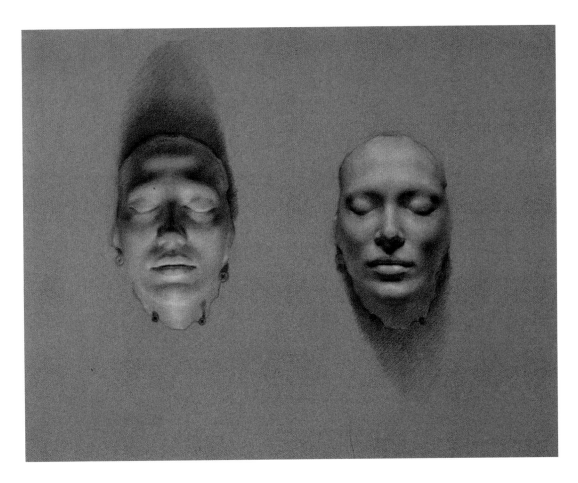

Frontal Lighting

Placing the lighting directly in front of a subject will rid it of all form-describing shadows. (Imagine: A sphere lit from the front will appear as a circle; likewise, a cone becomes a triangle.) Some artists use this technique to emphasize the linear quality of a pose. Artist William Bouguereau painted numerous beautiful figures flooded with front-facing light. In the hands of someone like Bouguereau, the result can be delicate and exquisite. It can be more of a challenge to make these alternate lighting situations work, but depending on your image it may be just what is needed.

Poor lighting obscures the form and character of your subject; choose lighting that reveals structure.

KATE LEHMAN, *Masks,* 1999, pencil and white chalk on gray paper, 20 x 23 inches (50.8 x 58.4 cm)

This drawing affords us the opportunity to contrast two lighting scenarios—one from below and another from above.

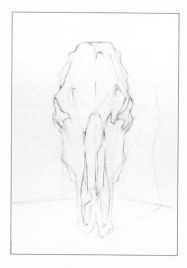

A carefully measured line drawing locks in accurate proportions forming a solid foundation for rendering in tone.

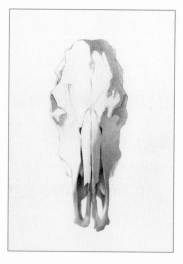

A uniformly toned shadow shape separates the light from the dark, providing another way to make comparisons.

ANY PRACTICAL DISCUSSION OF FORM must include a thorough review of shadows, as the impression of light is only created by its absence. In other words, the shadows and halftones are responsible for creating the illusion of light hitting form. Otherwise you would just have a flat shape. The more halftones and shadows you have in your drawing, the more sculpted the light will appear. Let's take a close look at one artist's work, and see how this process plays itself out in practice.

A form drawing typically progresses in the following manner: First there is the block in; next, the delineation of the core shadow line; and then, a designation of the shadow shapes. Once the shadow shapes are drawn, many artists lightly mass in a general tone. The shadow shape will be a flat, uniform tone that provides an immediate separation between the dark and light. It will look like some funky undiscovered country on a map. Perhaps it is for this reason that artists refer to the process as "mapping in" your shadow shapes. The virtue of this generalized lay in is that it allows for another entrance point for spotting corrections; proportional errors are immediately apparent. After your shadow shapes seem to be as close as you can manage them, the time is right for moving on to turning form or rendering the halftones in value.

In the traditional art world the debate rages about how much information should be included in your shadow shapes. Should the shadows be rendered as a flat shape or modeled? Before choosing sides, let's discuss the merits of each.

Keep in mind that the only time there is no change of values on a subject is if an object is completely flat and evenly washed with light. When light hits an object, every little bit of it is receives more or less light, depending on the how much of it is facing toward or away from the light, and if it is closer or farther away from the light source. This means that, in reality, even a flat piece of paper will have some tonal changes unless a bright light is shining directly down on it. Even if it is rarely present in reality, a flat rendering of a shadow shape can be used as a device to make an immediate graphic effect, creating unity of tone and ensuring that your values do not lose their hierarchy.

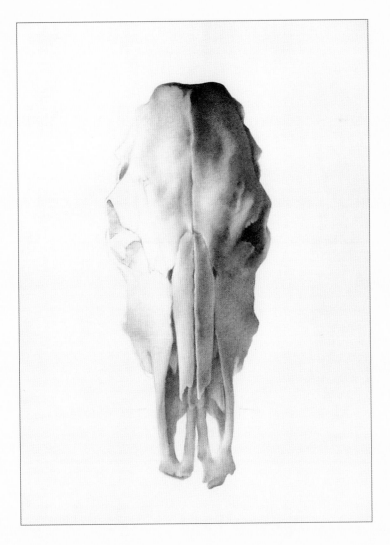

In most situations, the shadow shape is alive with bouncing light and turning forms. This nighttime world has a topography of hills and valleys that can describe important information about your subject. Observing these forms is a discerning visual experience. After all, when you look into the shadow side of an object, in many cases it does not disappear; everything is still in its place, ready to be explored. The challenge is to place some of these tonal changes without losing sight of the big picture of value in your work.

BOBBY DITRANI, *Cow Skull*, 2010, charcoal on paper, 24 x 18 inches (61 x 45.7 cm), courtesy of the Aristides Atelier

The artist focuses all of his attention on each tiny area of nuanced halftone to bridge the light and shadow sides of the skull.

DEAN SNYDER, *Study of a Cast Shadow,* 1972, ink on paper, 10 x 6 inches (25.4 x 15.2 cm)

In this analytical study, note the change in value as the shadow moves away from the wheel. The shadow keeps its shape because the surface of the ground is flat and smooth.

Two Types of Shadows

Often, the people I find the most interesting are those who have experienced hard times in life. A certain depth, perspective, and resiliency often get worked into a life through suffering. Likewise in art. In the most interesting works, the dark side is essential. The brilliance of light depends on the shadow.

When people hear the word *shadow,* what often comes to mind is the dark shape on the ground that follows you outside at recess. Yet there are actually two kinds of shadows: cast shadows and form shadows. Taken together, shadows provide a work of art with its structure and visual impact.

Cast Shadows

I was in Rome two summers ago with a friend who was leading an art history tour. We were in a hot piazza, and there was no cover from sun. She looked and saw a thin, long shadow projected from a two-story obelisk onto the stone ground. "Look!" she announced. "A beam of shade." We all ran and took refuge.

A cast shadow anchors your object to the ground plane, providing a sense of weight and permanence to your object.

This type of shadow, called a "cast shadow," projects away from its source (in this case, the obelisk) and lands on something else. Because the surface of the piazza was flat, the shadow directly echoed the shape of the monument. If, on the other hand, the shadow had fallen on benches and trash cans, it would have been greatly distorted by those objects.

Cast shadows often have sharp edges. In art, they provide an important visual element, anchoring your subject to the ground plane. They also give a sense of weight and permanence to your subject.

Form Shadows

The second type of shadow, called a "form shadow," attaches itself directly to the subject. It is inherently part of the subject itself. For instance, it is the unlit facet of the obelisk in the piazza, the dark crescent on the underside of the sphere, the part of the nose thrown into darkness when light hits the other side of a face.

This kind of shadow often reveals a lot about the form that created it, hence its name.

Descriptive shadows are an essential element of creating form with value.

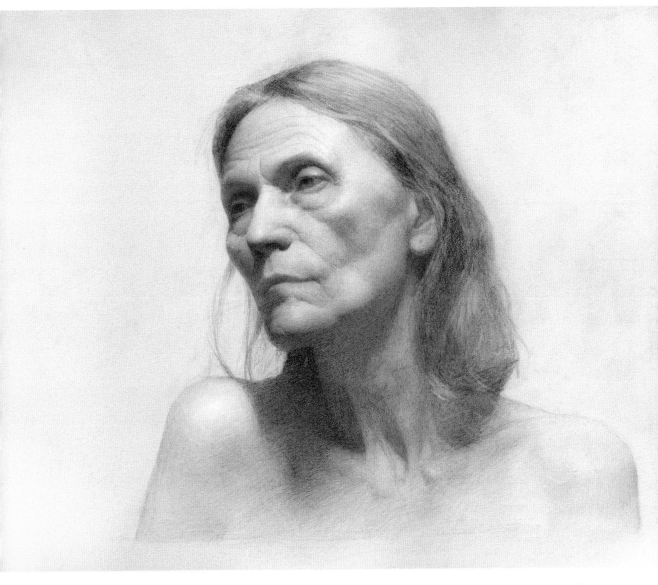

GREGORY MORTENSON, *Anna Nina*, 2008, graphite and white charcoal on paper, 12 x 14 inches (30.5 x 35.5 cm)

The form shadows, such as those under the cheeks and nose, help describe the planes of the face. The careful attention given to the small shadows and halftones in the drawing capture the sitter's character.

ELIZABETH ZANZINGER, *Glass Cup*,
2006, charcoal and white chalk on paper,
5 x 5 inches (12.7 x 12.7 cm)

In spite of the light that floods through
the glass cup, many of the characteristic
attributes of the cast shadow can still
be seen.

Anatomy of a Shadow

The placement of the light source dictates the length of the
shadow—for both cast shadows and form shadows. The lower the
light source, the longer the shadow; the higher the light source, the
more truncated the shadow. If the light shines straight down, there
may be no cast shadow at all.

The intensity of the light impacts the strength of the shadow. The
stronger the light source, the sharper the shadow. Likewise, the edges
of a shadow are sharper the closer it gets to the object casting it; as the
shadow moves farther away, it becomes softer and more diffused.

In addition to shape and strength, shadows—both cast and
form—contain various nuances. The following terms will help you
to better appreciate the subtleties of shadows.

*It is worth investing time in drawing cast
shadows, as they create a sense of gravity. This in
turn integrates your subject into believable space.*

Dark Accent

If you look closely at the cast shadow of a sphere, on the ground
plane you will see that the darkest part undercuts the sphere. This is
the point where the shadow meets the sphere itself. The dark accent
is the part of the shadow where often no light hits.

Body of the Shadow

This is the large shape of a shadow, such as the ellipse cast onto
the ground plane from our sphere. Often the body of the shadow
contains some bouncing light, so keep in mind it is often not as
dark as it first seems. The body of the shadow is found on both cast
and form shadows.

Reflected Light

The light from the surrounding areas bounces light into the
shadow, making it awash in luminosity. Normally this can be seen
most clearly near the contour of an object (away from the core
shadow or dark accent). By including areas of reflected light in a
form shadow, you can create an increased feeling of volume.

Shadow Edge

This is the boundary around the body of the shadow. People often
put a contour around the shadow edge, yet in reality it is usually

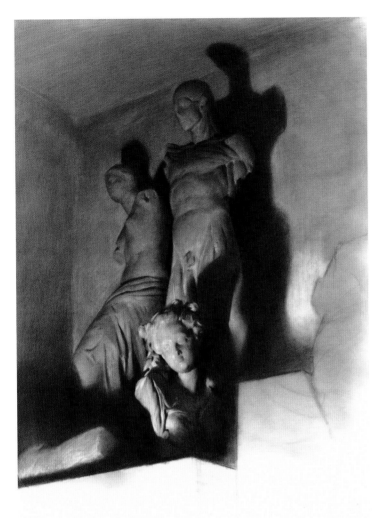

MICHAEL GRIMALDI, *Judgment of Paris*, 2007, graphite on paper, 24 x 18 inches (61 x 45.7 cm)

A cast shadow projects away from an object. In this case the bust's shadow hits the figures behind it, obscuring the legs. The extreme lighting projects shadows of Houdon's flayed figure onto the wall and ceiling.

a permeable form—more or less sharp, depending on the circumstances. Each type of shadow produces a different type of shadow edge. The edge of a form shadow is called a "core shadow."

Penumbra

This is the diffuse half shadow that hovers between the light and the shadow edge. The penumbra can be seen on cast shadows. On the sphere on page 160, the penumbra is the area that forms a soft transition next to the shadow and onto the ground plane.

Shadow shapes provide key information about the nature of your light source.

The Core Shadow

The terms *core shadow, terminator,* and *bedbug line* all refer to the line that divides the form shadow from your lights. Feel free to invent your own name, if you're so inclined. No single line is more crucial to form drawing than this one: It describes the structure of your subject, gives you critical clues about where to render form, and provides a major landmark. The core shadow should provide an anchor for carefully gradated form; as such, it must convey strength and accuracy.

The core shadow is not always easy to see. To locate it, look at the light shape of your object and slowly scan your eyes toward the shadow. The darkest moment between the two is the core shadow.

The line of the core shadow tends to be straight and angular rather than curvilinear. Tony Ryder wrote, "Of all the landmarks, the terminator is the most centrally important. Its little zigs and

zags serve as starting points for tonal progressions that grow out of it—into the light on one side, and into the shadow on the other— further defining the various features of the form."

The core shadow also tends to be darker and more pronounced than the shadow shape as a whole. It is a dark accent point that catches the eye and moves the viewer's attention to the middle of the volume. This is important because, in most cases, the contour of an object is farther away from the viewer than the center of the form. It makes sense that we want the viewer to see the center first and then to move his or her attention to the edges.

Throughout the rendering process, the core shadow transforms from a wall to a bridge, connecting the dark and light sides of your subject.

The core shadow may initially appear to be a barrier between dark and light; however, it is actually a bridge. Tone must envelop and pass over the line, connecting the dark and light sides of your subject. Often, if you look carefully, you can see tiny perpendicular cuts in the form that rake against the light. Grasping hold of those nuances can really aid your ability to describe the surface of what you are looking at. These cuts against the core shadow are descriptive of the volume or bulk of an object; they describe its girth.

Your "line" of core shadow will rarely be simply one continuous dark line. Sometimes it may appear that there is more than one core shadow, that the line is broken, or that it is just very faint. Even a light core shadow line or a very broken one is important to identify and formalize.

Never fake a completely closed, single core-shadow line running down your object. It is rarely continuous in that way. Rather, create an open, searching line that can be easily adjusted and amended throughout the drawing process. A white object being hit by strong light may give the appearance of a continuous line. But even then, it is important to find and depict cuts or breaks along the line to describe variations on the surface of the form.

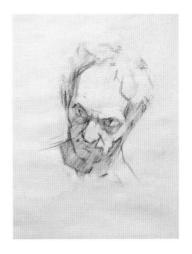

TENAYA SIMS, *Block In Study of Holger,* 2010, Conté pencil on paper, 10 x 8 inches (25.4 x 20.3 cm)

This image shows the intermediary stage of the drawing process; the terminator line clearly delineates the mapping of light and shadow shapes.

Halftones

I was once invited by a friend to pick chanterelle mushrooms in a forest in the Northwest. When we arrived, all I saw were trees and a carpet of leaves. Yet after some time, my eyes acclimated. As I learned where to look, sure enough, there were mushrooms. Although I had walked through those woods many times, I had never seen half of what was there.

Envision yourself on the surface of your object so that you can almost feel the undulation of the surface as it moves from shadowy valleys to sunlit peaks.

Halftones are a critical element for creating the appearance of believable volume yet, like the chanterelle, they are hidden in plain sight. They are everywhere, yet it often helps to have a guide to see them. Historically, students of art spent extensive periods of time working from white plaster casts of famous sculptures. (Examples of drawings done from casts can be seen on pages 181, 184, 185, 188, 189, and 194, for example.) These casts were—and are still—useful for a number of reasons: They are stationary, afford a good study of the figure, and contain valuable design lessons. Yet, perhaps the most critical reason cast drawings are essential is that they offer an opportunity to study subtle mid-tones. These delicate washes of tone are easier to perceive on a white surface, when the element of color doesn't complicate the process.

EDWARD MINOFF, *Waves*, 2009, pencil and gouache on prepared paper, 9 x 22 inches (22.9 x 55.8 cm)

Using a narrow range of values and applying them with seamless gradations, Minoff creates the impression of sand, water, and sky.

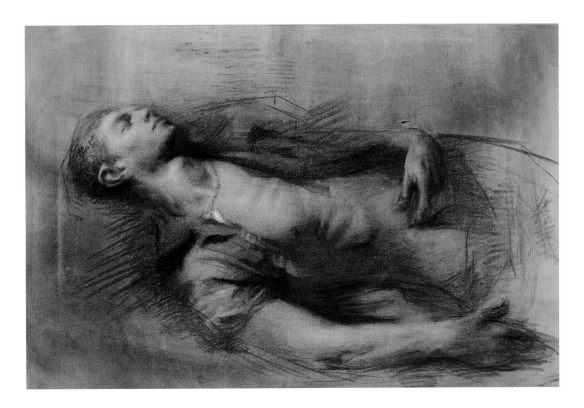

Halftones are the bridge of value that connects your shadow shape to your light shape. Some artists think that a wide value range gives a drawing the necessary punch to move into the third dimension; however, that is not necessarily the case. Rather, a series of small value changes that gradate over a surface effectively indicate the flow of light and communicate the volume of that object to the eye. These mid-tones portray the tip and tilt of planes in space. They project the object into the third dimension.

In our time, there is a revival of interest in creating beautifully observed and rendered form. This requires an extensive exploration of halftone. The person who has perhaps pushed an understanding of a topographical rendering of form further than anyone is teacher Ted Seth Jacobs. Our understanding of how light washes over objects has been expanded by his efforts. His focus on minute turning form requires a very literal and extensive observation from nature.

JULIETTE ARISTIDES, *Dirge*, 2010, charcoal on toned paper, heightened with white chalk, 18 ¼ x 25 inches (46.4 x 63.5 cm)

This drawing is comprised of predominantly mid-tone values. Many of the accents are formed by the undulation between hard and soft edges.

BARBARA KATUS, *Greek Keys*, 1999, charcoal and Conté crayon on paper, 22 x 30 inches (55.8 x 76.2 cm)

This trompe l'oiel drawing relies on an accurate portrayal of light to create a convincing illusion. The razor thin reflected light bounces into the shadow shapes and aids in the impression of girth. Notice how Katus plays with the geometric ideals as compared with their natural forms.

OPPOSITE: COLLEEN BARRY, cast drawing of *Laocoön* (detail), 2010, graphite on paper, 20 x 16 inches (50.8 x 40.6 cm)

This beautifully handled cast drawing contains many revealing elements. The arrow at the top of the page shows the direction of the light source, the box beneath it orients the box of the head, and the measurements on the side mark the divisions of the head. Note the light-filled shadow tone, behind the core shadow line, which implies bouncing reflected light.

Reflected Light

Reflected light is the light that bounces into a shadow from surrounding areas. This light may be strong or weak, depending on the surface that reflects it. For instance, if I hold a piece of tin foil next to a dark tone on a white plaster cast and tip it so it catches the illumination coming from the primary light source, the area will brighten immeasurably. By contrast, if I hold up a piece of velvet in the same position, it may reflect no light at all.

Imagine that you are walking into a room, directly toward a brightly lit window, when out steps a friend to greet you. The first image you see will be a backlit figure or a silhouette. Yet, as you focus on your friend's face, your eyes will gradually adjust, and the figure will come into sharp relief. The reflected light in the room allows you to see everything clearly.

This process works brilliantly in life but can create real problems in art. Your eyes naturally compensate in certain situations, inverting the primary visual truth. The more you look at an object; the more you will see. The shadows will pull forward, and the lights will drop away—the opposite of the way light and shadow really work. In a nutshell, this is the dilemma of reflected lights.

Properly used, reflected light adds volume and interest to your work. However, if the reflected light is used too much or becomes too bright, it ruins the artifice. To avoid pitfalls, throughout the progression of a drawing, establish visual truth by working from broad to specific. Assess the smaller tones and how they fit into the context of larger values. This process normally reveals the reflected light as being darker than we imagine. After you place your tones, double-check your areas of reflected light for accuracy. Keep comparing them to the wider field.

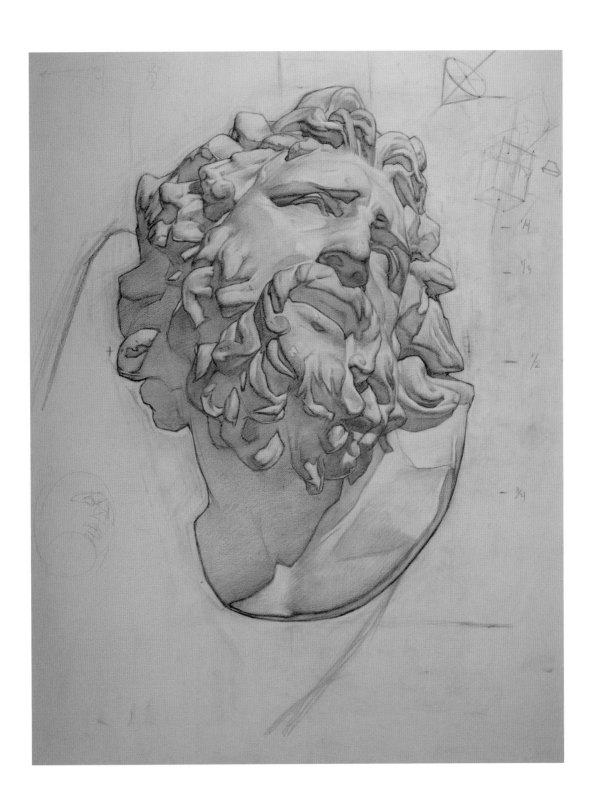

Highlights

Highlights are a light accent that, if placed perfectly, can impart a feeling of finish and brilliance. For this reason, many artists rush into placing highlights. Sometimes this works. If the drawing is far enough along and going well, a properly placed highlight can make a semifinished piece feel complete. If placed too soon, however, a highlight does nothing but draw attention to the fact that the drawing is not turning out as intended.

I recommend, as do most instructors, leaving the highlights until late in the completion of your work. In beautiful work, often the highest area of light is created naturally by the tone being built up around it. The form is slowly developed, and the feeling of light and brilliance is created throughout the piece. The highlight serves as a final focal point for a creation that is already complete.

In fact—and this may seem like artistic heresy—you do not actually need to put in highlights at all in some cases. Large shapes sometimes contain a graphic power that can get broken up by too many speckling lights. Sometimes it is fine to just leave your large light shapes as a broad local tone. It is okay to determine the treatment of your highlights by the goal of your work. Be choosy about which ones you want to achieve the best results.

Refrain from placing the highlights in your drawing for as long as possible.

Whatever you choose, remember that the highlight is a spot of glare that does not describe the form, but rather rests on top of it. This is especially true if you are drawing a shiny, reflective, or metallic subject. In these cases, the highlight will look no more attached to the surface than a magnet to a refrigerator; it may appear as though you could just pick up the highlight and walk away. By contrast, the softer the surface texture of your subject, the more the highlight will appear to be part of the light shape; the "highlight" on a child's foot, for instance, will be articulated by a gentle gradation of increasing brightness. If you misplace a highlight, you can easily send the viewer the wrong signal about your subject—making it look metallic when it is soft, or vice versa.

When rendering highlights, keep in mind both the principles of the classic order of light as well as your own personal artistic goals. A few tips to keep in mind: Find small areas around the highlights that imbed themselves into the values that in turn surround them. Identify any hard and soft edges that may surround the highlight. Look for ways to have the highlight describe the overarching volumes of your subject.

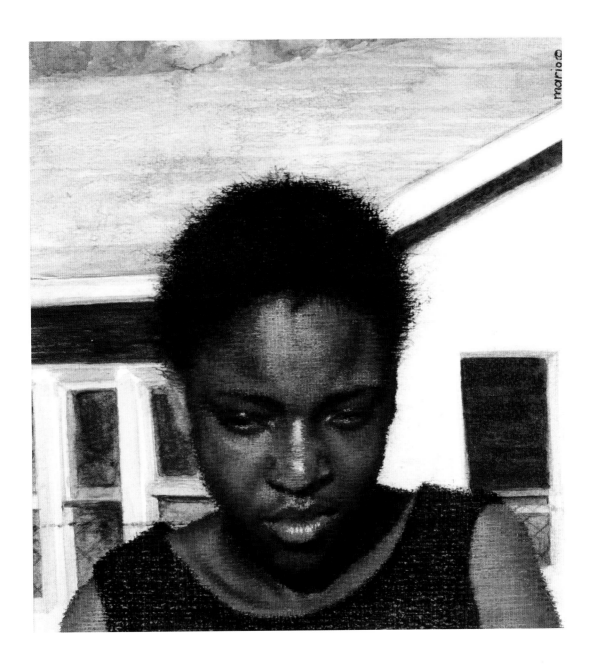

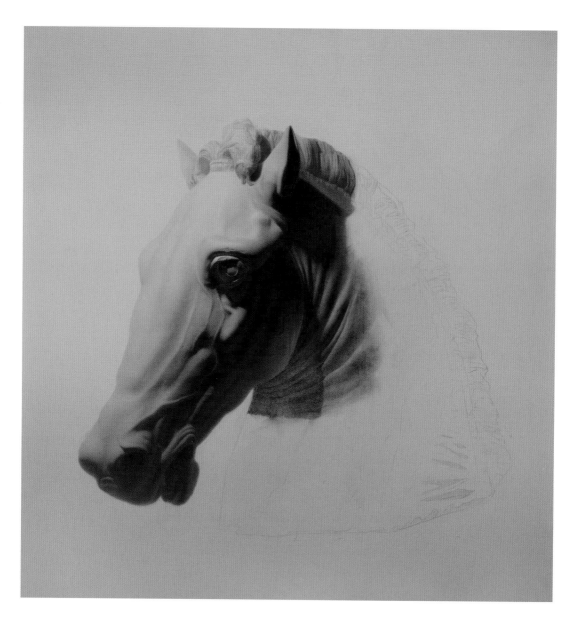

IRVIN RODRIGUEZ, cast drawing of
unknown artist's *Equus* (in process), 2010,
graphite on paper, 22 x 22 inches (55.8 x
55.8 cm)

In a form of rendering called "window
shading," the artist started at the top and
worked on the drawing, moving down
and to the right. Once he got to the bottom
of the drawing, he was done.

Practical Tips for Form Drawing

When drawing form, practical elements can dramatically affect
your outcome. Of course, your eye and hand must both be trained,
but other (largely procedural) considerations can help to stack the
cards in your favor. Having a consistent working method is a real
asset, one that eliminates the need to reinvent your artistic process
each time you sit at the easel. The goal is to have a seamless method
of linking your thoughts with your eye and hand.

In my development as an artist, I have found it helpful to follow a recommended practice that both anticipated what I should look for as well as helped me to recognize it once I found it. In other words, I followed the recommended practice first and only fully understood it afterward. Artistic systems enable doors of perception to open as you experience the artistic symbiosis between hand and eye. The following pages highlight some time-tested ways to begin drawing form.

Work Systematically from One End to the Other

When I was a young student studying in New York City, I took a workshop with Tony Ryder (a former student of Ted Seth Jacobs's). He said that I was jumping around on the page, and suggested that I render methodically across the form, from one end to the other. He used the analogy that I needed to take a ground route from one location to another with my pencil, not travel by air. I fought with him as I wrestled with this new way of seeing volume.

Now this may not mean much to you, but an apt word at the right time can be life changing. I was jumping all over the drawing. I needed to be deliberate with how I reconstructed tone. The skin of a subject needs to be literally laid across the image. This requires intense concentration—keeping your eyes wide open and making the most of every small event you can find.

To work in this manner, pick an area next to the core shadow and place a value that is almost the same tone. Look for a seamless transition of minute changes that form tiny value step scales from the shadow to the light. It can be helpful to have your value step scale in hand and take note of the tone that best describes your core shadow. Then attribute a value to your highlight. Know, even if you cannot see it, that you are going to have to hit those in-between values to get the image right. Gradually place the adjacent tones next to the first, moving systematically along your value step scale. Keep in mind that, although the scale has nine steps, this process involves countless gradations of tones.

Stay in one area at a time. You may cringe, as I did, at the painstaking rendering of small areas of form. You may feel the tendency to be more efficient with your time and lay in a large flat area of tone. I would not recommend doing this anywhere besides your shadow shapes, because it is more difficult to go back in later and place small value gradations and structure than it is to put them in at the beginning. Later effort—however intense—can never quite shake a simplified start.

IRVIN RODRIGUEZ, cast drawing of unknown artist's *Equus*, 2010, graphite on paper, 22 x 22 inches (55.8 x 55.8 cm)

The successive rendering of graphite builds up a convincing layer of tone. The artist gives the full power of his attention to each area of the drawing, bringing it to a high level of completion before moving on to the next one.

GIUSEPPE PIETRO BAGETTI,
General View of the Part of Italy Which Was the Theater of the War during the Italian Campaign of 1800, date unknown, watercolor on paper, 3 feet 10 ⅞ inches x 6 feet 2 inches (120 x 190 cm), collection of the Palace of Versailles and the Grand Trianon, Versailles, France

Photograph by Franck Raux

Photo Credit: Réunion des Musée Nationaux / Art Resource, New York, NY

The sunlight washes over the mountain range, clinging to the peaks and filtering into the valleys in the same way that it falls on the convexities and concavities of the human form.

OPPOSITE: LISA JOSEPH, master copy after Marco da Oggiono's Study of *Christ's Drapery Rising from the Tomb*, 2010, silverpoint on blue-prepared paper heightened with white, 11 x 9 ¼ inches (27.9 x 23.5 cm), courtesy of the Aristides Atelier

Drapery provides an excellent opportunity to study turning form and rhythm of movement. It also affords good training for the eye in citing angles and measurement.

Start with a Busy Area

The discipline of form drawing requires much patience. The process is slow and methodical—and requires a new way of viewing the world. Do not be surprised if at first you do not see much. Like when walking from a lit room into a dim one, you may find it takes a while for your eyes to acclimate.

Remember that every subject has mid-tones that are located between the core shadow and the light. The only time you will not be putting in transition values is when you are describing a 90-degree angle change, as in a razor-edged fold. Some areas are easier to see form in than others. Because value changes in flat areas can be very subtle and hard to see (as in the vast expanse of a thigh that is hit by direct light), it can be hard to get a handle on the form. Other objects, such as the complex folds found in fabric, are easier because there is more to see and, therefore, to render.

For this reason, I recommended starting to turn form in a busy area. Doing so will allow your eyes to adjust more readily when you move to a flatter or more subtle area. It can be particularly helpful to locate an area of core shadow that is a little jagged, or that has a number of smaller subforms coming from it. Lightly sketch the shape of your halftone as it comes out of your core shadow.

This series of cast drawings, by Florence Academy of Art instructor Stephen Bauman, were created using the sight-size method discussed on pages 54–55. First, Bauman articulated simplified angles, establishing a blocky foundation that determined both the proportions of the image and the major divisions between dark and light areas.

Next, Bauman placed a background that absorbed the shadow of the face. He preserved the large light shapes, which drew attention to the core shadow areas. Notice the flatness of the values; at this stage they were treated as pattern rather than as volume.

Work from Shadow to Light (or Vice Versa)

When I studied with Jacob Collins, he always stressed that we should work from a shadow area into the light. I remember the first time he demonstrated this concept. He started rendering his tone, moving carefully out from the core shadow. I thought he was getting way too dark. I looked at the model and did not see any values nearly that intense. Yet, when the piece was finished it was beautiful, accurate, and completely convincing. It took some time—watching Jacob work and questioning him about this practice of shading from the shadow side—before it started to sink in. He explained that it is hard to see the halftones. You are more likely to leave room for these subtle, shifting fellows when you move out from a dark area than when you come from the light side.

The range of values we are able to capture with a drawing medium is inherently limited. If you place the halftone exactly as you see it, you may notice the piece ends up being too pale overall at the end. To give the full illusion of form, you may need to go

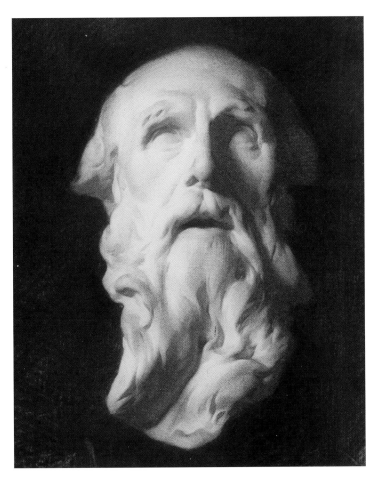

STEPHEN BAUMAN, cast drawing of unknown artist's *Old Man with a Beard*, 2008, graphite on paper, 21 ½ x 15 ½ inches (55 x 40 cm), collection of the Florence Academy of Art

To complete the image Bauman carefully modulated the halftones, creating a convincing illusion of light hitting form. The strength of his original block in and the unity of the big values were preserved through to the finish of the work. This progression shows that, above all, halftones inform the viewer about the character of the light and the subject.

darker than what you see when shading out of the core shadow area, like Jacob did during his demonstration. This extension of the halftone creates a telescoped effect of light. Condensing the light shape into a smaller area fools the eye into reading it as luminosity. In this manner, we extend past the limits of our medium.

Form drawing is an act of faith before it is one of sight. You have to trust that this process works—it does. It requires you to put down more tone than you see. In the beginning you will put tone down because you are supposed to, and eventually you will see it for yourself.

There are times when you may want less halftone, in which case, it makes sense to do the reverse—and work from light to dark. As early as the seventeenth century, Sir Joshua Reynolds mentioned in his *Discourses* this alternative way of working, saying, "Shade downwards from the lights, making everything darker in due proportion, until the scale of our power being ended, mass of the picture is lost in shade." You may want to try the same drawing using both ways of working and compare the results.

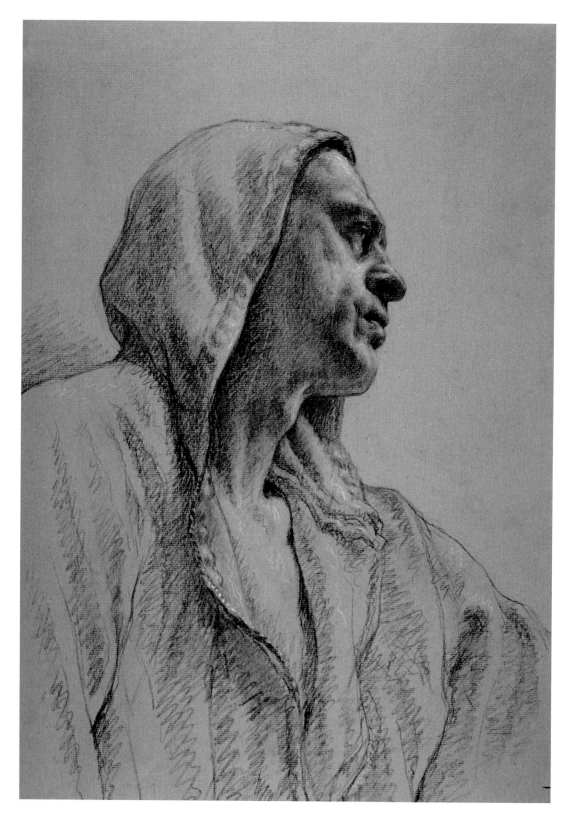

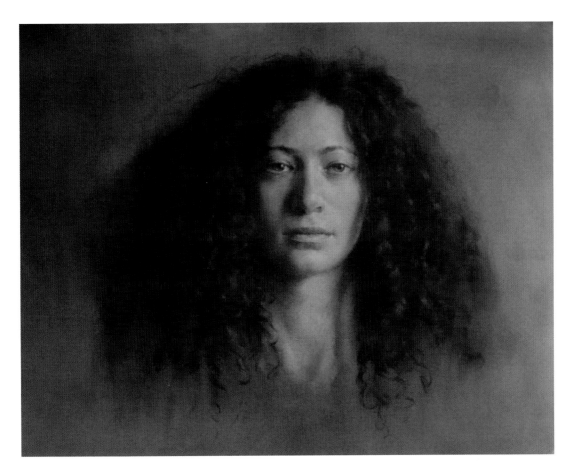

Scan for Value Differences

The study of form drawing is a love of small changes that capture the surface topography of your subject. It is difficult, even for one who has studied drawing for a while, to see and render these areas. You want to look for very tiny rivers of light and shadow that ripple across the

Form drawing is concerned with representing the real, instead of an imagined or idealized subject. It gives permanence to that which is transitory.

skin of a subject. If you have ever looked at a rapid photographic progression—one that starts at the galaxy, zooms to the earth, focuses in on a continent, then a state, a city, a neighborhood, and lastly a house—you can envision this ever-increasing zooming in on smaller shapes. Forget what you know and simply become an explorer creating a topographical map of the surface. Follow each tiny shadow as it leads to a small hill of light. Travel up peaks and down valleys. At the end of your grand tour, you will have described it all.

STEPHEN EARLY, *The Reckoner*, 2009, graphite on paper, 11 x 14 inches (27.9 x 35.6 cm)

The meticulous rendering of the portrait creates a striking contrast with the dark mass of the hair and background. The artist further arrests our attention through the unswerving gaze of the subject.

OPPOSITE: JON DEMARTIN, head study for *Faith in the Wilderness*, 2006, black and white chalk on toned paper, 20 x 15 inches (50.8 x 38.1 cm)

This marvelous self-portrait drawing forms the preparatory work for a finished painting. All the tiny subforms on the face convey the character and resolve of the artist.

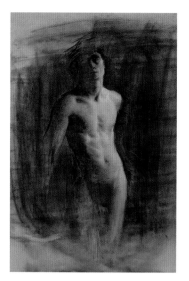

JULIETTE ARISTIDES, *Apollo*, 2010, charcoal on toned paper heightened with white, 24 x 18 inches (61 x 45.7 cm)

The light washes down from right to left, dropping quickly in intensity as it gets further from its source. A challenge of rendering the figure is keeping unity in the flow of light while carefully modulating all the smaller structural areas.

OPPOSITE: ELIZABETH ZANZINGER, *Sarah Resting*, 2008, charcoal on paper, 20 ½ x 18 inches (52.1 x 45.7 cm), courtesy of the Aristides Atelier

The artist, as a second-year atelier student, remained consistently aware of her light source, which was coming from the front of the figure. All the halftones turn incrementally toward the area of brightest rim lighting and the white highlight on her shoulder.

Remain Aware of Your Light Source

When creating volume it is important to remember the relationship between the light source and your subject. Objects turn and are shaped in such a way that every tiny change in surface area reflects a corresponding adjustment of light and shade. Every point on the object is hit by a different amount of light, depending on its origin and intensity. If the light is coming from one side, every form facing that direction will be getting lighter to some degree. Form lightens as it moves up, closer to the source. (But if your object is very dark, this may not be as evident.) Likewise, the farther away the form is from the light source, the darker it will be.

In portraits by Rembrandt, the light hitting the face is inevitably strongest on the forehead, in keeping with his light source. By the time he models the light planes in the lower part of the face and the chin, he has dropped several significant value steps. Rembrandt knew to look for a diminishment of value the farther the plane was away from the light source; even if the difference in distance was only a matter of a few inches. Keep in mind, however, that the whole light side of the face would have appeared equally bright to him at first glance. Rembrandt knew it was important to create a darkening of value in that area in the interest of form. He knew what he was looking for.

Make a mental note of the quality of your light source—its angle and distance away from the subject. This information will help you construct, rather than copy, your value gradations.

Tony Ryder said it well: "It's very easy to miss the quality of light if you're just copying values. The light should shine in your drawings. Shaping the light is like molding the amount of light for each form, building up more light in one place and tapering it off in another."

Do not copy what you see. Rather, use your understanding to inform your vision. The ultimate judge of the work will not be whether it is like your subject, but that the image reads beautifully on its own.

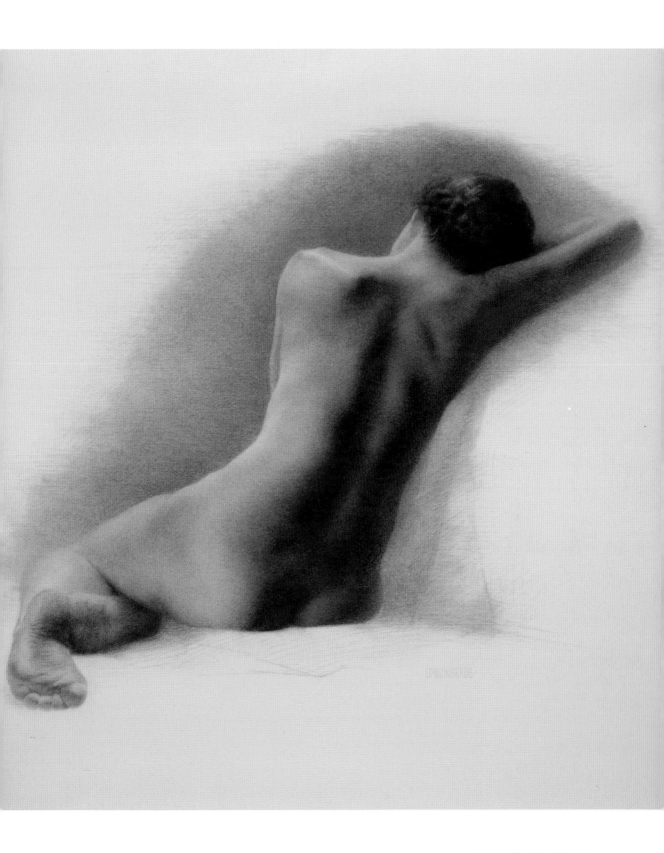

This tiny sketch shows the artist's first thoughts about the value composition of her subject. This sketch became a guide for the overall value distribution of the finished piece.

KATHERINE LEEDS, cast drawing of Claude-Francois Attiret's *La Chercheuse d'Esprit*, 2010, charcoal on paper, 18 x 12 inches (45.7 x 30.5 cm), courtesy of the Aristides Atelier

Katherine, as a first-year atelier student, developed her piece systematically, working from a thumbnail sketch to a measured drawing. After locking in the proportion, she carefully rendered each small area of form without fear of losing the bigger picture.

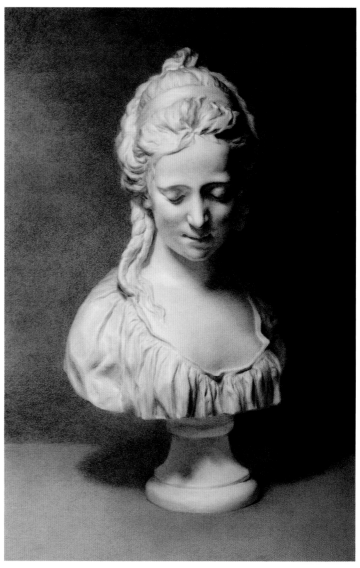

Remember the Bigger Picture

Focusing on small forms for an extended period can easily lead you to lose sight of the big picture. I have seen beautifully rendered drawings that include truly rudimentary errors both in measurement and tonal distribution. Once a drawing has been finished with these kinds of imbedded mistakes, it is almost impossible to rescue.

Fortunately, this situation can be avoided by doing a little preliminary work. A small thumbnail sketch can serve as a guide for your overall value distribution. A gesture drawing can ensure that a solid flow of movement links diverse parts of the drawing. A carefully

measured drawing, if adhered to, will keep your proportions in check. The natural progression of the drawing process is designed to serve as a firm foundation for rendering tone. This will free you up to focus on small areas without worrying that you are going off track.

Make sure that the small forms hang on a bigger structure. In the last chapter, we developed a plan for making sure that the whole drawing works together as a unit. Now we are working on a balance, or, more to the point, we are reconciling the two extremes. We need the whole drawing to stay connected and feel of one piece, yet we do not want it to be simplified as if our subject were made of plastic rather than flesh and blood. The antidote is to keep checking in with the whole. When executing a form drawing, one part will continuously be jumping ahead of another in terms of finish and contrast. The new part needs to be connected to the parts next to it by careful and seamless transitions.

When rendering form, continue to make small corrections to the overarching accuracy of your drawing. In essence, you will be making a final round of drawing corrections, working with a fine-tooth comb. As you are toning, tapering, and connecting one area of your drawing to another, small discrepancies in shape will become apparent. The more realistic a drawing becomes, the more obvious these inaccuracies feel. By making lots of tiny adjustments, this final look through the drawing can greatly improve the overall feeling of accuracy.

DAVID DWYER, *Thumbnail Sketch for Leek and Squash*, 2007, graphite on paper, 3 x 7 inches (7.6 x 17.8 cm), courtesy of the Aristides Atelier

David does a value sketch for every painting he endeavors. (See his demonstration on pages 155–157.) His deliberate placement of large tones at this stage helps capture much of what makes the final images compelling.

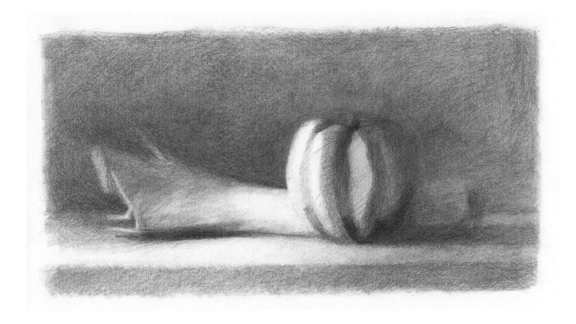

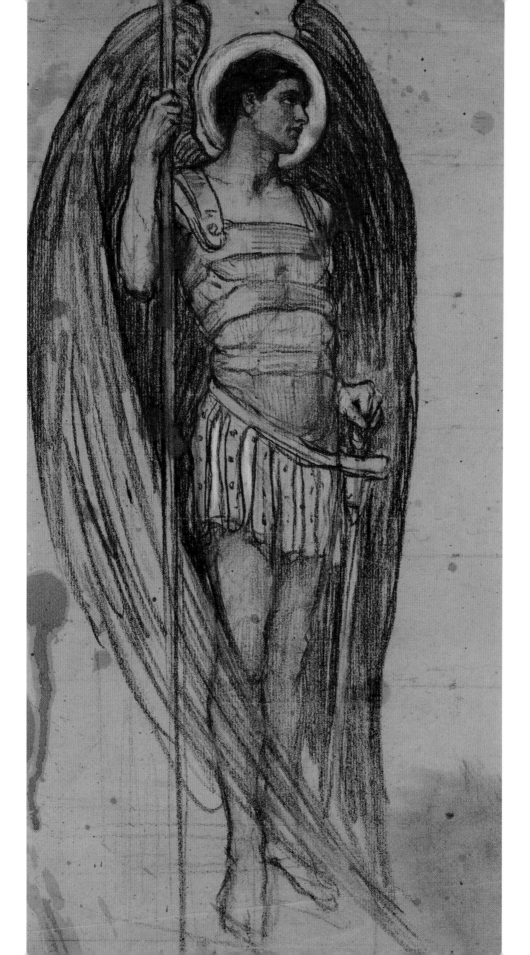

Take Materials and Methods into Consideration

There is a certain, purely technical aspect of turning form that involves your use of materials. To some degree, the success of your image depends on the type of paper you have, the drawing implement you choose, and how heavy-handed you are. Make an effort to personalize your process. There is no right or wrong way to make the tone adhere to the paper; if the end result works, the process works.

The outcome of the drawing can be dramatically affected by how the paper handles the medium. The actual tooth of the paper can become an obstacle if it is too rough and, say, you are using charcoal. Experiment with different papers. (See my website, **www.aristidesatelier.com,** for some recommendations for getting started.) Find one that works best for you, and use it regularly.

If you are a beginner and you struggle with keeping your lines light, you may opt for a graphite pencil, rather than charcoal. Either way, keep your drawing instrument as sharp as possible and slowly build up tone.

Tonal progressions are made a number of ways—through adjusting what medium you are using, choosing either hard or soft material, or pressing firmly or lightly on your drawing implement. When using charcoal, I recommend starting with a very sharp piece of medium or a hard vine charcoal (which is easier to control). Start by massing in your tones lightly and building up your darks gradually to increase tonal depth. The shadow areas are more forgiving than the subtle lights, so go slowly and carefully as you work. Likewise, use a harder pencil for the lights and shift to softer pencil or charcoal as needed to extend the darks. When rendering form, do the best job you can, regardless of the time it takes. In art, as the saying goes, there is no prize for finishing first.

JOSHUA LANGSTAFF, *Study of a Twisted Yellow Birch*, 2007, graphite on paper, 14 x 11 inches (35.6 x 27.9 cm)

Langstaff, a graduate of the Aristides Atelier, approached the twisting surface of this tree as an opportunity to study light as it ripples across a form.

Putting It All Together

Managing light, shadow, value, and form can be daunting at first. Trying to keep all these elements of value in mind while still focusing on proportion and gesture can be overwhelming. When I learned to drive a stick shift as a teenager I could not believe anyone could watch the road, manage the pedals, change the gears, and steer at the same time. Now, of course, I do all that without a second thought—in addition to talking, drinking coffee, and eating breakfast. Practice makes it second nature. After a while you will not have to think about it.

The first few drawings you create implementing all these principles will no doubt be a lot of hard work and probably not much fun. You may feel like I did, that you are getting worse before you get better. Your natural drawing technique can start to become self-conscious and awkward. Allow that to happen. Each hard-won drawing allows you to bring a new skill to your next one. You will soon learn to take shortcuts and streamline the process. My experience has shown me time and again that the students who can hang in there and keep focus gain ownership of the material very quickly.

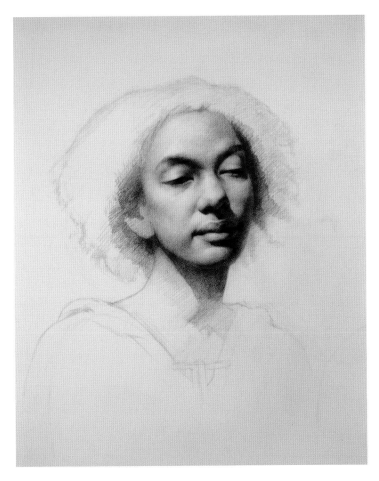

JOSHUA LANGSTAFF, *Pigeon*, 2006, pencil on paper, 14 x 11 inches (35.5 x 27.9 cm)

Partially finished drawings are a treasure trove of information about the artist's working method. We can see Langstaff, a graduate of the atelier program, starts with a line drawing before focusing specifically on turning form.

In my atelier, students routinely struggle for the first few months of their training, seemingly making no progress at all. And then, all of a sudden, they make a drawing that is a major break-through. This is often followed by a disheartening slide back for a week or so. But before long they have a baseline of solid technical skill; this rock-solid start becomes the norm rather than the excep-tion. Expect this cycle. If you know it is coming, you will find it easier to wait it out.

It has taken me many years to learn to really see form, and now I find it an endless source of pleasure and fascination. My tastes have changed, and although I still find the broad, well-placed strokes of a block in beautiful, the drawings I sincerely love are nuanced. They exhibit a deep insight into the subject. The study of form is an irreplaceable study of small things for their own sake. It has to be observed from life. It is a celebration of the concrete, the real, and the personal. This type of seeing captures the absolute uniqueness, the particulars, of your subject rather than its breadth or universal qualities.

LESSON 6 FORM DRAWING

THE EFFECT OF LIGHT HITTING A FORM is an intriguing phenomenon regardless of subject matter, as light is inherently beautiful. The logic and principles of light and volume can be used to render anything from a complex landscape to a simple still life arrangement. Yet studying form on a portrait model adds another level of complexity, as correct proportion becomes essential, and the achievement becomes all the more rewarding when done well.

The goal of this lesson is not only to create a sense of mass and weight through the sculpting of light and shadow but also to document a conversation about the human condition. The careful, analytical approach illustrated in this sequence remains classical in the best sense of the word. Eugène Delacroix wrote in his journal, "I would readily apply the term 'classical' to all well-ordered works which satisfy the mind, not only by an accurate, noble, or lively rendering of sentiments and objects, but also by their unity and logical arrangements; in short, by all those qualities which enhance the impression by creating a final simplicity."

GATHERING YOUR MATERIALS

In preparation for your light and shade drawing, assemble the following materials:

Vine charcoal
White chalk pencil
Sandpaper
Charcoal paper
Drawing board
Kneaded eraser
Tape
Plumb line
Narrow knitting needle or skewer

SETTING UP YOUR DRAWING

You can do this lesson from any subject matter, including a still life, a live model, or a cast in your studio. Another option, if you live near a museum with a strong collection of figurative sculpture, may be to work on location in the museum. Most places will let you draw in pencil. Some are accommodating enough to actually get you a chair. This lesson can be done as a small study over the course of one day or a finished drawing over a number of months, depending on your goals.

To the best of your ability, establish formal lighting conditions, from the upper left, if at all possible. You can use light from a window, or a desk lamp with a movable head (or the equivalent) to angle the light so it creates interesting shadow shapes on your still life, model, or cast. Create your setup so that you can view it comfortably without looking up and down. You can choose to use the sight-size method, which is illustrated here, or the comparative method (as shown on page 199). The rule of thumb is to stand back a distance of three times the height of your subject. Have your paper at a comfortable angle so that you can easily see both it and the subject.

CREATING YOUR DRAWING

Portrait drawing has existed as a formal subject for thousands of years. Its versatility enables it to record a single human life and capture a hidden psychological reality. The artist and teacher Richard Lack recommended that the student not attempt a portrait because of the difficulties associated with it. Rather he suggested it was better to focus on getting "a good head study." This perspective shift can alleviate some of the pressure of having to get it just right.

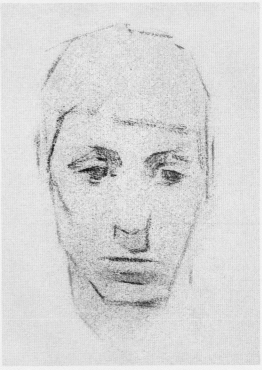

STAGE ONE: Find the contour and measurements of the head. This initial block in establishes scale and proportion and articulates the notional space.

STAGE TWO: Use the shadow shapes to help you measure the placement between the features. Look especially for a perfect alignment between the two sides of the face in relation to the imaginary centerline.

STAGE ONE: *Determining Size and Gesture*

Start by determining the scale. How big should the drawing be on the page? If you plan to use the sight-size method, the size of your drawing will be dictated by the size of the subject and your distance from it. You can see an example of Jordan doing a portrait drawing in the accompanying DVD. If you are using comparative measurements, the drawing can be any scale you wish. Either way, less than life size is recommended. Lock in the top, bottom, and width of the head. This will form a rough notional space and also dictate the composition on the page. Notice that Jordan included the neck right from the beginning and quickly found the major divisions, such as the bangs. He also used tonal spotting to find the features, choosing to use mass instead of line. Notice, too, how lightly he placed his lines.

STAGE TWO: *Finding the Landmarks*

At this point you might find it helpful to place a centerline along the middle of the forehead, between the eyes, and down the bridge of the nose. (In Jordan's drawing you can feel, rather than see, the centerline; the model's face is tipping just slightly to the right.) This will help you orient the direction of the head as well as place the features (which are always perpendicular to this centerline).

Once you place a few key landmarks through measuring, most of the critical proportional markers will be located. In Jordan's drawing he works from general to specific. He has indicated the placement of the features through spots of tone, which he later sculpts more fully into place.

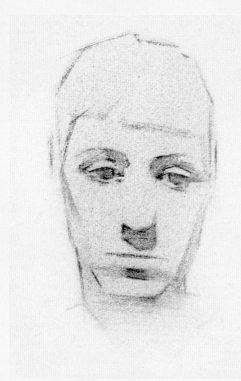

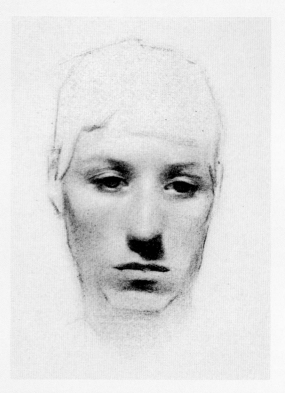

STAGE THREE: Add darker accent notes and straight edges to formalize the tones of the features, creating specific shapes.

STAGE FOUR: Develop the character of the shapes and forms closer to the light source.

STAGE THREE: *Formalizing the Shadow Shapes*

An important aspect of drawing the portrait is not being sidetracked by the features. Notice how Jordan focused on shadow shapes. The longer you can avoid drawing the "eyes," "nose," and "mouth," the better. Instead focus on abstracted shapes and how form can be suggested through a well-observed shape.

Using a light touch, mass in the tone of the shadow shapes. Jordan used straight-line relationships to find the broken lines of the eyebrows, the changing angles around the mouth, and a more complex contour. This stage will bring your drawing close enough to the likeness of the model that measurements are not essential; you can just flick your eyes back and forth between your drawing and the model to check for accuracy.

STAGE FOUR: *Developing the Value*

Developing value in a drawing starts with establishing parameters, observing first where the darkest darks are, as well as the lightest lights. This is referred to as "keying the drawing." The light hitting Costanza is soft and therefore creates subtle form lighting with a broad local-light tone. Notice how Jordan carefully developed the core shadow line as it alternated between lost and found edges. The darker moments in the core shadow indicate where some of the key accents will be found. The broken lines reveal where the halftones will be soft and diffused.

When using toned paper (as shown in this demo), it is important to identify the role of the paper—and whether it will either stand in for the shadow, mid-tone, or local tone of the subject. Jordan's paper forms the local tone for the skin; he used white chalk pencil to move into the lighter value range. White is best used like salt—sparingly. Notice how Jordan used white to sculpt the girth of the nose into the correct shape without much additional use of charcoal.

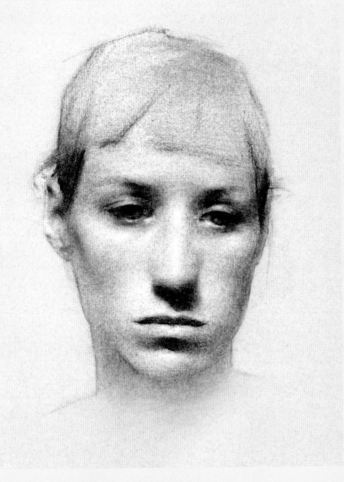

STAGE FIVE: Employ smokelike transitions of the halftones to describe the surface topography of your subject.

STAGE FIVE: *Rendering Form*

Drawing the face has a very narrow margin for error. Small shifts can make a major difference in the likeness. Concern yourself with shaping the value in each small area without losing sight of the big impression. The cumulative effect will be greater accuracy of the features.

Rendering form involves observing abstracted shapes of value as well as understanding how form turns in space. Finishing the drawing requires an obsessive love of small forms. Taken together, these nuances create big changes.

Form drawing is concerned with capturing the tip and tilt of planes toward and away from the light. The subtle adjustments of value gradations along the core shadow line are responsible for the feeling of girth. As you develop tone out of the core shadow, consider the character of the form that is being described. (For example, how round or how sharply does the form turn? How do the gradations of halftone explain those characteristics?) Each subform is considered as a tiny volume with a focus on its shape, core shadow, and qualities of the halftone.

AFTERWORD: A NOTE OF ENCOURAGEMENT

To the serious young artist I would say: Fix your eye on the highest, gird yourself for the journey, and Godspeed! If you fall by the way you may at least fall face forward. And it may be that even you may reach the goal. It may be that you, too, may find yourself, in the end, among that small but glorious company whose work the world will cherish and whose memory the world will not let die.

—KENYON COX (from *The Classic Point of View*)

THERE IS A SAYING AMONG STOCKBROKERS: "We are all just one trade away from humility." In my experience, such a sentiment could be said about the artist. Most artists feel that they are never better than their most recent work. The next one is always going to be the masterpiece. I have never met an artist, no matter how accomplished, who has not wrestled with self-doubt. We all fall short, at one time or another, with this high calling.

I had a discussion with veteran artist David Leffel about his days teaching at the Art Students League in New York City. He would ask each new student if he or she was a good draftsman (a prerequisite to moving into oil paint). If the person said yes, David would start them from the beginning again, knowing that they couldn't be. Drawing is way too complex a discipline for any new student to comfortably admit mastery. If any student showed such hubris, it was certainly a sign that he did not understand the enormity of the task. Drawing is hard.

It is difficult to avoid the inevitable emotional roller-coaster ride in art. In perfect honesty, I experience it during the creation of most of my work. There have been many moments when I have almost walked away. The internal self-condemnation—*I should be better than this. Why am I wasting my time? I invested so much time and money into something that is going so poorly. Everyone knows how badly this is going. Why don't I do something practical with my time? It has been done better by so many other people, what could I have to offer?*—can be an artist's undoing.

The artists who make a contribution are not always the ones who come out of the gate the strongest, youngest, or most

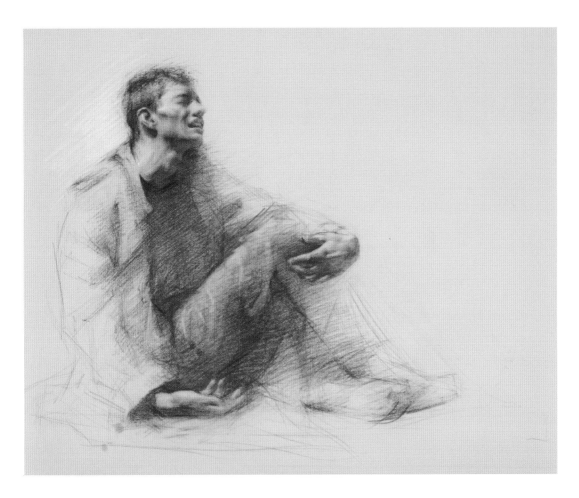

promising. They are the ones who do not give up. Most people, for whatever reason, don't make it because they quit. Struggle, doubt, fail . . . but get back up and keep going.

Self-doubt can be underrated; it is not all bad. Lack of confidence can keep you learning and growing your whole life, challenging you to improve and keeping you striving for excellence. Humility is an essential component of the artist. However, you need enough faith and self-confidence to keep on the path and weather the inevitable hard knocks. Sometimes the most interesting work conveys the artist's search and struggle to create it. Keep in mind that when you care enough to do your best at each stage, the end will represent your best effort overall. Whether you know it or not, you have an irreplaceable voice to add to the world. I guarantee that there is something you can see more clearly than anyone else. It is just a matter of finding the proper vehicle. Remember that it is your goal to create not a photographic likeness, but an emotional accuracy. Your drawing doesn't have to look just like your subject; it just has to be honest, consistent, and believable.

JULIETTE ARISTIDES, *Grief,* 2009, sepia pencil on paper, 14 x 19 inches (35.5 x 48.3 cm), private collection

The highest contrast areas are reserved for areas of key importance, drawing the viewer's eye to the hands and face.

BIBLIOGRAPHY

ARISTIDES, JULIETTE. *Classical Drawing Atelier: A Contemporary Guide to Traditional Studio Practice.* New York: Watson-Guptill Publications, 2006.

ARNHEIM, RUDOLF. *Art and Visual Perception.* Berkeley: University of California Press, 1954.

BARGUE, CHARLES, AND JEAN-LEON GÉRÔME. *Drawing Course.* Paris: Art Creation Realisation, 2007.

BARRATT, KROME. *Logic and Design: In Art, Science, and Mathematics.* New York: Design Press, 1980.

BRIDGMAN, GEORGE. *Bridgman's Complete Guide to Drawing from Life.* New York: Sterling, 2009.

CHAPMAN, JOHN GADSPY. *The American Drawing Book.* New York: A. S. Barnes & Company, 1873.

CHING, FRANCIS. *Design Drawing.* New York: John Wiley, 2010.

CURTIS, BRIAN. *Drawing from Observation.* New York: McGraw-Hill, 2002.

DONDIS, DONIS A. *Primer of Visual Literacy.* Cambridge, MA: MIT Press, 1973.

GOLDFINGER, ELIOT. *Human Anatomy for Artists: The Elements of Form.* New York: Oxford University Press, 1991.

GOMBRICH, E. H. *Art and Illusion.* Princeton, NJ: Princeton University Press, 2000.

HALE, ROBERT BEVERLY. *Drawing Lessons from the Great Masters.* New York: Watson-Guptill Publications, 1989.

HARDING, J. D. *Harding's Lessons on Drawing: A Classic Approach.* London: Frederick Warne and Company, 1849.

JACOBS, TED SETH. *Drawing with an Open Mind.* New York: Watson-Guptill Publications, 1991.

KELLER, DEANE G. *Draftsman's Handbook.* Old Lyme, CT: Lyme Academy College of Fine Arts, 2003.

RUSKIN, JOHN. *Lectures on Art.* New York: Allworth Press, 1996.

RUSKIN, JOHN. *The Elements of Drawing.* New York: Dover Publications, 1971.

RYDER, ANTHONY. *The Artist's Complete Guide to Figure Drawing.* New York: Watson-Guptill Publications, 2000.

SPEED, HAROLD. *The Practice and Science of Drawing.* New York: Dover Publications, 1972.